the knot
ultimate
wedding
lookbook

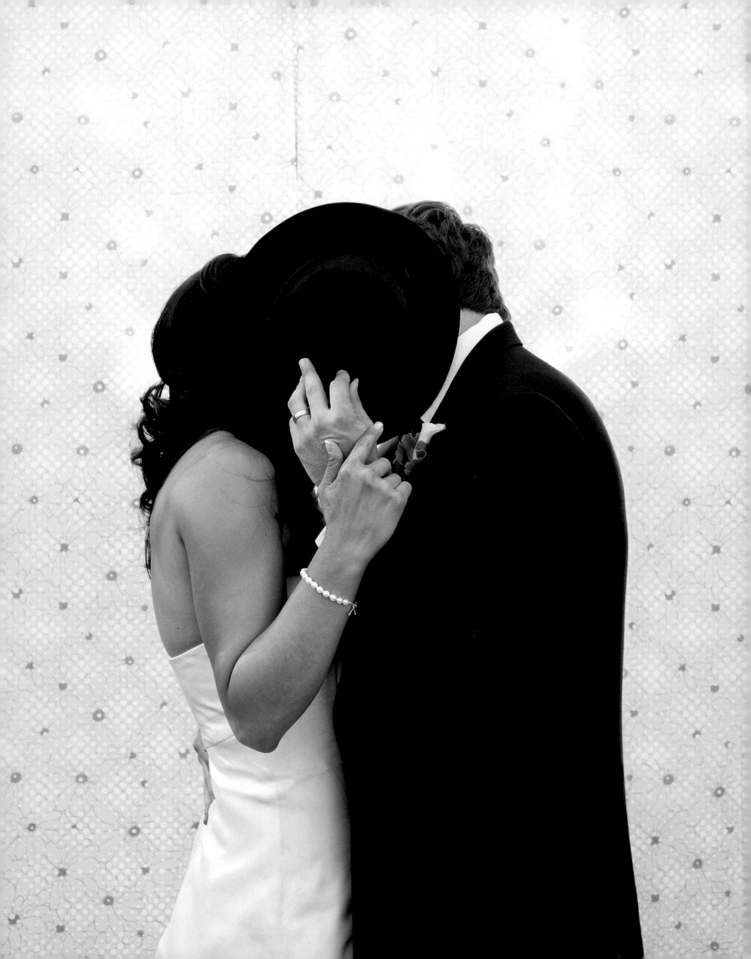

the knot
ultimate
wedding lookbook

More than 1,000 cakes, centerpieces,
bouquets, dresses, decorations,
and ideas for the perfect day

carley roney
and the editors of TheKnot.com

Clarkson Potter/Publishers
New York

Published in the United States by Clarkson Potter/Publishers, an imprint of the Crown Publishing
Group, a division of Random House, Inc., New York.
www.crownpublishing.com
www.clarksonpotter.com

CLARKSON POTTER is a trademark and POTTER with colophon is a registered trademark of
Random House, Inc.

Library of Congress Cataloging-in-Publication Data
Roney, Carley.
 The Knot ultimate wedding lookbook : more than 1,000 cakes, centerpieces, bouquets,
dresses, decorations, and ideas for the perfect day / Carley Roney and the editors of
TheKnot.com.—1st ed.
 p. cm.
 Includes index.
 1. Handicraft. 2. Wedding decorations. 3. Weddings—Equipment and supplies.
4. Weddings—Planning. I. Knot (Firm) II. Title.
 TT149.R65 2010
 745.594'1—dc22 2009051949

ISBN 978-0-307-46290-9

Printed in China

Design by Liza Aelion for The Knot

For photography credits, see page 284.

10 9 8 7 6 5 4 3

First Edition

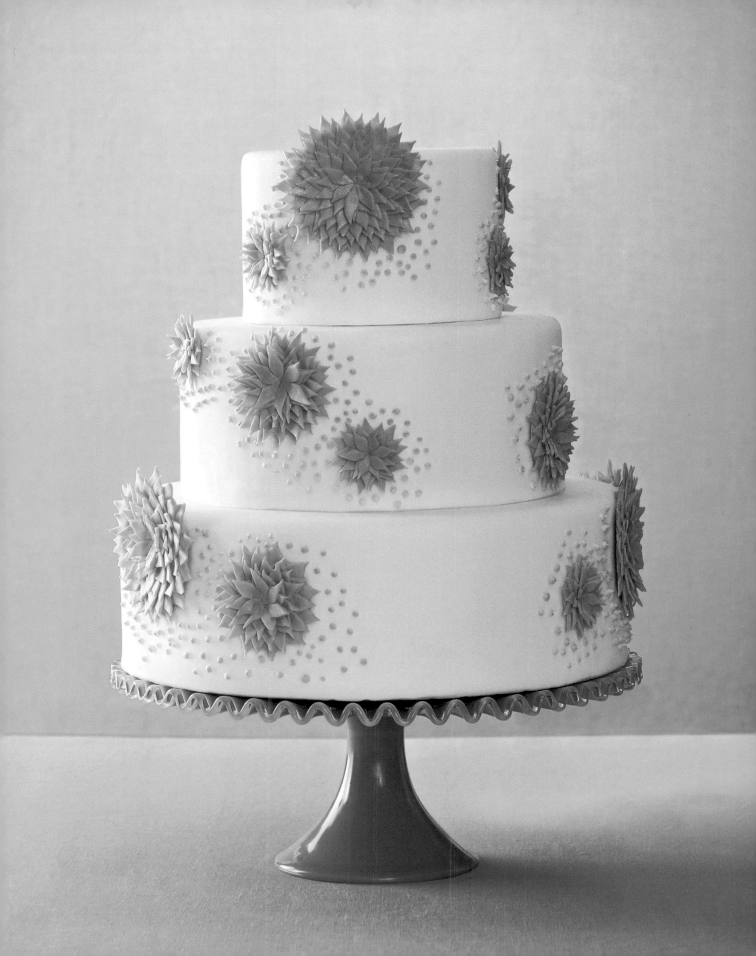

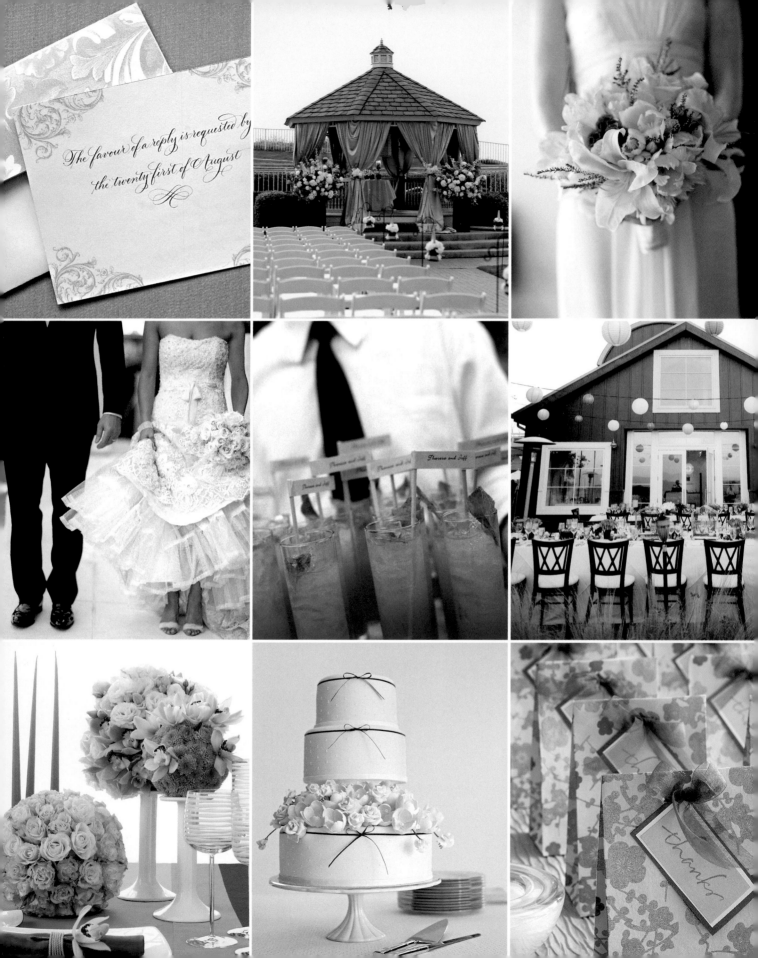

contents

Introduction: Finding Your Style
9

Turn to these pages to browse by color

A white-on-white palette is a classic wedding choice, but a closer look reveals this one isn't quite so basic: The motif and attention to small details add texture and make this wedding stand out. Choosing a font that's whimsical instead of formal, unexpected types of flowers, or even a special detail, like a cable-knit vase wrap, can create a distinctive style.

opposite Mixing flowers you may not normally imagine together adds a surprising texture and dimension.

Mr. and Mrs. William Myers
request the pleasure of your company
at the marriage of their daughter
Lesley Elizabeth
to
Adam James Bradley
Saturday, the fifth
two oo
at half

please reply by the fifteenth of November

finding your style

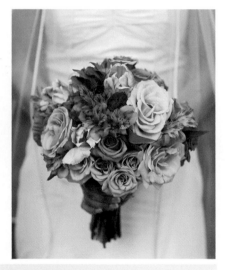

your planning to-dos
- Create your guest list
- Figure out what your budget will be
- Tap into your wedding style

To get married all you really need are a few rings, a dress, and an appointment at City Hall. But many couples feel the wedding is an important step in their lives together—one they want to share with their family and friends as well. How to express that excitement in a way befitting the occasion? That's where all the extras come in: flowers, music, fancy escort cards. Every detail adds up to a lovely manifestation of the emotion the day is brimming with. But deciding on those elements can seem downright daunting. Where—and how—do you begin? With the big picture: by establishing the style of the day.

Don't worry if you find the idea of your wedding style to be vague and abstract, or the task at hand—choosing one particular vibe for the event—to be overwhelming. This book is meant to make the process inspiring and fun, guiding you

TOGETHER WITH THEIR FAMILIES

Sarah Ann Benedict
& Michael Godfrey Bero

REQUEST THE HONOUR OF YOUR PRESENCE
AT THEIR WEDDING
SATURDAY, THE SIXTEENTH OF MAY
TWO THOUSAND AND NINE
AT HALF AFTER FIVE O'CLOCK

ST. PAUL'S CHURCH
CHICAGO, ILLINOIS

Often just a single piece of inspiration can represent your wedding style. Here that inspiration is a beautiful piece of lace. In your case, it might come from your wedding dress or your mother's. Maybe it's the same lace you're using as your chuppah's canopy. While the other details don't have to pick up the lace exactly, they can share the same romantic mood.

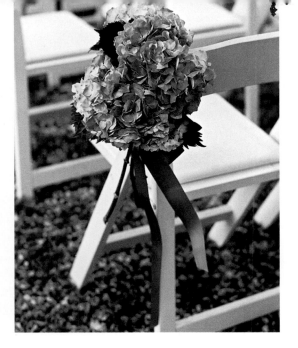

through each element of your wedding day and offering a sense of the many options available that can be tailored to suit you and your groom. Each chapter focuses on one specific aspect of the event, giving you the information you need to organize your thoughts and to choose a mood that's unequivocally *you*. You'll also discover useful tips that will help you flawlessly pull off every detail, along with hundreds of inspiring photographs of every kind of wedding, from fancy-free to formal. When planning a wedding, every choice you make will influence your next decision and the overall feeling. For a seamless aesthetic that translates into an unforgettable day, it's crucial to settle on one concept and stick with it. Here's how.

thinking about your wedding style

The guiding principle for your big day could be as simple as a palette of pink and green, or as specific as a modern-day interpretation of *A Midsummer Night's Dream,* complete with swags of floral garlands, gauzy bridesmaid dresses, moss-and-ivy-filled centerpieces, and special "Love Potion" cocktails. Where you start—and how far you carry out the concept—is entirely up to you. No matter how elaborate your theme, a common thread will pull the whole day together.

Consider these perfectly thought-out, though stylistically distinct, examples straight from recent brides: A bride and groom who couldn't resist New England in the summertime hosted a preppy lobster bake (page 262). A California couple who loved the idea of an outdoor wedding decided on a harvest-style reception in Napa Valley (page 70). Another couple chose to tip their hats to their Mexican wedding location and served their guests cervezas and seviche (page 224).

gathering inspiration

Sounds fun, right? But if you're nowhere near nailing down your wedding style to this extent, don't panic. The beginning of the process is the dreaming phase, when ideas are allowed to be disparate and not completely formed. Start collecting inspirations, and don't limit yourself to browsing the obvious sources; something as unlikely as a wallpaper pattern or a photo of a terra-cotta urn can spark

design-era dictionary

Georgian (1714–1830, England)
THINK Matchy-matchy with a decadent flair. Chippendale chairs, refined colors, fans on the seats, and bridesmaid dresses with an emphasis on the waistline will unify your theme.
WEDDING-STYLE INTERPRETATION
Your signature shade is lilac or pale pink. Your bridesmaids carry monochromatic bouquets, and the groom and his gang wear formal attire, but perhaps in a light color. The reception is probably under a tent with paper lanterns above the dance floor.

Regency (1750–1850, England)
THINK Classic and timeless. Brass and marble make a refined statement.
WEDDING-STYLE INTERPRETATION
You're hosting a ballroom affair; black tie optional. Your tables are a mix of rectangles and rounds, set with simple gold-rimmed white china. Chandeliers and pinspot lighting accentuate the cascading table arrangements.

Victorian (1837–1901, England)
THINK Queen of England meets Newport mansion. White lace and orange blossoms infuse a romantic setting with sophistication.
WEDDING-STYLE INTERPRETATION
Your palette is all about pastels. You welcome unexpected elegance to the tables with vintage teapots

continued . . .

holding fluffy pink and white peonies. Consider clustered floral or pale damask linens.

Belle Époque (Late 1800s, France)
THINK French cafe and nightlife epitomize the era.
WEDDING-STYLE INTERPRETATION Bring in charming, round bistro tables. Mix casual touches with more ornate pieces, such as a heavy velvet curtain that separates the cocktail hour from the reception.

Hollywood Glamour (Late Nineteenth Century to Mid-Twentieth Century, United States)
THINK Magic in the air. Lighting is most flattering; sparkle is key; jewel tone colors and lacquer are essential. Elizabeth Taylor would feel comfortable at your wedding.
WEDDING-STYLE INTERPRETATION Black-and-white photos of weddings past hang around the cocktail area. Metallic details and mirrors are everywhere. Tables are mostly squares and rectangles with votives and lanterns running down the center.

Art Deco (1925–1939, Europe and United States)
THINK Opulent and lavish are the idea here—South Beach hotels, lots of black and white.
WEDDING-STYLE INTERPRETATION Work the black-and-white parquet floor and don't shy away from color like bright magenta or sunny yellow accents. Your reception tables sparkle thanks to the mirrored bases for your centerpieces.
continued . . .

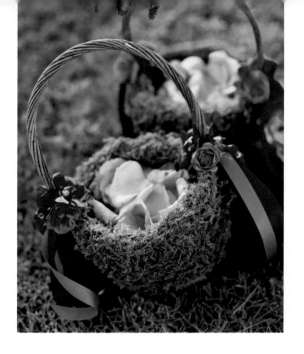

an idea. If fabrics, color chips, stationery, and other interesting trinkets catch your eye, collect those, too. Soon, you'll start to see a theme or color palette emerging, which will help to organize your planning.

focusing on a theme
If you find you're stuck for ideas, think about interests and hobbies you and your fiancé share, and places and experiences that are meaningful to you. A shared love of Baroque art could lead you to a wedding in a museum space with centerpieces straight out of a Dutch master's still life. If 1950s movies are what brought you together, the film *High Society* could inspire the retro, elegant look of your event: The venue could be on the grounds of a beautiful old mansion; the decor would be sophisticated and chic, such as white garden roses brimming out of round silver vases; and the dress would channel Grace Kelly—a chic A-line with a natural waist. Perhaps there's a special place that could serve as a touchstone: Did you get engaged on a snowy mountaintop in Vail? You may want to hold a winter wedding with a theme that inspires every detail down to the save-the-date cards designed like ski passes.

If nothing has come immediately to mind, try to describe your personal style using a few evocative adjectives. Words like *rustic, preppy, glam, modern, elegant,* and *beachy* may suddenly inspire a eureka moment. Even "classic wedding" is a theme. Then, as you refine the concept, try layering on another filter to help further polish and personalize your theme. Your idea of a glam wedding may be a glam, *Art Deco* wedding, or your garden wedding might be an *English* garden wedding.

Another trick to figuring out your style is to think about venues you're attracted to. If you know you love the idea of having your wedding in a posh hotel, that may dictate a more classic, elegant, or old-world style. On the other hand, if you're drawn to a sleek new art museum, you may want to complement that space with modern, minimalist decor.

Your faith and culture may also play important roles, influencing the kind of food you serve, the music you play—even the attire you and your wedding party wear. You may prefer to simply cherry-pick details from your

Infusing cultural elements, such as a special pattern or specific color combination is not only meaningful but also the perfect starting point for what will become the aesthetic of the day.

Vikas Mathur with Pria Rana

Something blue is also a wedding-perfect jumping-off point. To keep the cool hue from feeling too frosty, chartreuse accents join the party. Whimsical dots on the stationery, playful appliqués on the cake, surprising flower bundles, and multilevel center-pieces keep the mood carefree, while a bold ring and a beaded clutch add a touch of glamour.

Quail B
230 QUAIL GARDEN
Quail Botanical Ga
San Diego, in t
35 acres

please be seated at table

ourwedding/anthony
annonbretthorst

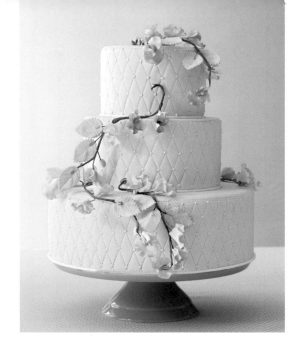

backgrounds rather than strictly follow the rules of one particular culture, but even those choices will have resonance. A Chinese-American couple decided to mix elements from their Asian heritage—origami cranes and red paper lanterns dotting the reception space—with more modern Western objects, like cupcakes in birdcages and cylinder vases full of floating candles and submerged flowers (page 146). Consult with family and religious leaders before you get too far into the planning so you'll know what's allowed and what isn't (a Catholic ceremony needs to take place in a Catholic church, and a Jewish ceremony needs to happen under a chuppah, for example). Check with your venue, if you have one, to see if there are any limitations on use of the space.

A final word of advice when it comes to settling on a theme: Don't load up on too many ideas. It's fine if you like Broadway musicals and your groom is into drag racing, but trying to incorporate both ideas into your wedding day is going to lead to a weirdly disjointed affair. For the best chance at a day that dazzles, choose one concept and stick to it.

picking your colors and motif
Just as a theme will emerge from your collected bits of inspiration, so will a palette. In fact, since nearly every wedding has a unifying color scheme—and since colors can be more concrete than themes—you may even want to start here first. Take a look at a color wheel to see what shades you're drawn to (check out the tool on TheKnot.com/color), or look through your closet or in your home. Are there certain colors you keep seeing? Thinking about the kinds of flowers you like will definitely narrow down your options. To learn more about what flowers come in what colors, see the lists at the end of each chapter. Check out the special guides at the end of each chapter, too, for inspired color pairings, from deep fuchsia and orange to robin's-egg blue and chocolate; they also provide tips on how to use color to unify all the elements of a wedding.

Design-challenged brides, take note: The easiest way to make all of your wedding elements come together is to stick with two colors rather

Fifties (1950s, United States)
THINK Everything is over the top. Bold, bright retro style is fun and fashionable.
WEDDING-STYLE INTERPRETATION Turquoise and pink with a pop of tangerine—you're all about colorful flair. Maybe your save-the-date resembles a retro postcard. Your invites include song request reply cards for the DJ, and you'll surprise guests with a photo booth.

Pop Art (Late 1950s, United States)
THINK Kitschy and overemphasized use of color and graphics. Warhol prints are the go-to art selection.
WEDDING-STYLE INTERPRETATION Cherry red, lime green, and sunny yellow—yes, all together. Your invites have dimension, be it a bloom that pops up when you open it or an embossed design, and use bold, oversized fonts and graphics. Photos of your favorite modern-art prints top your escort cards.

Minimalist (Late 1960s–Early 1970s, United States)
THINK Less is more. Emphasize clean lines and natural, non-fussy colors and elements.
WEDDING-STYLE INTERPRETATION Nothing says sophistication like an all-white wedding. Your details come in the textures, such as cable-knit or linens, and in the lighting. Your go-to flowers are hydrangeas, orchids, garden roses, and ranunculus.

BOOKMARK IT

See the hottest
wedding color combos at
TheKnot.com/color

Get tips to define your
wedding theme at
TheKnot.com/weddingstyle

Find ideas for a creative
couple monogram at
TheKnot.com/monograms

Design your own
inspiration board at
TheKnot.com/inspiration

See the latest
wedding dress styles at
TheKnot.com/fashion

Find chic ways to
decorate your ceremony at
TheKnot.com/ceremony

Get must-have hair
and makeup tips at
TheKnot.com/beauty

than juggling three or more. And while a color combination alone is enough to inspire everything from soup to Jordan almonds, you may want to add another layer of inspiration. This would be your theme. The color combination and your theme will help you zero in on specific details. For example, a black-and-white wedding implies a formal affair, but you'll find plenty of leeway when it comes to the specifics. A black-and-white wedding with an Art Deco theme is more focused and may call for a dress with a sheath silhouette, centerpieces bursting with oversized white feathers, and a cake with a geometric design. Likewise, a black-and-white fifties-themed wedding may consist of polka-dot decor, a flirty ruffle hem dress, and pops of cherry red as accents. With the right details, you can take a simple color palette in just about any direction.

Your motif is that last flourish that completes the overall look of your wedding and can crop up everywhere from the cake to the invitations. It's a shape, a pattern, or an insignia that conveys your style. A monogram, a family crest, cherry-blossom branches, or a pretty toile pattern—it can be any design, pattern, or graphic you use. Whatever you choose should reinforce the mood you're trying to create. Toile, for example, connotes a French, pastoral feel, whereas a cherry blossom is fresh and modern. Use your motif sparingly, in three or four places; any more than that can feel forced. When paired together, your colors, theme, and motif should exude the look you've always pictured. If it doesn't, revisit one of these three design elements and see what's throwing off the scheme.

don't forget the vibe

Finally, while your theme obviously affects the look of your wedding, it can also set the tone. A nighttime wedding in a gilt-trimmed ballroom meant to conjure *The Great Gatsby* will ramp up the chic quotient a notch, while a clambake on the beach will have guests kicking off their shoes and enjoying beer from the bottle. Either is appropriate as long as it feels right to you. Aside from having a gorgeous event, you want your guests to celebrate who you and your spouse-to-be are as a couple. You want your personalities and passions to shine through, which is what makes a wedding stand out as truly special.

When it comes to wedding stationery, there are limitless choices—from a lavender envelope with elegant flowers and the bride and groom's initials foreshadowing a formal event to a vintage-style label that signals an informal Vegas wedding. **opposite** This elaborately designed reply card is paired with a complementary envelope.

Ms Sharon Riber
120 EAST 57TH STREET
APARTMENT F4E
NEW YORK, NEW YORK 10138

Please join us
FOR A REHEARSAL DINNER CELEBRATING
Day and Max
Friday, August 15

Six o'c...
The Santa Barbara ...
136 East De...

RSVP ...
Kay Unger and ...

Rsvp

○ HAPPILY ACCEPTS
○ REGRETFULLY DECLINES
Kindly reply by the fifteenth of July

Mary & John
B

Mary Ellen Omsford
&
Mr. John Borden

REQUEST THE HONOUR OF YOUR PRESENCE AT THEIR MARRIAGE
ON SATURDAY, THE THIRTEENTH DAY OF SEPTEMBER
TWO THOUSAND AND EIGHT
AT HALF PAST FIVE O'CLOCK IN THE EVENING
THE SHOREBY CLUB · 40 SHOREBY DRIVE, BRATENAHL, OHIO

IT'S A
**VEGAS WEDDING,
BABY!**

Jenni and Jay

MR. AND MRS. FRANCIS JOSEPH MCKEE
REQUEST THE HONOUR OF YOUR PRESENCE
AT THE MARRIAGE OF THEIR DAUGHTER

Jennifer Lynn McKee TO *Jay William Hannon*

SATURDAY, THE TWENTY-SEVENTH OF SEPTEMBER
TWO THOUSAND EIGHT
THREE O'CLOCK IN THE AFTERNOON

OLD SAINT MARY'S CATHOLIC CHURCH
PHILADELPHIA, PENNSYLVANIA

the stationery

1

your countdown

6–12 months before:
Find and send save-the-dates.

4–6 months before:
Order invitations.

3 months before:
Have a calligrapher address the envelopes; send invitations.

6 weeks before:
Order printed menus, table numbers, and favor tags.

get inspired by

- A favorite wallpaper pattern
- Souvenirs and postcards from the location
- Your wedding colors
- Seasonal symbols, like leaves or snowflakes

While ordering your invitations is one of the tasks that comes later in the wedding to-do list, you should begin thinking about them early in the process. When your guests open the invitations, they get their first taste of your wedding. By choosing textures, type, and wording that express your wedding style, you'll have guests envisioning and anticipating your wedding day as soon as they tear open the envelopes.

Of course, the invitation and save-the-date have a practical function, too. A save-the-date is especially critical for destination weddings or events held over a holiday weekend, and it should be sent even earlier than the six to twelve months ahead we recommend for close-to-home weddings to give guests ample notice to make travel plans.

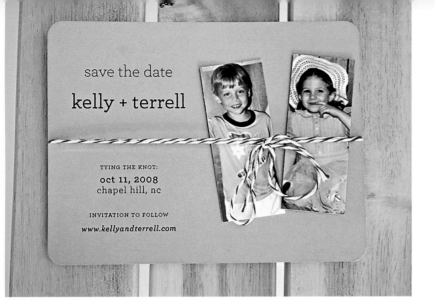

save the date
kelly + terrell

TYING THE KNOT:
oct 11, 2008
chapel hill, nc

INVITATION TO FOLLOW
www.kellyandterrell.com

making an impression While both the save-the-date and
the wedding invitation will give a hint to your style, the save-the-date can
be more inventive, making it perfect for playing up personalized details.
While you do want it to complement your invitation, it's a great place to use
an engagement photo or a quirky sketch of your wedding locale.

Your invitation, on the other hand, is an important place to work in
the overall vibe of your wedding. Find a monogram or motif (two birds, a
leaf, a peony) that you can carry throughout your stationery and into other
elements, like your cake or your lighting. Or choose a pattern to use as a
border in a corner or even as the entire background on the card. This pat-
tern can appear again in your aisle runner, on the reception table linens, or
in favor packaging.

color and shape Ivory cards with black text are a classic choice
that can exude formality, but today it's even more common to be creative
with color. Bold ink hues, like navy blue, ruby red, and fuchsia, are all easy
to read, but avoid pastels, including yellow and light green.

Even a simply designed invite can make an impact if it has a distinct
shape. An ultranarrow or horizontal orientation can give an invitation a
more modern feel. Squares used to be as contemporary as they come but
are now suitable for even classic brides. Looking for something a little more
offbeat? Circles, triangles, or custom shapes cost more to create but will
send the message to your guests that your wedding won't be like any other
they've attended.

invitation wording

How you word your invitation depends on
who's hosting the event and on your
family situation. Here are the most common:
top, bride's parents hosting; bottom, both
parents hosting.

Mr. and Mrs. John L. Smith
request the honor of your presence
at the marriage of their daughter
Heather Marie
to
Michael Francis Jacobson
Saturday, the fourteenth of May
two thousand eleven
at half past four in the afternoon.

OR

Mr. and Mrs. John L. Smith
and
Mr. and Mrs. Mark Jacobson
request the honor of your presence
at the marriage of their children
Heather Marie
and
Michael Francis
Saturday, the fourteenth of May
two thousand eleven
at half past four in the afternoon.

For a complete list
of wording ideas, go to
TheKnot.com/invitations

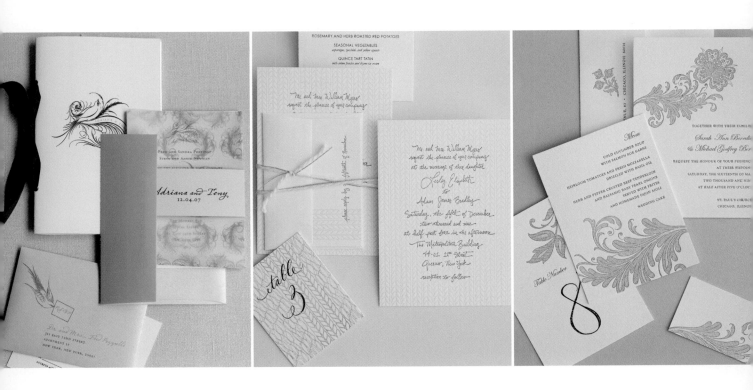

opposite Save-the-dates are the perfect opportunity to get playful. Here, childhood photos and bakery string lend a homespun feel.

top All the pieces of your stationery work together to underscore your theme. ■ To create a luxurious look, a suite with a hand-drawn bird motif is embellished with details like a sumptuous ribbon on the program, and a sheer, patterned vellum overlay and pale purple personalized bellyband on the invitation. ■ Black calligraphy-style lettering is given a twist with an unexpected background: an abstract leaf pattern. ■ A vintage-style floral, reminiscent of a rococo architectural detail, ups the elegance.

taking stock
For a simple design, the paper is an incredibly important choice. You're considering four factors: weight, color, tooth (or texture), and finish. The heavier the weight, the more luxurious the invitation will feel. The more tooth a paper has, the better the ink will take to its surface. You can layer different kinds of papers for extra effect. Some unique materials that can be printed on or engraved are acrylic, metal, glass, and even chocolate.

anatomy of a typeface
Script (or cursive) fonts were once the only acceptable option for a wedding invitation, but now any style of print is in play. Roman fonts, the type you tend to see in magazines, books, and online, come in two categories: serif and sans serif. Serif fonts feature little "flags" on the tops and bottoms of letters and look a bit more formal than sans serif. Sans serif tends to lend a modern or whimsical feel.

beyond wedding-day paper
When you're placing your invitation order, also consider the stationery you may want *on* and *after* the wedding day, such as ceremony programs and escort, place, table, menu, and thank-you cards. While these don't have to perfectly match your invitations (they won't be in the same room, after all), coordinating their lock helps you achieve a cohesive wedding style.

PLEASE SAVE THE DATE

August 18, 2007

FOR

LAUREN & JESSE

Bonnet Island Estate
LONG BEACH ISLAND, NEW JERSEY

SAVE THE DATE

Save the date

Gwendolyn Teller
and
Morgan Weingarten
ARE GETTING MARRIED!
THE SIXTH OF MAY, 2006

San Francisco, California

{08.11.10}

Julianne Tseng & Lance Cook
SAVE THE DATE · ST. PAUL, MINNESOTA

Amanda
and
Harrison

PLEASE HOLD THE DATE OF
SATURDAY, THE TWENTY-FIFTH OF AUGUST
TWO THOUSAND AND TWELVE
FOR THE WEDDING OF
AMANDA AND HARRISON
MR. AND MRS. ANDREW SIMON

SAVE THE DATE!
KIRSTEN & ERICH
ARE GETTING MARRIED
ON
JUNE 9, 2010
IN
CHICAGO, ILLINOIS
DETAILS TO FOLLOW

New York City

Save the Date
Corinne and Jeff
June 23 · 2007

Save-the-dates have
plenty of personality,
from formal green lace
accents to whimsical
coaster shapes.

save-the-dates

While invitations have more rigid rules, it's easy to get creative with the save-the-date and the stationery for other wedding-related events.

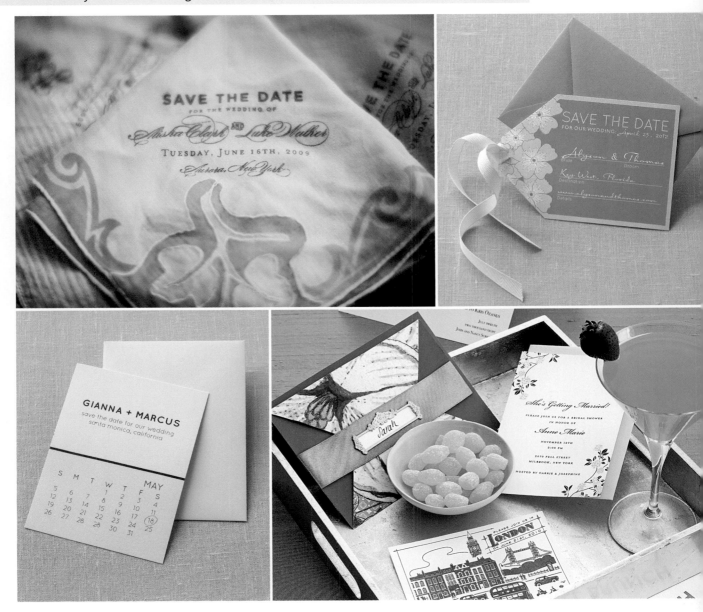

top Wedding stationery doesn't *have* to be paper. Save-the-dates printed on embroidered handkerchiefs make timeless keepsakes. ▪ A playful luggage tag shape lets guests know a destination wedding is in the works.

bottom A calendar of your wedding month is quirky and practical—with your date circled, guests won't forget it. ▪ Have fun with all the stationery that surrounds your wedding's events, whether it be the save-the-date or an invitation to the morning-after brunch.

℘ invitations

A missive that piques guests' interest most marries the perfect wording with color, design, shape, and printing style.

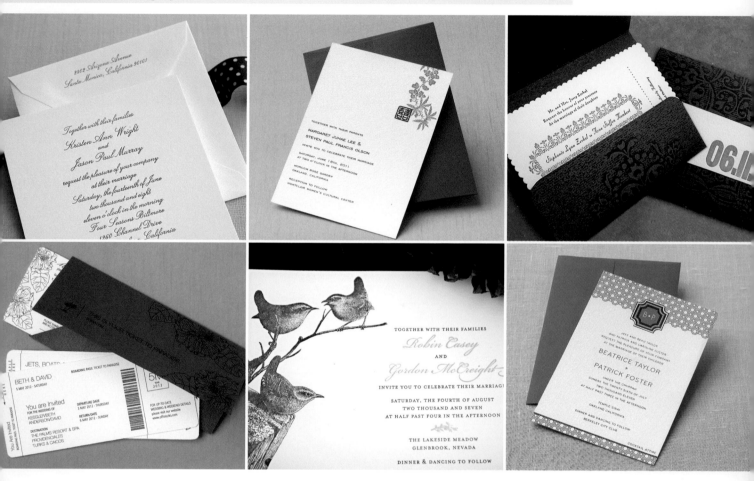

top A classic wedding invitation is always in style. Printed on a square card, this one is ultrasimple. ■ A double happiness symbol and Chinese blossoms decorate an invite to an Asian-themed wedding. ■ Peeling back the layers of an invitation can feel like opening a gift. This one has a band that slides off to fully reveal a brown and blue folder.

bottom A clever idea for a destination wedding: designing invitations that look like boarding passes. ■ The wedding site can inspire a design idea. Here, a celebration in a meadow was announced with the help of some feathered friends. ■ Monograms don't have to be formal. This one adds a personal stamp in a fuss-free way.

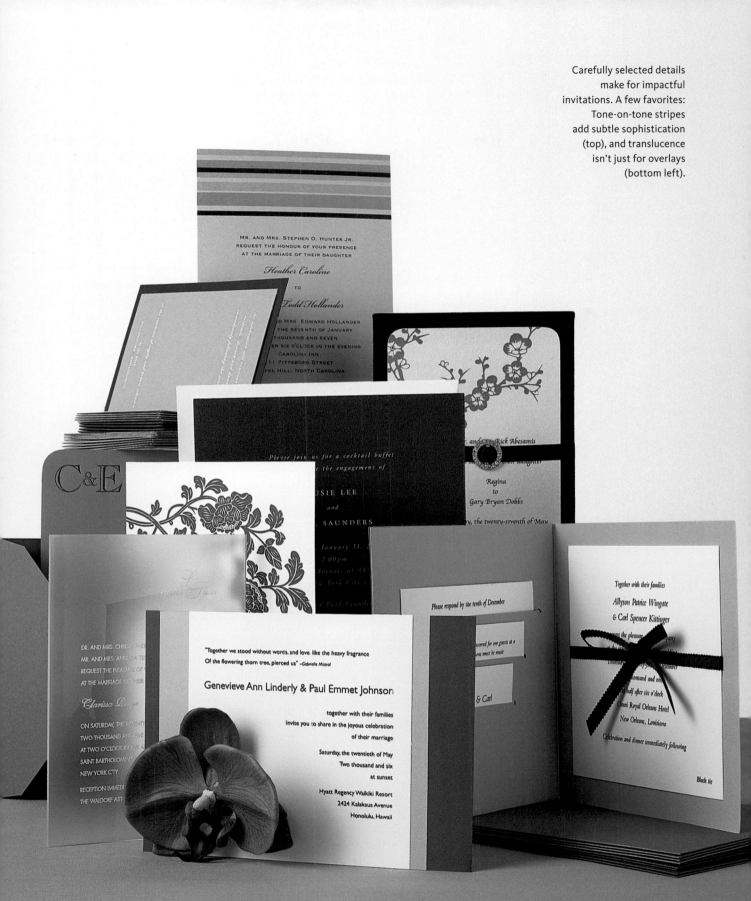

Carefully selected details make for impactful invitations. A few favorites: Tone-on-tone stripes add subtle sophistication (top), and translucence isn't just for overlays (bottom left).

MR. AND MRS. STEPHEN O. HUNTER JR.
REQUEST THE HONOUR OF YOUR PRESENCE
AT THE MARRIAGE OF THEIR DAUGHTER

Heather Caroline

TO

Todd Hollander

D MRS. EDWARD HOLLANDER
THE SEVENTH OF JANUARY
THOUSAND AND SEVEN
ER SIX O'CLOCK IN THE EVENING
CAROLINA INN
11 PITTSBORO STREET
PEL HILL, NORTH CAROLINA

C & E

Please join us for a cocktail buffet

the engagement of

USIE LEE

and

SAUNDERS

January 31, 2

7:00pm

Avenue, at 9

ew York City

d Paul Saunders

and Rick Abesamis

Regina

to

Gary Bryan Dobbs

y, the twenty-seventh of May

DR. AND MRS. CHRIS
MR. AND MRS. AN
REQUEST THE PLEASURE OF
AT THE MARRIAGE OF THEIR

Clarissa

ON SATURDAY, THE TWENTY
TWO THOUSAND AND FIVE
AT TWO O'CLOCK IN THE
SAINT BARTHOLOME
NEW YORK CITY

RECEPTION IMMEDI
THE WALDORF AST

"Together we stood without wares, and love, like the heavy fragrance
Of the flowering thorn tree, pierced us" –Gabriela Mistral

Genevieve Ann Linderly & Paul Emmet Johnson

together with their families
invite you to share in the joyous celebration
of their marriage

Saturday, the twentieth of May
Two thousand and six
at sunset

Hyatt Regency Waikiki Resort
2424 Kalakaua Avenue
Honolulu, Hawaii

Please respond by the tenth of December

rved for our guests at a
ns must be made

& Carl

Together with their families

Allyson Patrice Wingate
& Carl Spencer Kittinger

st the pleasure

December

nd and ni

ix o'clock

Omni Royal Orleans Hotel

New Orleans, Louisiana

Celebration and dinner immediately following

Black tie

jenna and ronald young
paige and gavin edwards
request the honour of your presence
at the marriage of their daughter

Bailey Angelina Edwards
to
Chase Evan Maxwell

saturday, the twentieth of june
two thousand and nine
at four o'clock
blessed sacrament church
madison, wisconsin

MR AND MRS JACOB BUTTERFIELD
MR AND MRS DEACON REYNOLDSON
REQUEST THE JOYOUS OF YOUR PRESENCE
AT THE MARRIAGE OF

JOY ELIZABETH
and
ISAAC DAVID

SATURDAY THE FOURTH OF JULY
TWO THOUSAND AND NINE
THREE O'CLOCK IN THE AFTERNOON
MARCONI BEACH STATION
WELLFLEET, MASSACHUSETTS

Feast and merriment to follow

victoria stocking & adam argo

request the pleasure of your company at their wedding

SATURDAY
APRIL 21st, 2007
4PM

studio 1050
1050 se water avenue
portland, or 97214

reception to follow

www.adamandvictoriaforever.com

*please join us
for brunch in honour of*

maria & james

*monday, january seventh
starting at ten o'clock
in the west lobby
of the overlook.*

DIANE AND MALCOLM TAYLOR
HAPPILY INVITE YOU TO CELEBRATE
THE MARRIAGE OF THEIR DAUGHTER

Emma Jane Taylor
TO
Robert Tou

ROBERT TOURTELLOTTE

FRIDAY, THE SEVENTH OF MAY
TWO THOUSAND TEN
AT SIX O'CLOCK IN THE EVENING
THE INN ON THE GREEN
MARLBOROUGH, MASSACHUSETTS

RECEPTION TO FOLLOW
GEDNEY ESTATE

Offset: The text sits flat against the paper, much like at-home printing does—but with higher quality. It's usually an affordable option, but note that the more ink colors you use, the higher the price.

Thermography: This very popular choice was made to mimic engraving for a cheaper price. A combination of heat-treated powders and ink creates that 3-D look. The only dead giveaway is that it doesn't have the indentations on the back of the invite that engraving does.

Engraving: Created using an etched metal plate, this technique gives you slightly raised ink, a look that comes with a high price tag.

Embossing: Different from thermography because the paper itself is raised, this option is often used to add drama to one design element—like large initials or borders. It's hard to read, so you wouldn't use it for your whole invite.

Letterpress: Essentially the opposite of engraving, the text is indented into the front of invites using a hand-operated press. It's highly sought after because of its old-fashioned craftsman feel, but it's pricey.

Calligraphy: This option is technically not a printing technique, but an option for envelopes. For a casual event, choose a print font with few flourishes. Straightforward script suits a semiformal wedding, while big loops feel fancy.

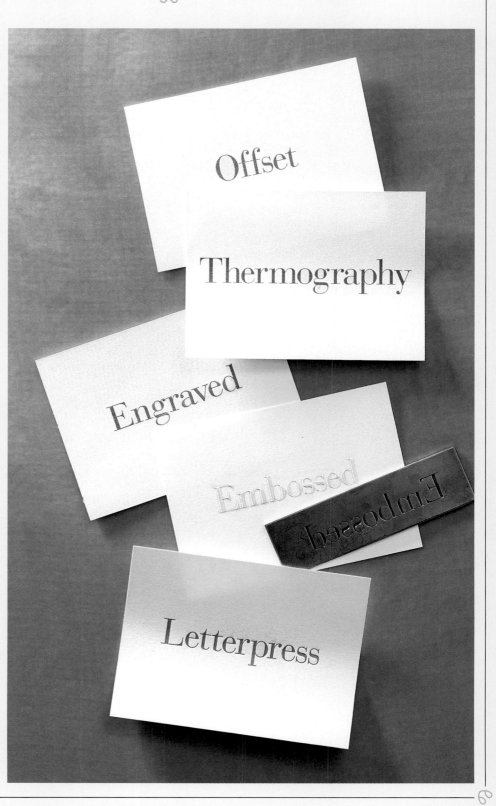

Gather addresses early
Collect addresses before invites arrive, but not too early—more than six months in advance and guests' addresses are more likely to change.

Don't email invites
Spreading the word about your impending nuptials digitally is kinder to the environment, but an event of this magnitude deserves printed invitations. Plus, with flooded inboxes and spam filters, some of your guests might not get the message.

Opt for plain envelopes
Remember that many guests will trash the envelope right away. While colored, textured, and lined envelopes are pretty, they're worth skipping in favor of more elaborate (and lasting) invites.

Order wisely
Stationers tend to sell invitations in batches of twenty-five. Round up.

Make a wedding website
A wedding website is essential to convey information, like hotel room booking details, maps of the wedding locations, and suggestions on what to do in the area. TheKnot.com has over fifty gorgeous website templates to choose from. Post all of the info from your invitations (make sure it's password-protected) and print the URL on your save-the-date and invitation.

Go green
Recycled, bamboo, and organic cotton papers come in more colors than you think. The most eco-friendly action you can take, however, is to reduce the amount of paper used for the invite. Forgo the inner envelope and extra enclosures, like a protective piece of tissue paper (ink hardly ever bleeds anymore) and reception cards. Hotel information and maps can live on your website.

Fake the reply-by date
No matter how on the ball your friends are, there will always be a few who don't RSVP on time. If your caterer needs a head count two weeks before the wedding, indicate on your response cards that guests should reply at least *three* weeks before your wedding.

Number your response cards
In your spreadsheet of guests' names and addresses, assign each guest a number. Write that number on the back of that guest's response card. That way, if they return the card to you and their name is illegible, or they've forgotten to write it altogether, you'll be able to identify who replied.

Avoid writing "and guest"
Before you send the invites, call anyone you're inviting with a plus-one so you can write his or her name on the envelope.

Spell it out
With the exceptions of numbers, *Dr., Mr., Mrs.,* and *Ms.,* every word gets spelled out on the envelope, from apartment to avenue—even the state name.

Go in order
Stuff your envelopes in this order, so that the invitation is at the back and all cards are facing up: invitation, response card tucked under its own envelope's flap, reception card, and then other enclosures.

Keep it light
The more layers your invite has, the more expensive it will be, because you'll be paying for extra paper and postage.

Weigh it
You may think your invite is light enough for a regular postage stamp, but to make sure, bring a fully assembled invitation with all of the enclosures inside the sealed, addressed envelope to the post office to find out the proper postage.

Bring an invite to your wedding
You spend all that time and energy picking out your perfect invite to make a good first impression on your guests . . . and then you wind up with zero photos of it at your wedding! Frame one of your invites and display it on the escort-card, guest-book, or gift table, or have a trusted bridesmaid bring one to your photographer to be sure to get a shot of it.

Questions to ask your stationer

1. How long does printing take?
Offset printing may take three to four weeks, but letterpress printing may take six to eight weeks.

2. Will I see a proof?
The answer should be yes. It can be digital or printed, but you need to see and approve a mock-up of your exact invite before all of them are printed.

3. Is there a design fee?
If you're ordering custom invites, you may need to pay a separate charge to the graphic designer who creates a monogram or illustration just for you.

4. Can I order extra invites if I need them?
Most stationers are happy to sell you more of the original design after your initial order, but some may charge an additional fee, especially if you opted for letterpress printing, so it's best to order 10 percent more invites than you need from the get-go.

5. If I change my mind about my design or wording, how long do I have to change the invite?
Usually, you can make small changes to the wording and fonts until the final proof.

Want more wedding stationery ideas? Go to **TheKnot.com/invitations**

Addressing the envelope

Married couple:
Mr. and Mrs. Rogers

Unmarried couple (alphabetical by last name, unless the other is a close friend or relative):
Ms. Jennifer Beal
Mr. Paul Rogers

Husband is a doctor:
Dr. and Mrs. Paul Rogers

Wife is a doctor:
Dr. Jennifer Rogers and
Mr. Paul Rogers

Couple where both are doctors:
Drs. Paul and Jennifer Rogers

Unmarried man:
Mr. Richard Baron

Unmarried woman:
Ms. Sara Ericson

Same-sex couple (alphabetical by last name):
Ms. Elizabeth Crowley
Ms. Annemarie Foster

Family with children under age eighteen (oldest child goes first):
Mr. and Mrs. Paul Rogers
Miss Hayley Rogers
Mr. Gregory Rogers

green

Fresh and natural, this sassy, grassy hue can be used to set a mood that's either bold or serene, depending on the shade.

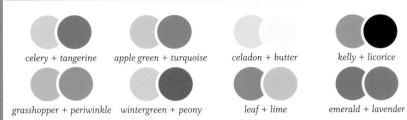

celery + tangerine

apple green + turquoise

celadon + butter

kelly + licorice

grasshopper + periwinkle

wintergreen + peony

leaf + lime

emerald + lavender

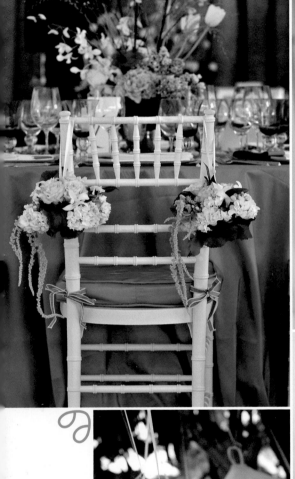

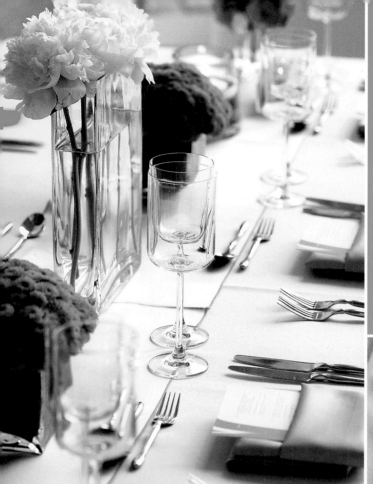

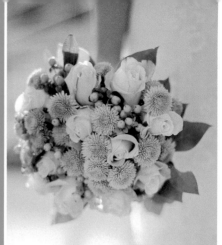

Flowers that come in green
Amaryllis
Calla lilies
Cockscomb
Gerbera daisies
Hydrangeas
Mums
Orchids
Ranunculus
Roses
Viburnum
Zinnias

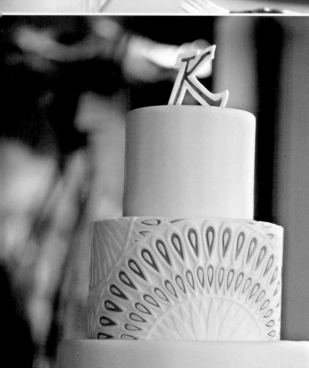

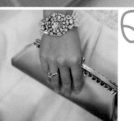

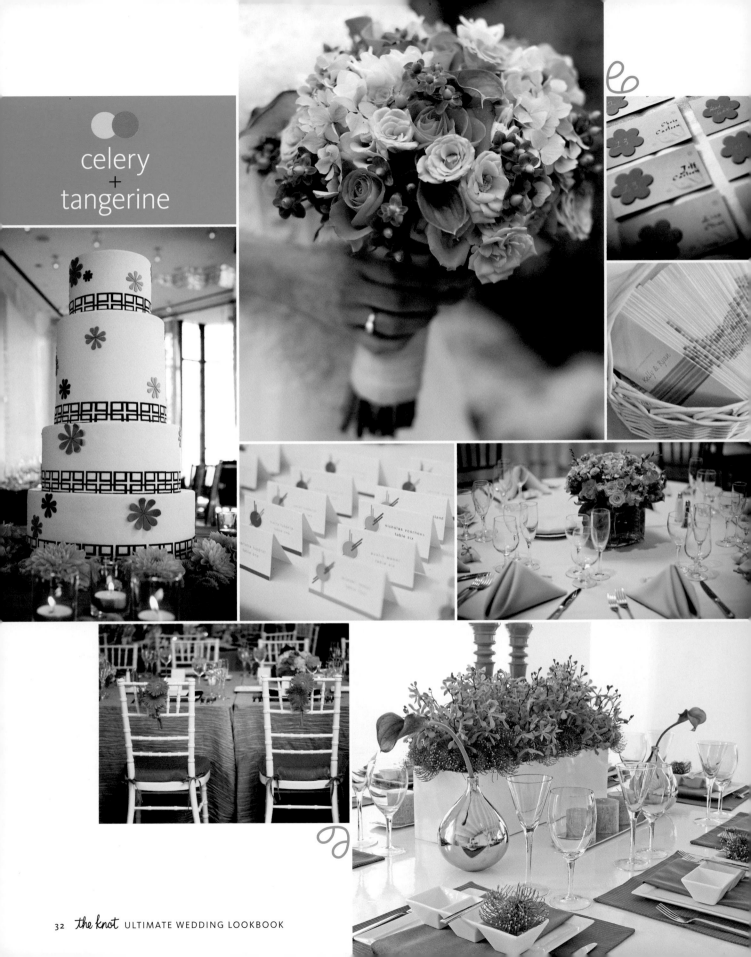

celery
+
tangerine

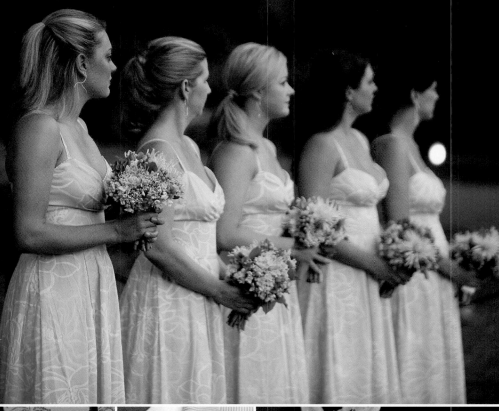

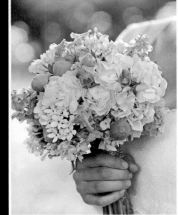

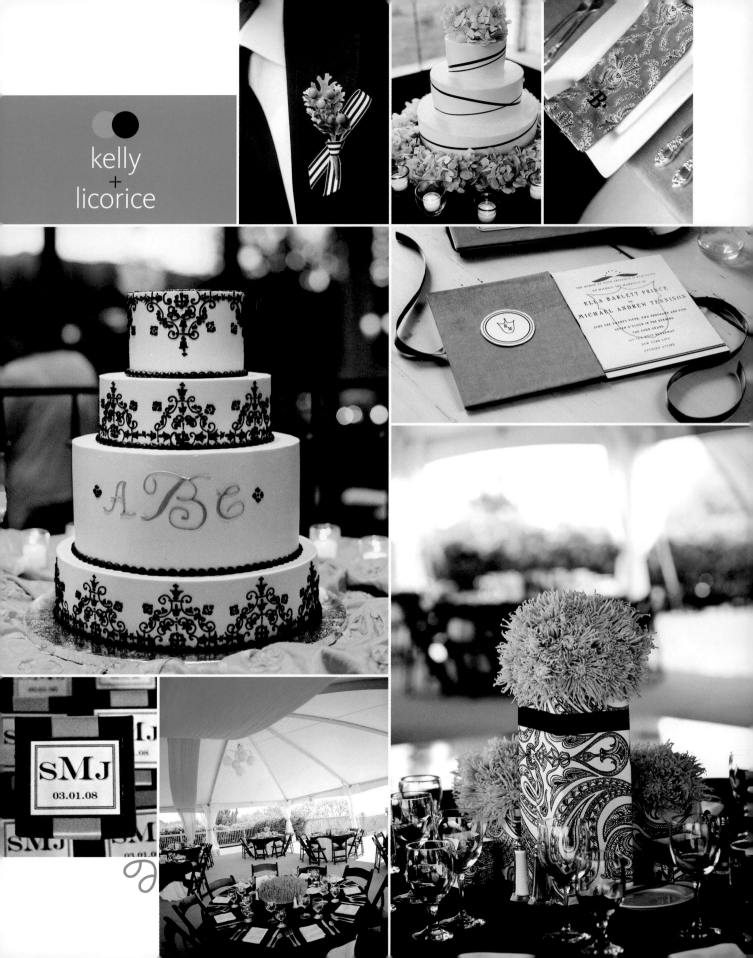

kelly
+
licorice

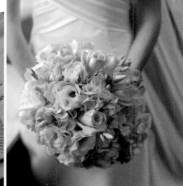

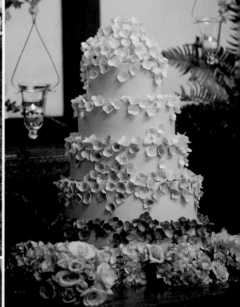

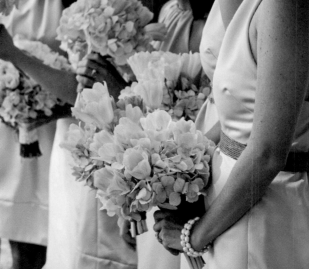

KRISTIN + JARED

a retro wedding

Kristin and Jared wanted to show off their fun-loving spirits with a Las Vegas soiree. They were inspired by Sin City in the 1950s. Bold red, white, and blue details, including playful pin-tuck linens; plastic sunglasses; and arrangements of roses, hydrangeas, and orchids set the scene. The pièce de résistance was a cake decorated with sugar poker chips, playing cards, and a top tier made to look like a die.

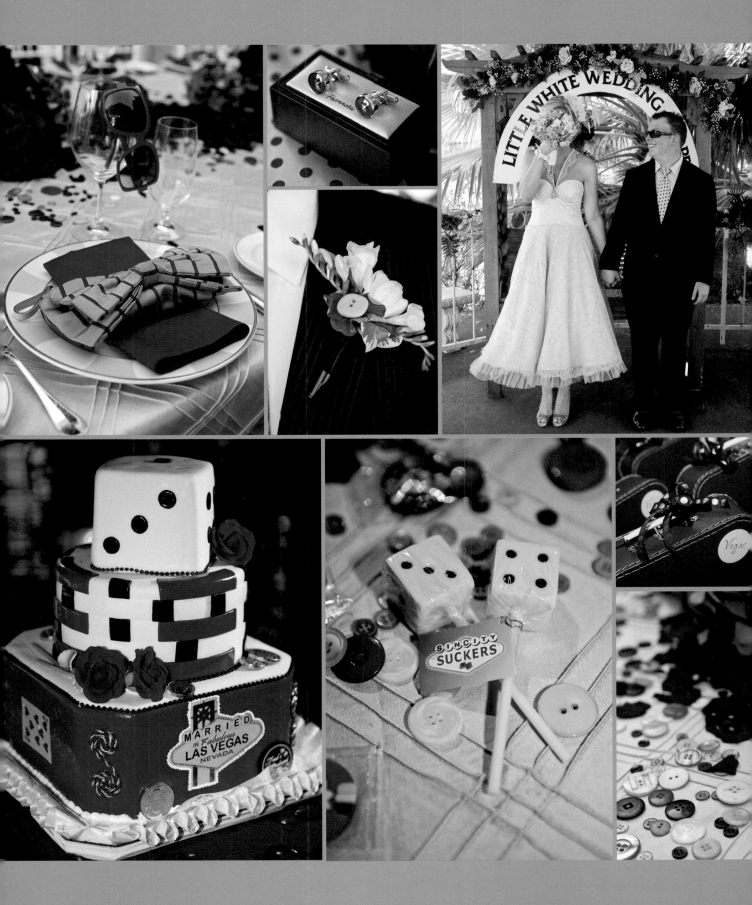

Part of what makes this ceremony setup so enchanting is the use of space and the creation of dimension with the aisle, the canopy, and the trellis just beyond it.

opposite Shepherds' hooks are an easy way to spruce up an aisle. Here cascading flowers and a wide ribbon create a formal look.

the ceremony

2

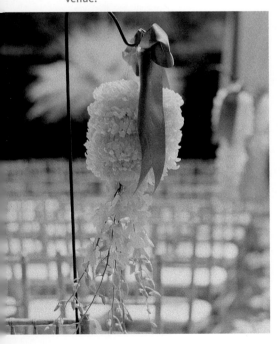

Your ceremony is *the wedding*—the whole purpose of the
day—but sometimes the ceremony is treated as the opening
act for the reception. Give your ceremony the full attention it
deserves. Even though it may last only twenty minutes, it's
prime time to show off your style and set the tone for the day.

Your ceremony location will have a big influence on
your decor. A traditional house of worship, a stretch of beach
with a sweeping view of the ocean, the hotel ballroom where
your ceremony will take place—each calls for different decor,
and there may be rules and regulations that limit what can
be used and how. Once you know them, you'll have plenty
of opportunities to personalize the space and the ceremony
itself.

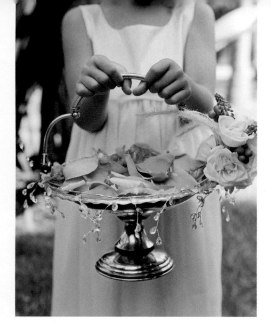

your venue

Churches, temples, and other religious buildings tend to have restrictions on the type and amount of decorations that you can use. Many prohibit petals on the aisle, candles around the room, and attaching anything to the walls. Luckily, a house of worship is usually beautifully designed on its own, and you can still find ways to personalize the space. Start by complementing the fixtures that are already in place, like the altar and the pews.

With an outdoor space you have built-in "decor" supplied by the ultimate event designer—Mother Nature! But you will need to create some elements from scratch—an aisle, for example—that are part of the package at religious venues. Use the opportunity to get creative. An aisle runner will help delineate the area—just make sure that whatever is underneath it, whether sand or grass, is easy to walk on.

Even something as practical as the chairs help to set the overall tone. You can never go wrong with plain, white folding ones, but if they don't do it for you, chiavari chairs, a reception favorite, can lend a formal air to a ceremony. Choose classic white, or silver or gold.

If your ceremony will be taking place in the same location as your reception, it's crucial to make the space look different for the two events or to separate the areas with drapery, lighting, or other decor. Be sure you have the manpower to remove everything in time for the reception. If not, consider creating an aisle from above by hanging two rows of paper lanterns from the ceiling. These will look appropriate for the reception if your dance floor or head table will be right underneath. For the chairs, it's easiest to use whatever will already be in the reception room, but if the staff will be able to change the seats without delaying the cocktail hour, this will distinguish the ceremony from the reception.

the focal point

Regardless of your ceremony's location, you'll likely want to highlight the area where you and your groom will take your vows. If you're in an open setting, such as outdoors, a focal point, like an arch, a canopy, a chuppah (for a Jewish ceremony), or a *mandap* (for a traditional Indian wedding) does the trick. This focal point may be an elaborate structure or it could be as simple as plain white organza with clusters of flowers in your signature colors.

ceremony music glossary

Classical: Brides have been walking down the aisle to compositions like Pachelbel's Canon in D Major and Purcell's "Trumpet Voluntary" for ages, and classical music is still the most popular choice. After you're officially joined as husband and wife, opt for an old standby—Mendelssohn's "Wedding March" or Beethoven's "Ode to Joy."

Contemporary: Some brides would prefer that the sound track to their ceremony come straight from their iPod playlist. If you're having a band for your reception, you might consider asking a few key members to play at the ceremony as well.

Cultural: Incorporate your cultures by using traditional musical instruments like an Indian sitar, Greek mandolin, or Scottish/Irish bagpipes.

Religious: Hymns or other sacred music don't have to be played by an organ. If you want to have a traditional processional, ask your musician to play a strictly instrumental piece and then save the choir (and all that jubilation) for your recessional.

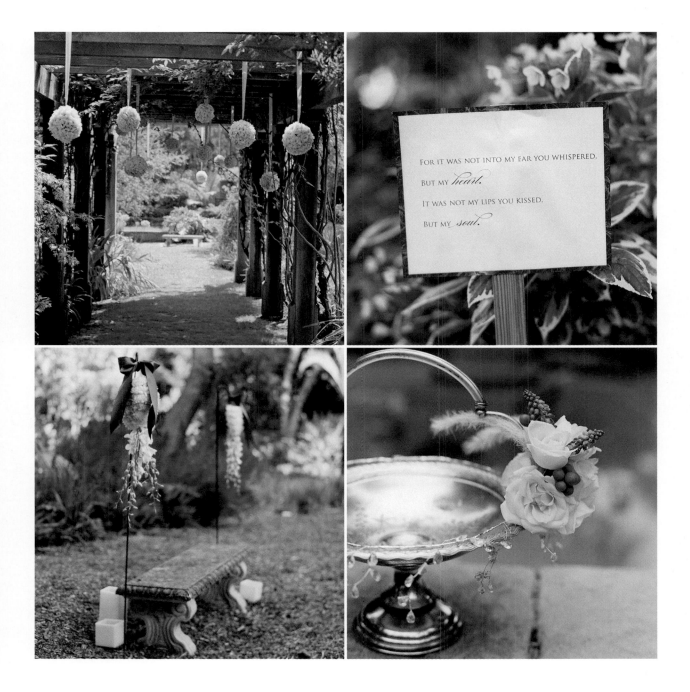

FOR IT WAS NOT INTO MY EAR YOU WHISPERED,

BUT MY *heart*.

IT WAS NOT MY LIPS YOU KISSED,

BUT MY *soul*.

opposite Instead of a basket, the flower girl carries an antique cake stand down the aisle.

top Even existing structures that are already beautiful can be dressed up a bit. Pomanders dangle at different heights to add whimsy to a wooden pergola. ■ A sign with the couple's favorite love poem instantly personalizes their ceremony.

bottom A stone bench becomes a pretty focal point when accented by shepherds' hooks tied with bows and flowers. ■ After your flower girl has strewn her rose petals, the empty cake stand that once held them makes a lovely decorative accent, with its blooms-and-feather theme, displayed on a table, bench, or railing.

The simple white and green palette, the symmetry of the arrangements, and the square shapes of the benches lend a formal garden feel to this ceremony space.

make it personal Your canopy can be a one-of-a-kind creation. Use fabric that reflects your cultural background or send out fabric squares with your invitations and ask guests to write a favorite poem or memory of the two of you. Sew the patches together to make a unique, quilted canopy. You can also incorporate intriguing elements in your archway—your initials or details that represent your passions, such as sailing paraphernalia for those who love the sea.

To make guests feel special and part of the event, offer thoughtful extras—a lei on each chair back, a fan on each seat, or individual cones of petals for tossing at the end of the ceremony.

Ceremony programs are another important detail that should be both practical and striking. As for the design, programs are a fitting place to flaunt your style, whether you choose solid papers in your color scheme or include a monogram or motif that carries through to your other wedding stationery. Putting a program on each seat guarantees that they'll get picked up, or a nice alternative is to store them in an embellished basket or bucket at the entrance to your ceremony so guests may pick them up on their way in. Whatever you choose, include key ceremony info, like the names of the people in the wedding party, the order of the service, and explanations of traditions you'll be including. Words of thanks to special friends and family members, or a remembrance of those not with you, add a meaningful touch.

Show style with the ring pillow and flower-girl basket, too: Cover each in the same fabric as your linens, bridesmaid dresses, or ceremony canopy. Substitute creative vessels for the traditional baskets and pillows to add a surprising and sweet element to the ceremony.

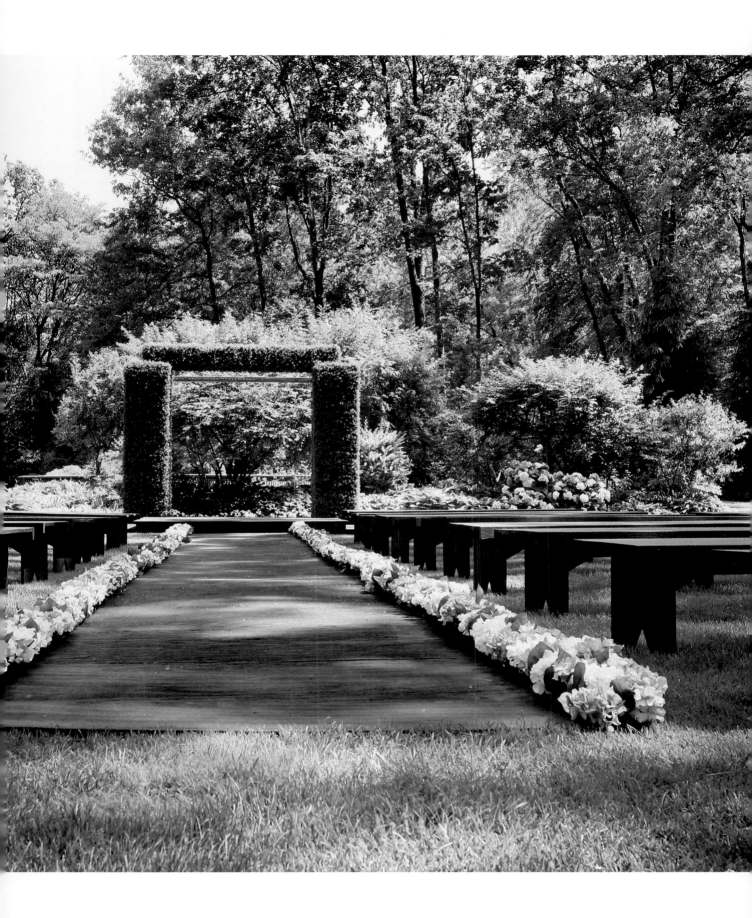

indoor ceremonies

In a church, synagogue, ballroom, or loft, your decor can highlight—or totally transform—your ceremony space.

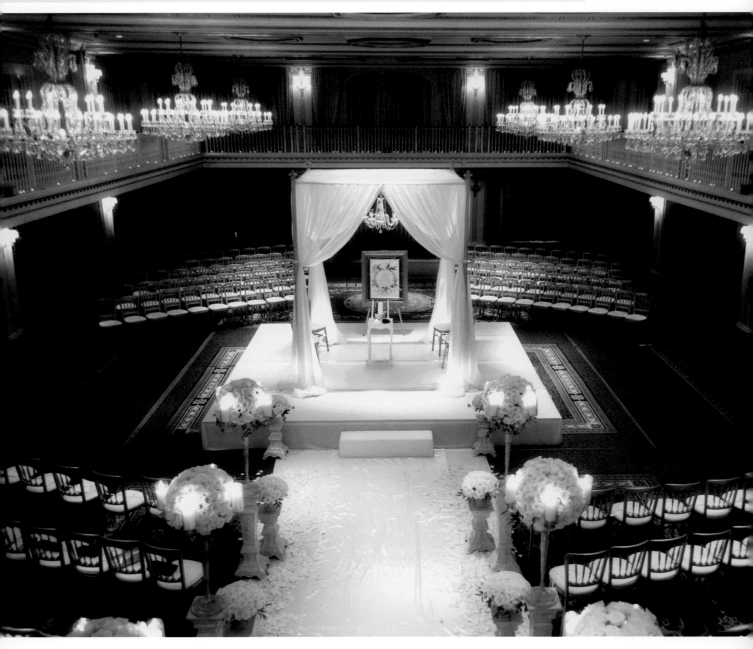

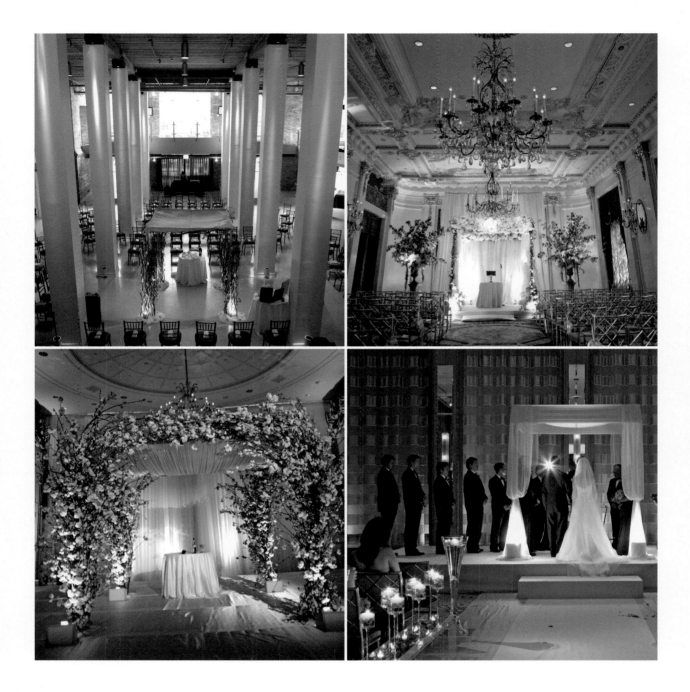

opposite Columns and pedestals with spheres of flowers and candles match the elegance of this ornate ballroom, but the chuppah in the center is the real glow-getter.

top Hot pink chair pads add instant vibrancy to a modern, airy venue. Clever seating turns the towering columns into decor instead of obstacles. ■ The grandeur of the altar arrangements is matched only by that of the ballroom's opulent crystal chandeliers.

bottom A canopy covered with cherry blossoms brings the outdoors in. Uplighting at the branches' bases draws eyes to the pretty pink blooms. ■ Though the overall look is understated, nothing about this setup is simple. Sleek glass candleholders pave the way to pilsner vases with floating candles. All lead up to the showpiece: an illuminated chuppah.

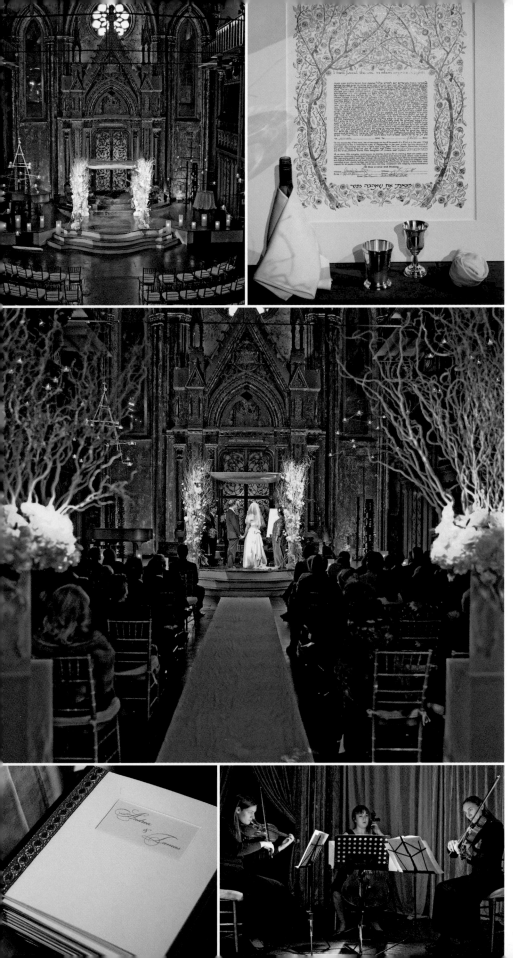

a formal ceremony

A dramatic venue rich in texture and history calls for equally over-the-top details.

top Directing lighting on key elements, like the chuppah, creates a spectacular effect. ■ The branches on this framed *ketubah* echo the branches in the chuppah, making this contract an attractive display.

middle Well-placed lighting adds drama and keeps focus on a few key elements, like the altar and floral arrangements.

bottom For a black-tie wedding, a scripted font on the programs is the only way to go. ■ A string trio is as refined as it gets.

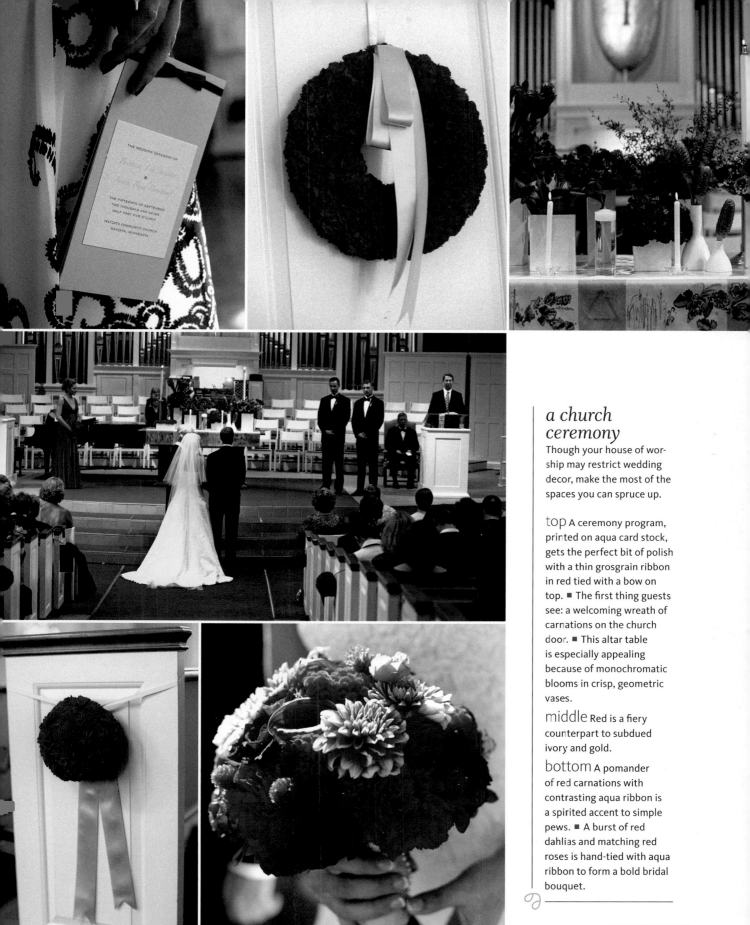

a church ceremony

Though your house of worship may restrict wedding decor, make the most of the spaces you can spruce up.

top A ceremony program, printed on aqua card stock, gets the perfect bit of polish with a thin grosgrain ribbon in red tied with a bow on top. ■ The first thing guests see: a welcoming wreath of carnations on the church door. ■ This altar table is especially appealing because of monochromatic blooms in crisp, geometric vases.

middle Red is a fiery counterpart to subdued ivory and gold.

bottom A pomander of red carnations with contrasting aqua ribbon is a spirited accent to simple pews. ■ A burst of red dahlias and matching red roses is hand-tied with aqua ribbon to form a bold bridal bouquet.

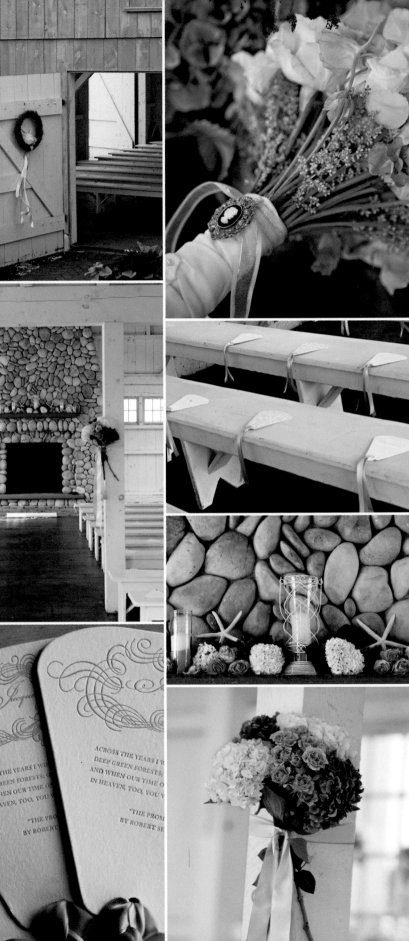

a new england style ceremony

Details can enhance the feeling a setting already offers. Here, blush and cream accents turn up the charm in a quaint venue on the coast.

clockwise A rustic venue, such as a weathered wooden barn, calls for subtle decor. ■ Traditional blooms wrapped in gauzy ribbon and accented with an heirloom give the bridal bouquet the same old-fashioned simplicity as the venue. ■ Instead of chairs, guests can sit on casually elegant, painted wood benches. ■ A ledge is a perfect place to personalize. ■ A bouquet that includes pink roses and white hydrangeas can become an instant decor element with nothing more than a satin ribbon used to lash it to a wooden post. ■ Letterpress programs double as fans to keep guests cool on a warm summer day. ■ A stone wall and fireplace up this ceremony setting's cozy feel.

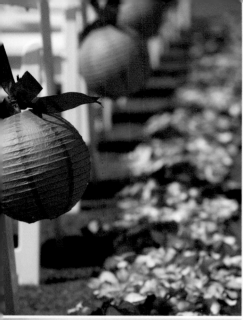

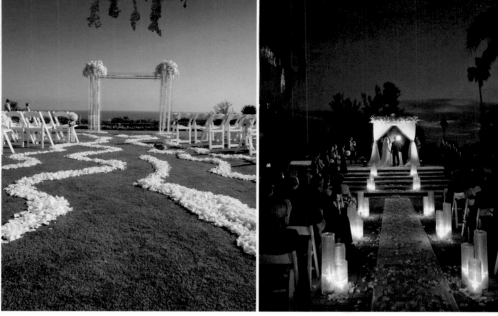

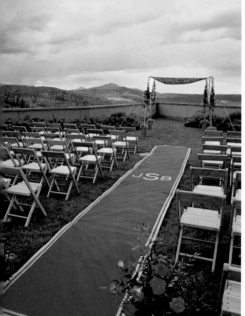

aisle style

No matter what kind of ceremony you have—modern, traditional, rustic—your aisle can help set the mood. *Clockwise* Poppy pink paper lanterns and loads of pink, yellow, and orange petals give this pathway pizzazz. ▪ An aisle doesn't have to be straight and narrow—think curving pathways lined with piles of petals. ▪ Candles serve as especially pretty aisle markers at an outdoor evening ceremony. ▪ A single, curvy monogram adds a dose of glamour to this runner. ▪ Unique lighting effects don't need to be saved for the reception. A projected pattern gives an illusion of texture to this aisle. ▪ A bride who's aiming for drop-dead drama at her ceremony will want to roll out the red carpet with her new monogram.

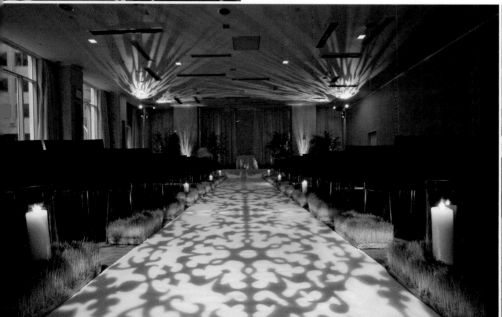

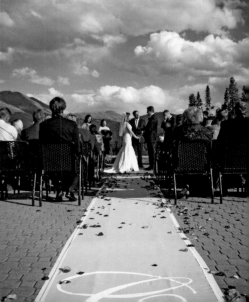

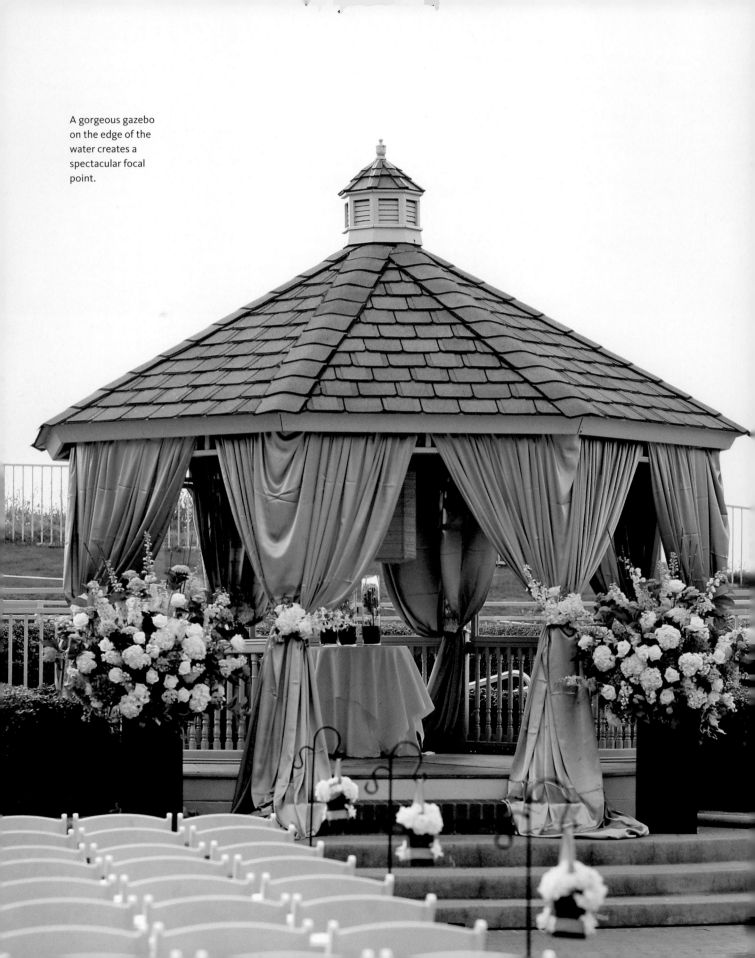

A gorgeous gazebo on the edge of the water creates a spectacular focal point.

ᵉoutdoor ceremonies

The design of an outdoor ceremony must not only define the space but also create a unique sense of place.

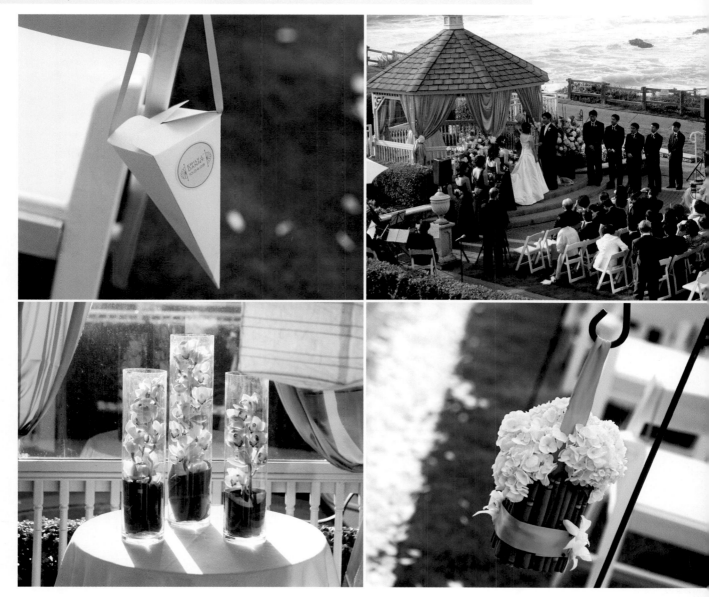

top Confetti (or petals) makes a nice touch for the end of the ceremony. To hold it until it's tossing time: cone-shaped paper boxes hung from chair backs with ribbon. ■ An amazing view is one of the big advantages to an outdoor space.

bottom To evoke an unfussy mood, shapes are kept simple and similar. ■ Even old coffee cans can be made wedding-worthy with a little creativity and stunning details like bamboo and ribbon.

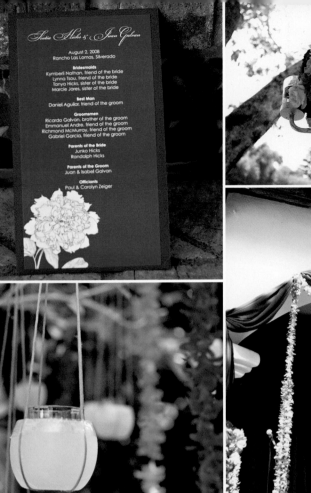

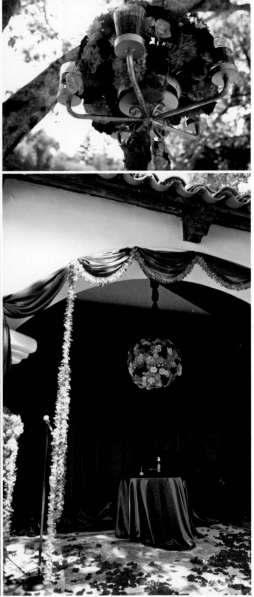

a cultural ceremony

You can play up a unique architectural element at your venue with colors that reflect its vibe.

clockwise The white-on-pink color scheme and single bloom on the bottom corner create a bold statement on this program. ■ The gold candelabra highlights the richly colored flowers. ■ A brown silk valance trimmed in flowers mimics the Spanish tile roof and ties in the brown curtain and fabric-covered table. ■ An aisle that's completely covered in dark pink petals is dramatic and even exotic. ■ Strands of flowers in fuchsia, orange, and yellow interspersed with hanging lights strike a festive chord.

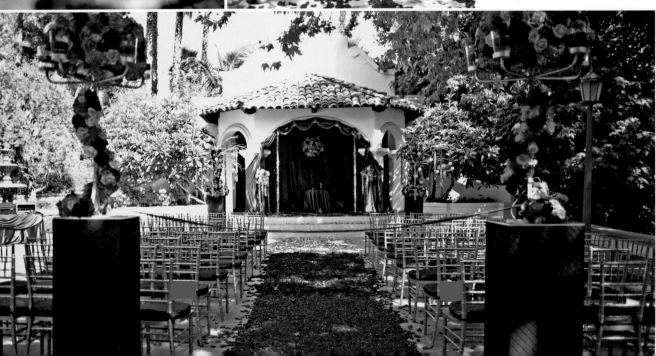

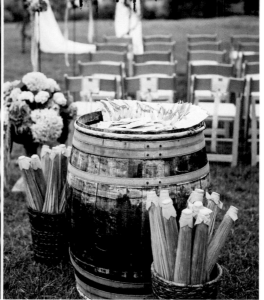

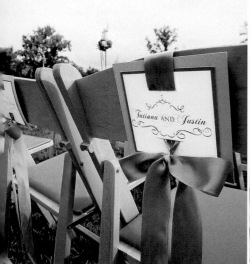

a rustic ceremony

This outdoor ceremony takes place in the Blue Ridge Mountains and relies heavily on the natural setting including mountain views and plenty of greenery.

clockwise "Flower torches" mark the aisle and are topped with arrangements of orchids, hydrangeas, and ferns. ■ A wine barrel borrowed from the winery where the wedding takes place is strewn with packets of seeds and confetti to throw at the couple and flanked by baskets of parasols. ■ Lavender buds for tossing are packaged in flower-adorned paper that gives off an appropriately old-fashioned air. ■ An arbor made of tree branches and draped with billowy fabric doesn't detract from the majestic view of the Blue Ridge Mountains. ■ The last row of chair backs is decorated with signs displaying the couple's names.

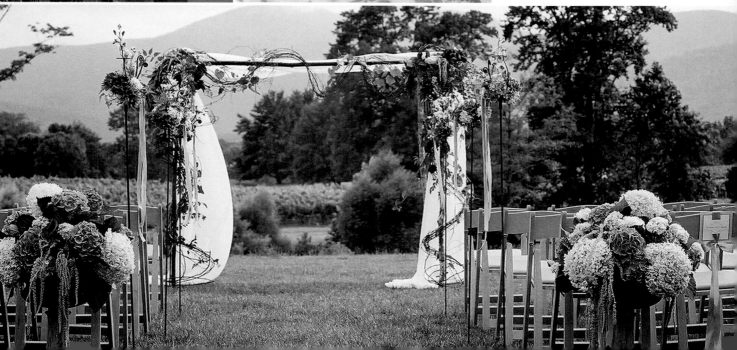

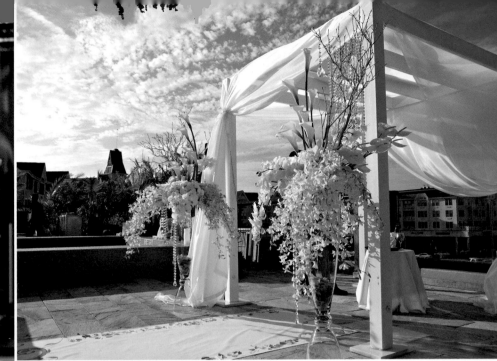

a rooftop ceremony

This outdoor wedding evokes a sense of modern glamour with sparkly details and a crisp palette that complements the setting.

clockwise Even traditional elements, such as the wineglasses used in a religious ceremony, can fit the color scheme. ■ The all-white canopy is perfectly juxtaposed with the ornate arrangements. ■ Silk pillows with pailettes are casually strewn over the seats to up the glam factor. ■ The azure pool combined with the ocean views give this ceremony space a destination wedding feel. ■ As guests enter, a cube vase with blue water sets the mood. ■ Tea lights in pool blue surrounded by sea glass reinforce the poolside motif. ■ Instead of petals along the aisle, sea glass adorns the border.

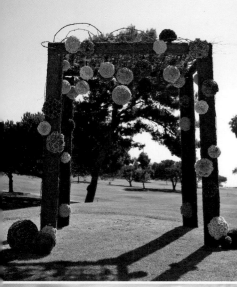

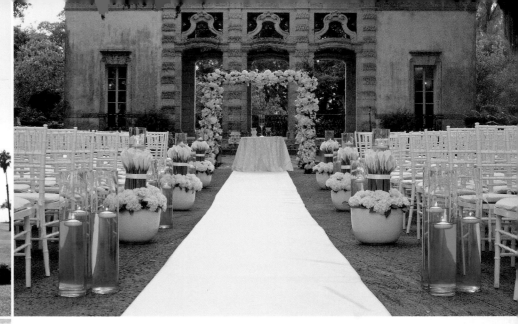

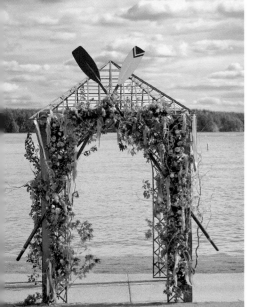

centers of attention

All eyes are on the altar. Make it worthy of the attention. *Clockwise* A rough-hewn pergola gets spruced up with colorful pomanders. ■ On the grounds of an estate or a historical site, the facade of a centuries-old building serves as a backdrop to transport you to another time. ■ Typical billowy white draping is swapped out for fabric with more pop. This ombré pattern mixes light and dark pinks for a spectacular result. The showstopping finish: a gorgeous chandelier. ■ Two towering floral arrangements on pedestals delineate the altar space while a carpet of roses creates the aisle. ■ A trellis archway is personalized with colorful oars for a riverfront setting.

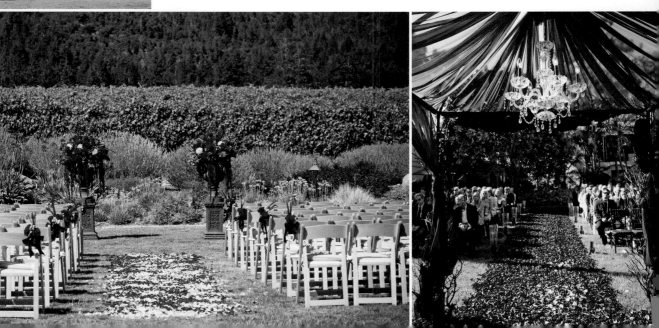

This program, with its swags and scrolls, recalls the title page of an antique book. You can carry out the theme by referring to parts of the ceremony as chapters.

Wedding
11.15.11

Paige
and
Shawn

ST. PAUL'S MEMORIAL CHURCH

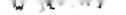

ꙮceremony programs

While their purpose is practical, programs have more impact when they're treated like a style element. There are countless ways to introduce the wedding party and explain the ceremony.

top Rather than having guests pick up a program on their way in, programs can be set out on every chair along with a cone full of confetti for after the ceremony. ▪ Programs with colorful patterned ribbons and monogrammed stickers emanate a quirky DIY feel. ▪ A clever idea for a destination wedding is to print programs on heavy stock paper and mount them on Popsicle sticks.

bottom Hanging a colorful program on the back of every seat with coordinating ribbon transforms this detail into a part of the decor. ▪ For couples who prefer to show their playful side, these programs are made to look like movie tickets.

ring pillows + flower-girl baskets

What the littlest attendants carry down the aisle can make guests smile. This is the perfect place to have a bit of fun and infuse your style.

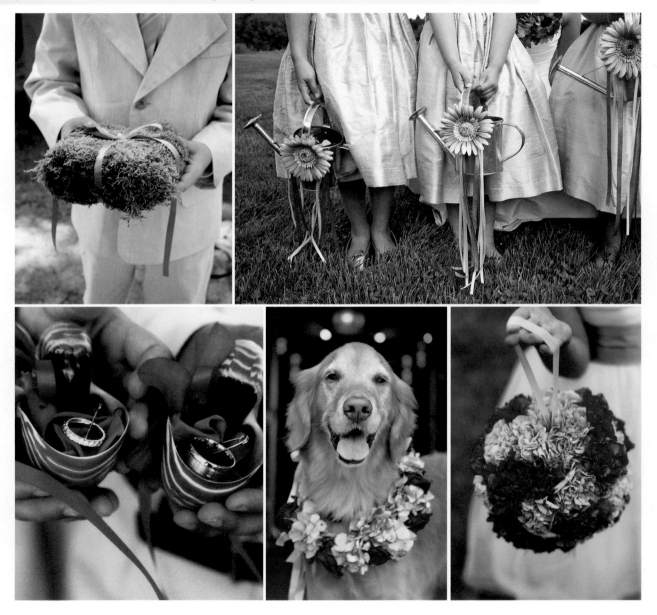

top A moss-covered cushion with a coordinating pink ribbon is understated and chic—perfect for an outdoor ceremony. ■ Watering cans decked out with daisies make a winsome "basket" for flower girls. The added benefit: There's no cleanup when the girls are just sprinkling water.

bottom Perfect for a destination wedding: shells as the vessels to carry the rings. ■ One way to add a personal element is to have a pet walk down the aisle as the ring bearer with a floral wreath as a collar. The rings dangle from a strand of ribbon. ■ A pomander in poppy pink is delightfully festive.

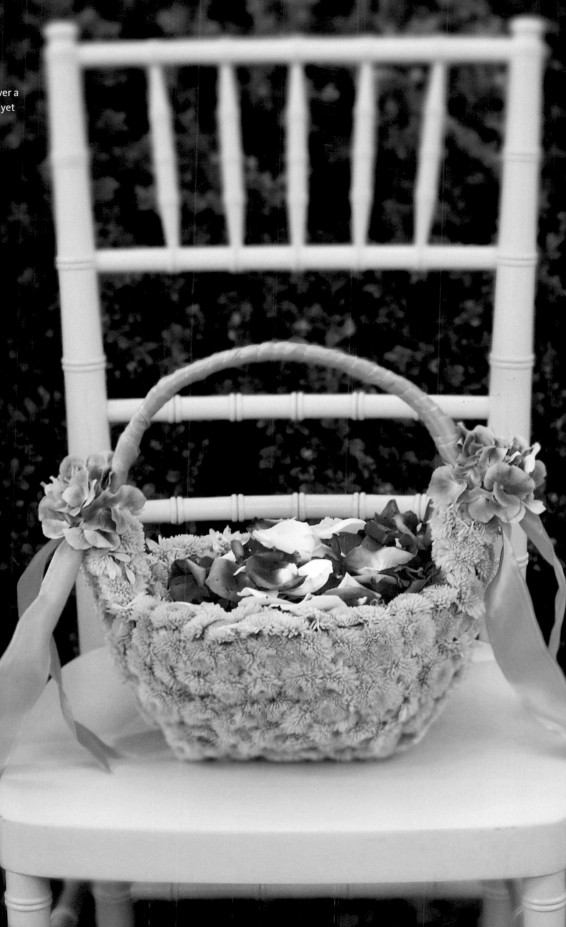

n mums cover a
t for a girly yet
touch.

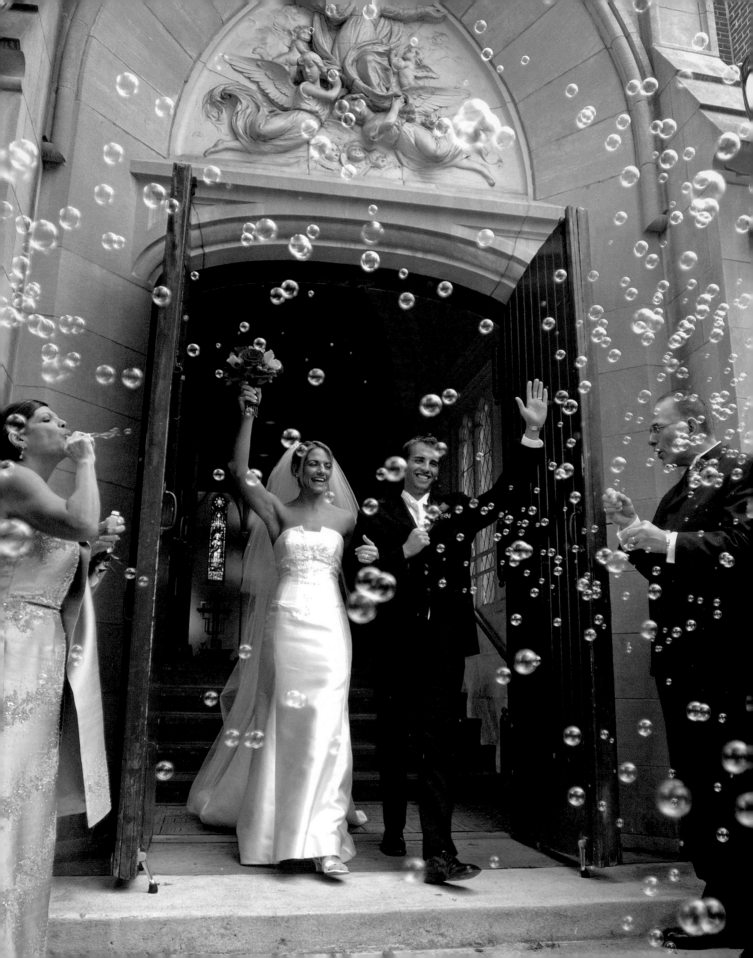

ɞ inspiring exits

There are plenty of ways to make your great escape memorable, from ducking under a petal toss to hopping into a vintage car.

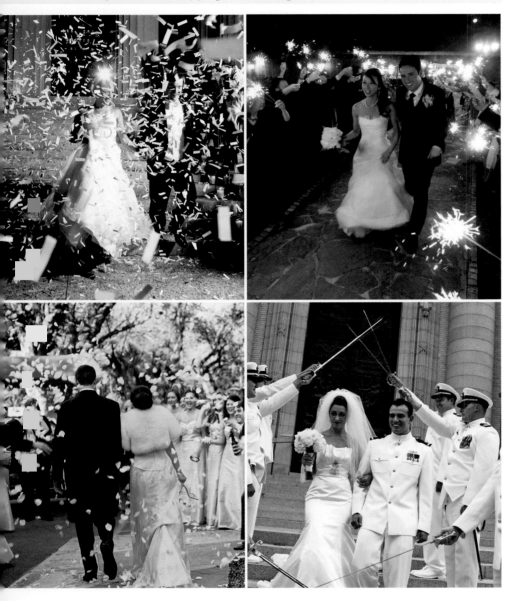

opposite Bubbles, which require no cleanup, look enchanting in photos and make a departure feel truly magical.

top Confetti makes for a festive escape. ■ Taking your leave in a shower of sparkler light adds a festive finale to an evening reception.

bottom Petals aren't just for the flower girl—give some to your guests to throw, too. ■ A formal military send-off includes an arch with swords.

exit ideas

After you've said "I do," it's time to walk *up* the aisle. Involve your guests at the end of your ceremony.

Birdseed: Couples once closed out the ceremony by having guests throw handfuls of rice, but a greener alternative is to use birdseed instead.

Streamers: Wands of flowing streamers make for a pretty exit—and easier clean-up afterward.

Pom-poms: Add a splash of color to your exit by having guests throw pom-poms. You can even DIY them.

Know the rules
If you're getting married in a house of worship, make sure you find out what's okay and what's not as far as decor, photography, videography, and lighting go.

Proof the programs
Have an eagle-eyed bridesmaid or your editor cousin look over the wording on your program before they're printed. A fresh pair of eyes can catch any mistakes that you may have missed. Ask your officiant to take a look, too—she'll be able to tell you the correct spellings (and definitions) of any religious traditions you're including.

Rehearsal required
Even if they've been in dozens of weddings, everyone needs to practice for yours, which will no doubt be at least a little bit different.

Get a table
If there's no altar, set up a small table for the unity candle ceremony or other rituals.

Listen up
Guests will not be able to hear your outdoor ceremony unless you employ a sound system. A microphone stand can be an eyesore; check with your audiovisual guys for options, or consider having the stand decorated by your florist.

Test the aisle
You may be able to run in your four-inch wedding shoes, but walking on your grassy aisle may be another story. Do a trial walk to be sure you don't sink in with every step. If you do, consider laying down a strip of wood—paint it or cover it in fabric. Test your aisle runner, too. You may find that your shoes get caught or the surface is too slippery.

Know what your flower girl and ring bearer can do
A two-year-old ring bearer can't be trusted with your platinum wedding bands, no matter how "responsible" his mother says he is. Have him carry a pretty pillow—with fake rings or with nothing at all—and let your best man handle the real ones. And don't expect your flower girl to evenly cover your aisle in petals. If she gets all the way down the aisle and throws a few petals, consider yourself lucky.

Timing is everything
Keep in mind that your officiant may want to do a full religious service beyond the marriage rituals so make sure your photographer has an idea of how long the ceremony should be—and what you expect him to capture.

Remember your marriage license
Many officiants won't perform the ceremony if you don't have your marriage license with you. Designate a person (not you and not your groom) to be responsible for bringing it to the ceremony and giving it to your officiant. This is especially important for destination weddings—you can't just stop by your house to pick it up if you forget it.

🌿 Think double duty
Make your decorations do double duty. Ceremony chair embellishments can do the same thing at the reception. Altar arrangements can spruce up the escort-card and guest-book tables.

Questions to ask your officiant

1. **Can you perform the ceremony outside a house of worship?**
Some religions may have restrictions on where the ceremony takes place.

2. **If you become unavailable on my wedding day, who will perform my ceremony?**
If the answer is "Oh, I never get sick," you may want to find a different officiant. There has to be a backup plan because officiants tend to work on their own.

3. **Are there any readings we have to include?**
Religious officiants usually require certain readings, but you may have some flexibility about which ones you incorporate.

4. **How long will the ceremony last?**
They're usually short, under a half hour.

5. **What items do we need to provide?**
For some Christian ceremonies, you'll be responsible for supplying a unity candle. With Jewish ceremonies, you may need to get your own *ketubah* and kiddush cup. There's a litany of must-haves for other cultures, too.

Want more ceremony ideas? Go to
TheKnot.com/ceremony

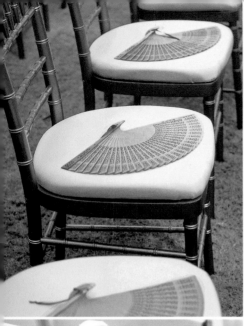

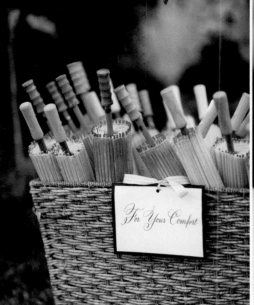

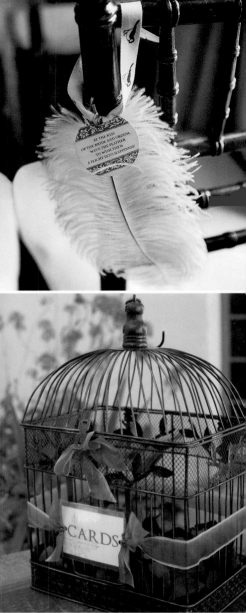

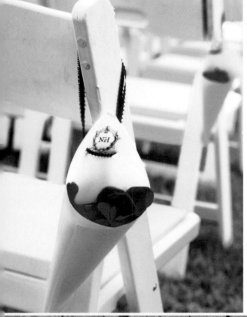

the details

The extra details make a difference. *Clockwise* On a hot day, a simple fan keeps guests happy. ■ Another stylish option to protect the crowd from the heat: parasols. ■ The tag hanging on each feather instructs guests, "At the kiss of the bride and groom, wave the feather to wish them a flight into happiness." ■ The most visually arresting vessels are often ones borrowed from other contexts. ■ Handwritten signs add charm. ■ A motif fashioned from less formal materials can be most appropriate. ■ Cones filled with confetti are hung on each chair.

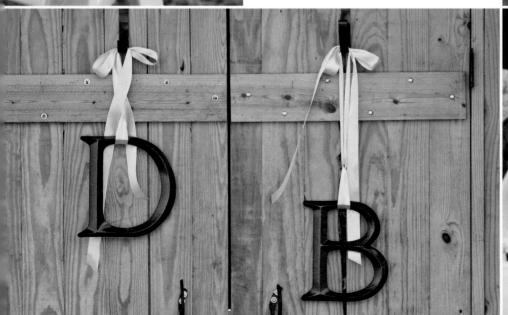

purple

Talk about versatility: Lavenders are girly, violets exude fun, and amethysts feel fit for a queen.

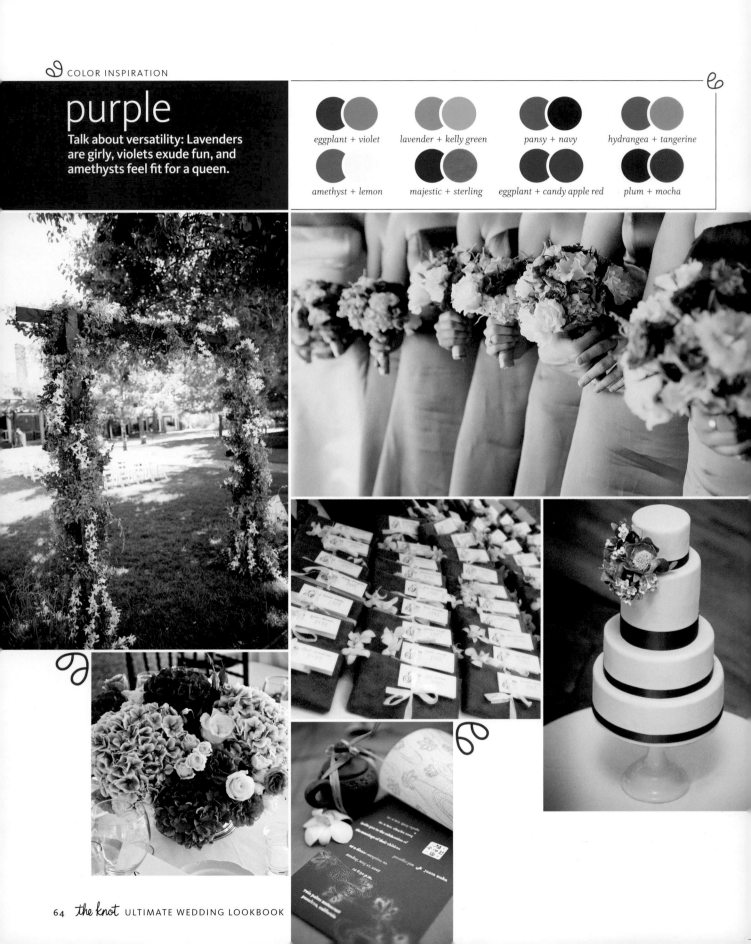

eggplant + violet

lavender + kelly green

pansy + navy

hydrangea + tangerine

amethyst + lemon

majestic + sterling

eggplant + candy apple red

plum + mocha

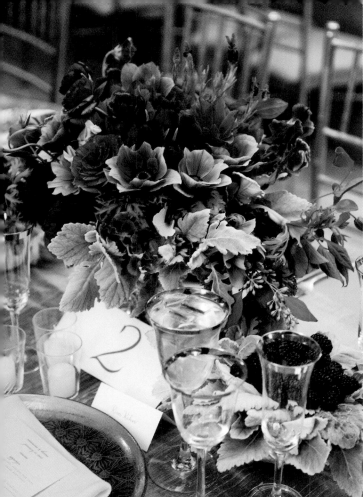

**Flowers that come
in purple**
Anemones
Dahlias
Freesia
Irises
Lavender
Lilacs
Orchids
Peonies
Ranunculus
Roses
Tulips

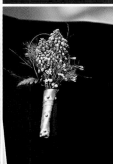

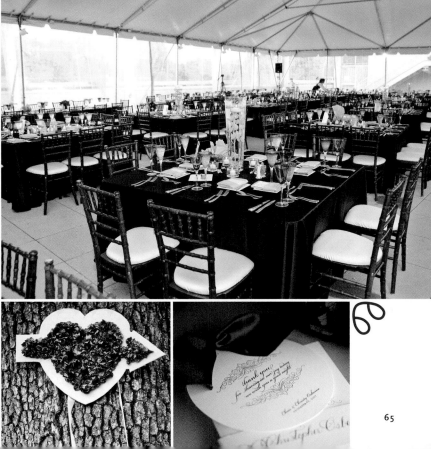

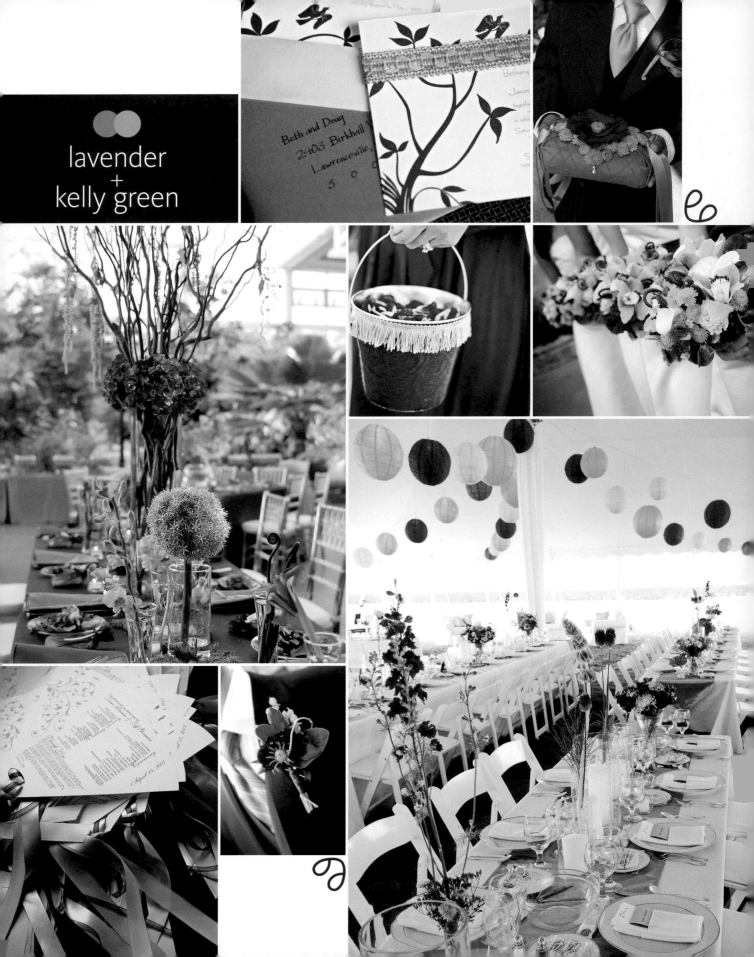

lavender
+
kelly green

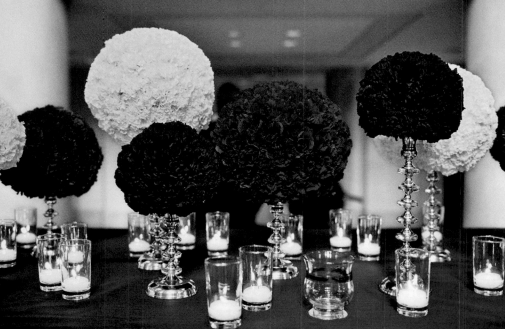

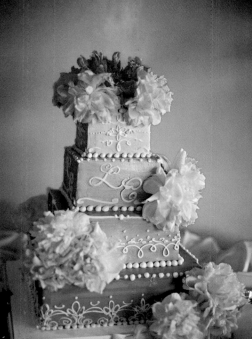

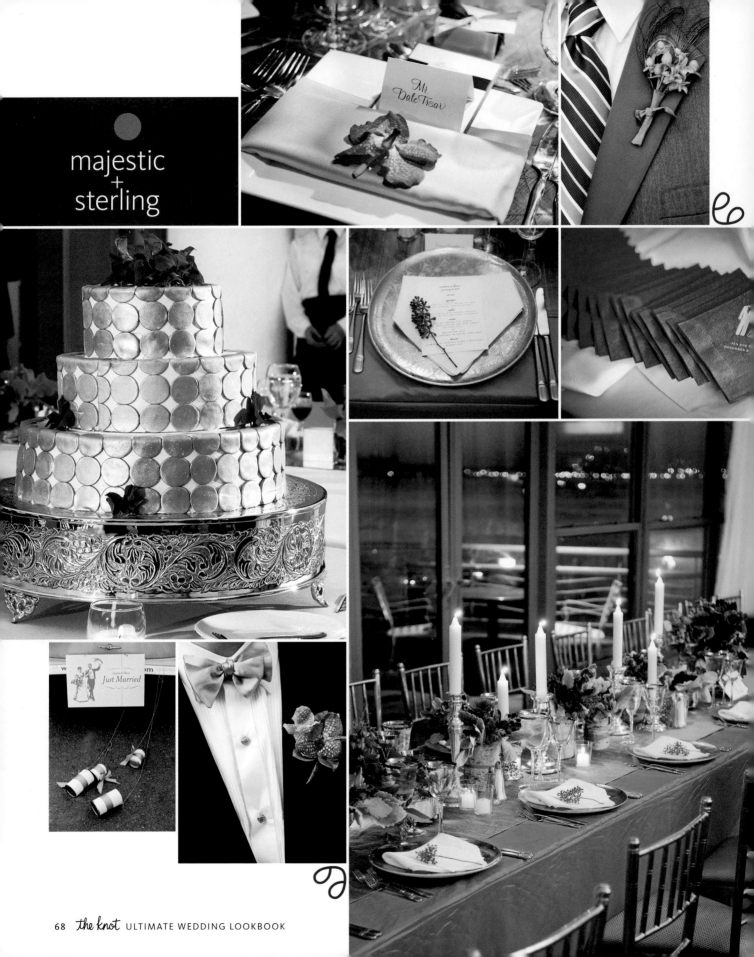

majestic
+
sterling

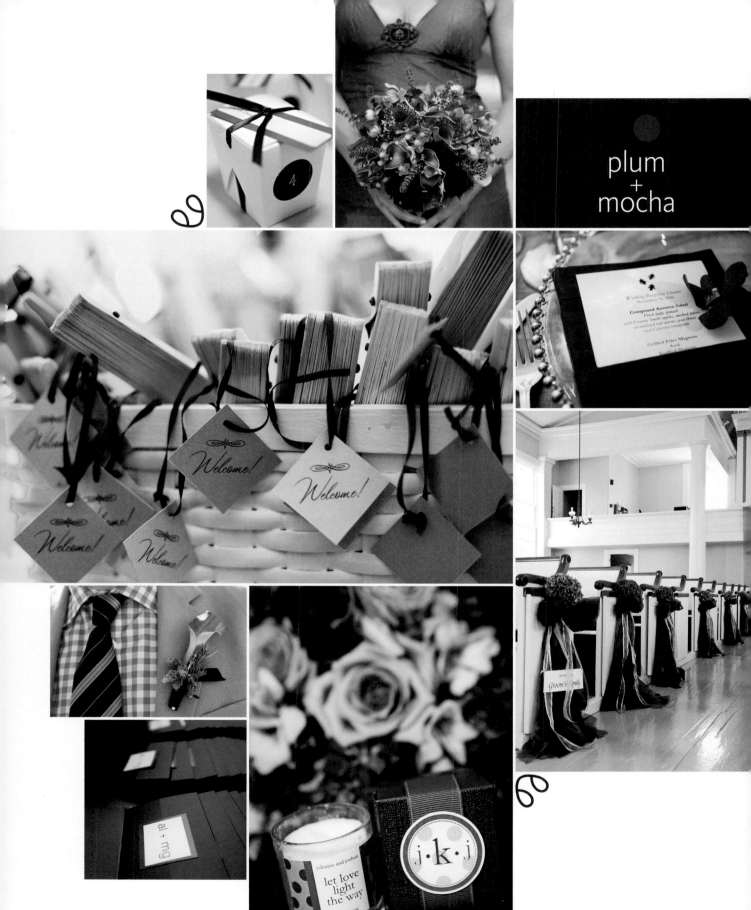

plum
+
mocha

Welcome!

let love
light
the way

MELANIE + DREW

an autumn wedding

Melanie and Drew were inspired by the colors of fall leaves—copper, orange, yellow, and red—for their semiformal vineyard wedding. To invoke the warm spirit of the season, they included details like casual place settings, a cheese and olive bar, amber lighting, and lots of candles. The result: a welcoming yet refined event.

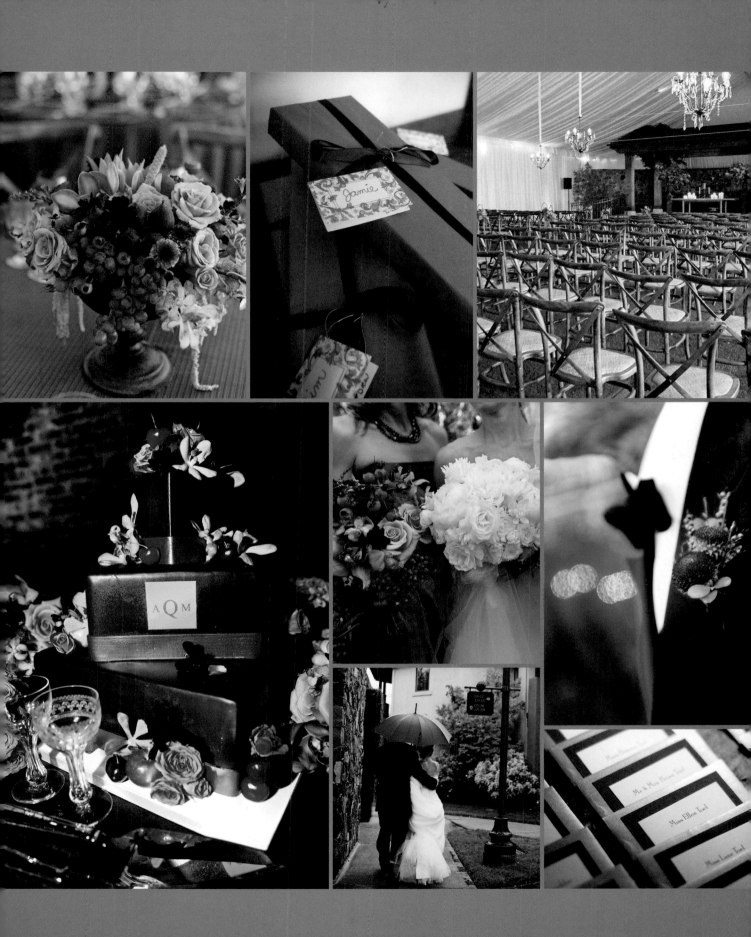

A bouquet of bright-colored roses
and peonies is festive yet elegant.

opposite Glam, oversized
Casablanca lilies fill out this striking
bouquet of parrot tulips.

3

bouquets + boutonnieres

your countdown

5–6 months before:
Meet with the florist.

4–5 months before:
Finalize the order and pay your deposit.

3 months before:
See a mock-up centerpiece and confirm delivery.

3 days before:
Double-check that florists will have access to the venue to prep.

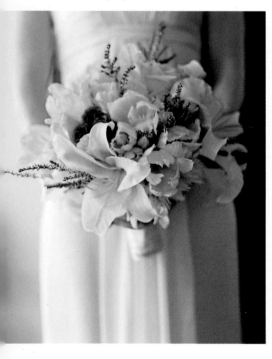

Beyond the veil, the bridal bouquet is your most important accessory—it's what guests will notice long before those diamond-drop earrings or your gown's intricate detailing. The bouquet plays a starring role from the moment you walk into the ceremony until you see the classic "bouquet close-up" photographs in your wedding album. It goes without saying, then, that this iconic element will dramatically contribute to your wedding-day style through everything from its color to the variety of blooms it incorporates—even the stem treatment. Once you've found your look, you can borrow ideas from it to inspire other floral elements, too. You might use a single stephanotis bloom like the ones nestled among the white roses of your bouquet to adorn your groom's lapel or opt to have bridesmaids carry mini–calla lilies in green that echo the full-size white ones in your own bouquet.

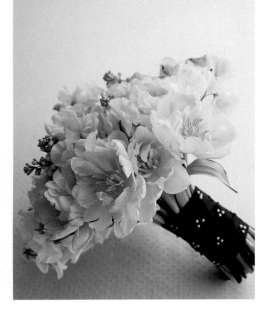

find your style

So how do you choose your bouquet? Start with the most important factor: color. Bridal bouquets are traditionally all white, but don't let that stop you from incorporating hues that reflect your individual style. Pastels are ultra-feminine; vivid shades can have a more modern feel; and soft green paired with white makes an unfussy, timeless combination. Choose one hue (an elegant choice), a pair (to match your palette), or mix a bunch for a casual paint-box effect.

Next, consider the overall style you're hoping to achieve—formal and elegant, casual and carefree, or minimal and modern. Your dress style in particular will inform the shape and size of your bouquet. A dramatic cascade would match a sweeping ball gown with miles of tulle, whereas a small clutch of calla lilies might better suit an understated bride wearing a slinky sheath. A one-strap mermaid gown calls for a bouquet with a contemporary edge, like an asymmetric grouping of cockscomb with spiky feathers on just one side. Are you more traditional? A round mix of tulips and peonies would work with a simple A-line gown.

Your body type should guide you, too. For example, if you're petite, you might try a delicate nosegay, which is around twelve inches in diameter. If you're truly tiny, a posy that's only eight inches in diameter might be a better choice. A taller bride could pull off something more voluminous, like a full, round bouquet that's almost eighteen inches in diameter.

When it comes to thinking about the style, a standard rule of thumb is the more formal the occasion, the more structured the bouquet design.

pick the best bloom
Factoring in the season may help determine which flowers you want to consider. Flowers traditionally considered to be summer blooms, such as zinnias and cosmos, not only evoke the season better at an August wedding than peonies—a spring bloom—might, but are cheaper then, too. What's more, flowers blooming locally at the time of your wedding are a greener option since they don't need to be shipped from far away. Also keep in mind that some blossoms won't hold up well in certain climates. At an outdoor affair on a sizzling summer day, gardenias may turn brown before you even begin your walk down the aisle.

bouquet glossary

Hand-Tied: A classic arrangement of densely packed flowers anchored in a bouquet holder, wired, or casually gathered with a ribbon.

Cascade: A waterfall-like arrangement of blooms and greenery meant to spill over the bride's hands and down the front of her dress.

Composite: A hand-made creation in which individual petals from many blooms of the same variety, such as roses, are wired together to create the illusion of a single, giant flower.

Nosegay: A small, round cluster of flowers, usually composed of one type of flower or a single color, tightly wrapped with ribbon or lace.

Pomander: Blooms arranged in the shape of a ball suspended from a ribbon and hung from the wrist.

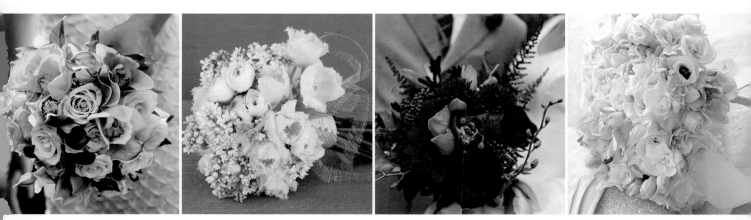

opposite A wrap is a smart way to work in a color you can't easily find in nature. This royal blue one adds preppy appeal to tulips, white camellias, and sweet peas.

above This bride really plays with texture—in her dress and her bouquet. Frilly, whorled roses, cup-shaped calla lilies, and spiky cymbidium add up to an arrangement with a strong dimensional quality. ■ Incorporating delicate white lilacs into a loose bouquet of ranunculus and fringed tulips gives it a more carefree look. ■ A mixture of dahlias, roses, mums, berries, and orchids makes a gorgeous choice for a winter wedding. ■ An arrangement of freesia, tulips, anemones, and ranunculus relies on an elegant white and cream palette to create a look that's subtle yet sophisticated.

When choosing flowers, you can also draw inspiration from their symbolic meaning. According to Victorian tradition, a pink rose stands for passion; a white lilac, innocence; and a gardenia, joy. Think about flowers' personal significance, too. You can feature the exotic orchids you both saw on your first trip together to Hawaii or re-create the lily of the valley bouquet pictured in a photo of your grandmother walking down the aisle.

Scent should also be a factor. Do you prefer the delicate, wafting fragrance of roses or the stronger scent of lilies? Although not all flowers smell (hybrids often don't), be sure to talk to your florist about exactly what you'll be getting, particularly if someone in your wedding party is sensitive.

flowers for the rest of the wedding party

Bridesmaid bouquets shouldn't be identical to yours (that would be too precious), but they should contain complementary colors and textures, and even some of the same blossoms. Size will set your bouquet apart from theirs as well: Your arrangement should be about one-third bigger.

To keep a uniform look in your wedding party, have the boutonnieres complement your bouquet. While the guys' buds were traditionally exactly the same as the bride's (in ancient Greece, they both wore strong-scented herbs to ward off evil spirits), times have changed. Now the boutonnieres' blooms don't have to match the flowers in your bouquet. If you keep the colors, the scale, and the feeling similar to what you're carrying, you can incorporate anything from feathers to felt cutouts. Some grooms go the quirky route, making their boutonniere out of a personal item, such as a guitar pick.

Jewel pins, crystal sprays, and a wrap with rhinestones spruce up these simple anemones.

Plush ranunculus comes in almost every color you can imagine. Stick to one hue for an elegant look, or mix in a few for a more playful feel.

white bouquets

It's simple, elegant, and timeless—and the perfect choice for blending in with the wedding dress, rather than overshadowing it.

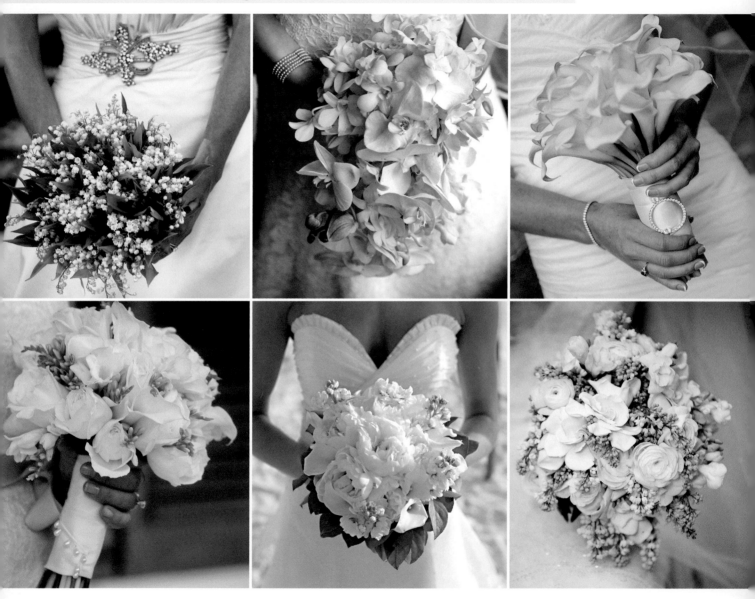

top Lily of the valley is often used as a secondary flower in a wedding bouquet, but it looks stunning on its own, too. ■ So dreamily romantic yet still so original, a variety of white orchids dazzles in a cascade bouquet. ■ The simple shape of calla lilies is unmistakably modern—and sets off a fuss-free dress to perfection.

bottom Wrap a bouquet with material left over from your dress fittings. ■ When combining two flowers with very different shapes and styles, such as peonies and calla lilies, the secret is to keep them in the same shade of color. ■ Green is a fresh accent to pair with white, in this case providing a bit of edge to the gardenias and ranunculus in an otherwise formal bouquet.

Nothing could be more
feminine than this lush white
and pink bouquet composed
of ivory French tulips, pink
garden roses, pink protea,
and white cattleya orchids.

A bouquet with flowers like peonies and ranunculus tends to work best for spring weddings when the air is warm but not hot enough for the petals to wilt.

pink bouquets

Nearly a hundred flowers come in shades of pink, so it's no surprise that it's one of the most popular colors for bridal bouquets, whether in a whisper-soft pastel or a knockout fuchsia.

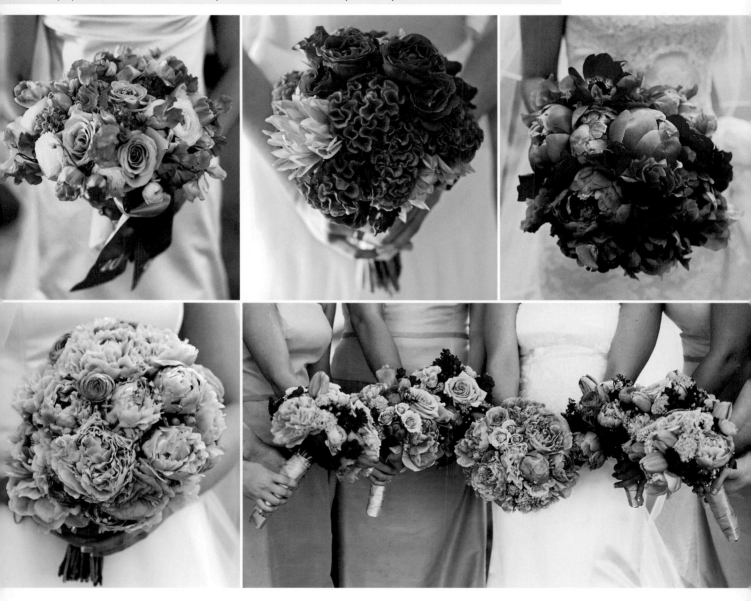

top This huge round arrangement of light pink roses, white ranunculus, and bright pink sweet pea blooms delivers plenty of impact. ■ Contrasting shapes and textures make a single-color bouquet a standout. This bouquet alternates full-blown roses and celosia with long-petaled dahlias. ■ For a look that's bold but still lush, deeper-hued versions of the classic combo of peonies and sweet peas are interspersed with dramatic, dark-centered anemones.

bottom Grouped together these peonies and ranunculus create a multilayered texture . ■ Rather than matching the bridesmaid bouquets to the bride's exactly, this suite incorporates the same colors but a few different blooms.

red bouquets

Roses may be the go-to bloom when this bold hue is your preference, but they certainly aren't your only option. Here are a few alternatives.

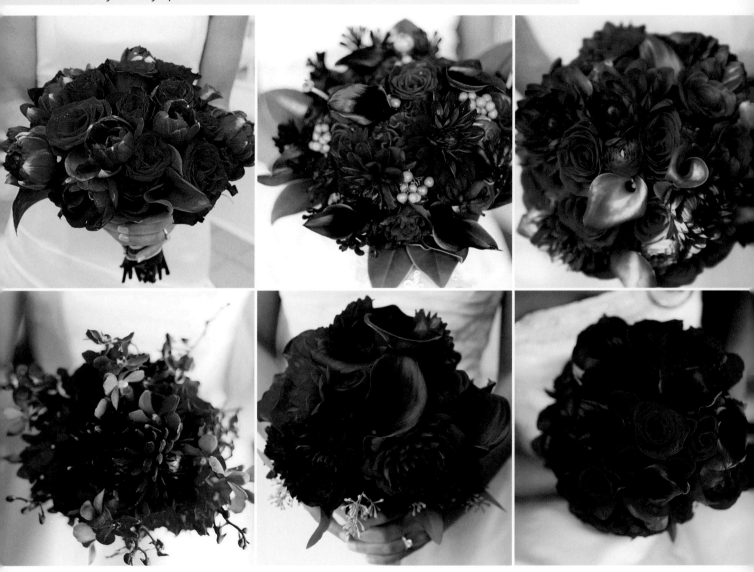

top This melding of peonies, roses, tulips, and calla lilies would simply shine at a summer ceremony. ■ Turquoise berries pop against a background of burgundy calla lilies and bright red dahlias, celosia, and roses. Adding hits of contrast contributes richness—and in this case offers a fun way to feature "something blue"! ■ The shape of your bouquet telegraphs your style. A sphere tightly packed with roses, calla lilies, ranunculus, and dahlias is a classic.

bottom Rich colors, like deep burgundy, mean you can go small in scale but still emphasize the wow factor, as in this vanda orchid and dahlia mix. ■ A slight variation among shades makes for a dense, rich look in a monochromatic bouquet. ■ This cocktail of red and pink roses augmented with like-hued peonies and calla lilies is stunning.

A full arrangement of dazzling peonies takes on a slightly earthy note when the blooms are paired with elements like berries, curly willow, or other greenery.

orange + yellow bouquets

As welcome on a wedding day as a ray of sunshine, these hues offer everything from bursts of bright orange to cool, ladylike lemon.

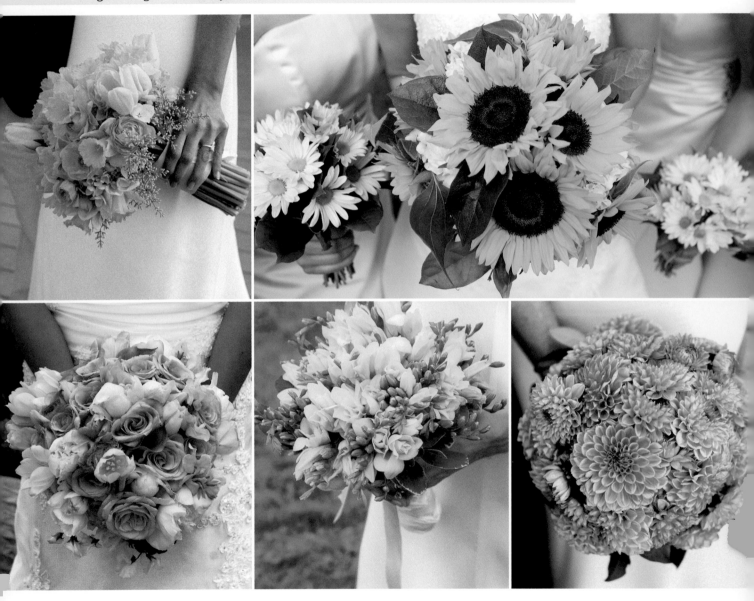

top A combination of fluttery daffodils, plush roses, and sleek tulips fairly sings of the exuberance of spring. ■ A bouquet of sunflowers has that casual, lighthearted, fresh-from-the-fields-of-Provence vibe that complements an outdoor ceremony.

bottom Romantic and fragrant, this cloudlike mix features peach garden roses, yellow and orange tulips, yellow freesia, and white peony buds. ■ Casually grouped stems of fragrant freesia and pittosporum greens have a fresh-picked appeal. ■ Heavily textured dahlias can seem like too much next to a highly detailed fabric; they call for a gown that's perfectly plain.

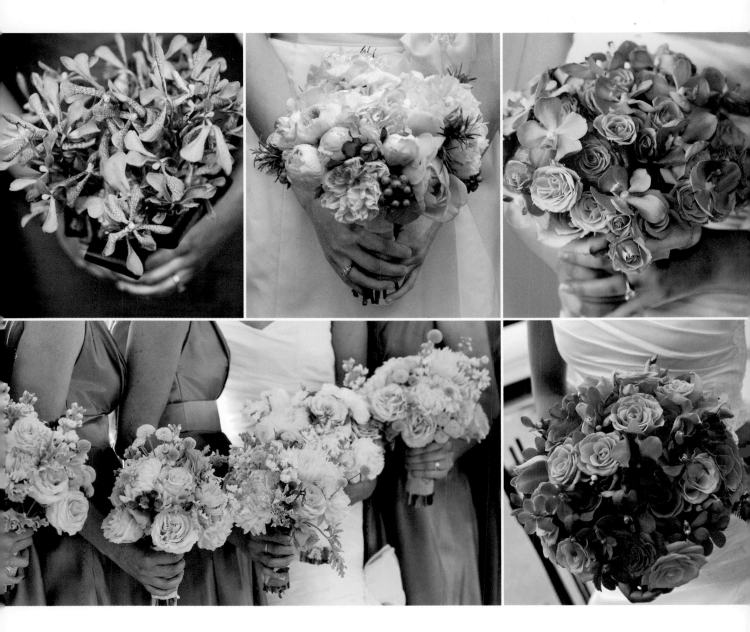

top Bold, graphic, and in a hue that sizzles, this bouquet of Mokara orchids may match the dress of the bridesmaid who carries it, but it certainly doesn't disappear into the background. ■ Sprays of hypericum berries and spiky sprigs of rosemary add a note of stark contrast to plump peonies. ■ Roses and vanda orchids come together to create a rich, classic bouquet.

bottom You can't get any sunnier than these garden roses, mums, and snapdragons at an outdoor wedding. ■ Dripping with glamour, this oversized bouquet relies on orange and coral tea roses and matching vanda orchids for its undeniably rich appeal.

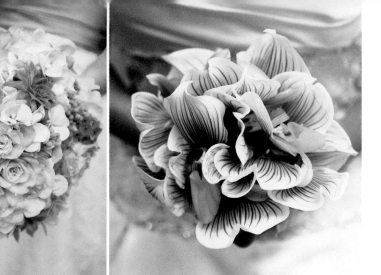

☙green bouquets

If you like the road less traveled and gravitate toward the unusual rather than the tried-and-true, try a fresh green bouquet.

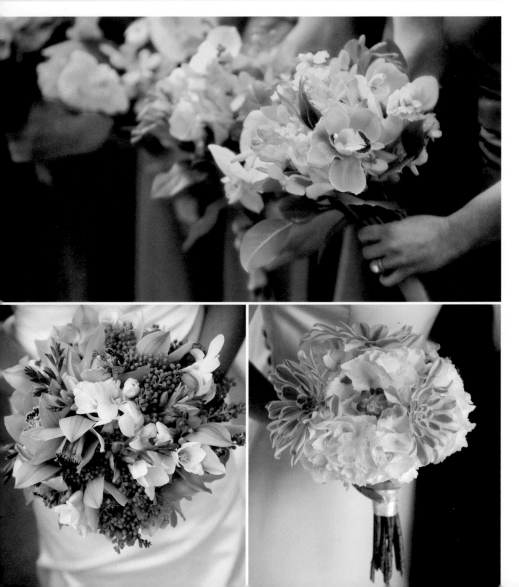

top A sensational large-scale round bouquet of roses, scabiosa pods, gardenias, and succulents becomes just as much of this bride's look as her dress. ■ The traditional white calla lily bouquet gets a fresh twist when showy green and white striped Maudiae orchids are used. The graphic pattern lends even more depth to these cone-shaped blooms.

middle A hint of green works especially well in a mix of white and yellow blooms, as proven by these chartreuse cymbidium orchids, which serve as a chic complement to yellow narcissus and white phalaenopsis orchids.

bottom This gorgeous bundle of blooms features green cymbidium orchids, green berzillia berries, and ivory amaryllis. ■ This hand-tied bouquet intersperses pittosporum with hydrangeas and succulents for an unusual but still classic formality thanks to its full, round shape.

Green cymbidium orchids and lotus pods are accented with swooping loops of lily grass.

There's nothing shy about this grand bouquet, from its massive size to its big-headed blooms to its striking palette, which includes fragrant pink peonies, roses in yellow and peach, lavender and white sweet peas, and rich purple hydrangeas.

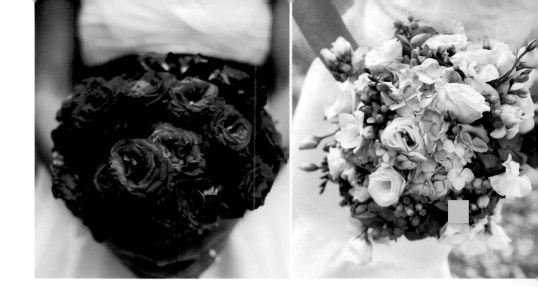

blue + purple bouquets

Deep shades of red or dark pink used to be the most popular choices for a dramatic effect, but now purple and blue are equally popular.

top If the classic white bouquet isn't for you, a clutch of amethyst blooms might suit your fancy. ■ The surprise of green hypericum berries is what gives this time-honored blend of hydrangeas and lisianthus its modern feel.

middle This bouquet relies on a range of unusual elements to make its unique statement: purple irises, purple fiddlehead ferns, thistle, and even feathers. ■ An arrangement of anemones and bougainvillea encircled by lady's mantle creates a full appearance out of the otherwise delicate blooms.

bottom Waxflower sprays are a dainty addition to lisianthus, scabiosas, calla lilies, and sweet peas. ■ This exotic cascade features dark purple Mokara orchids and lighter-hued phalaenopsis orchids.

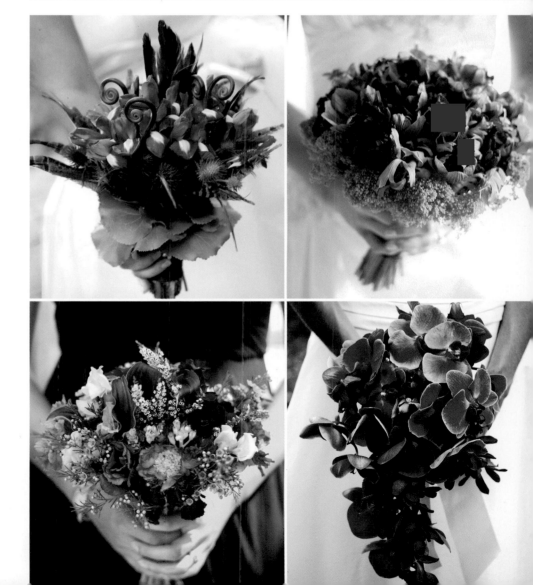

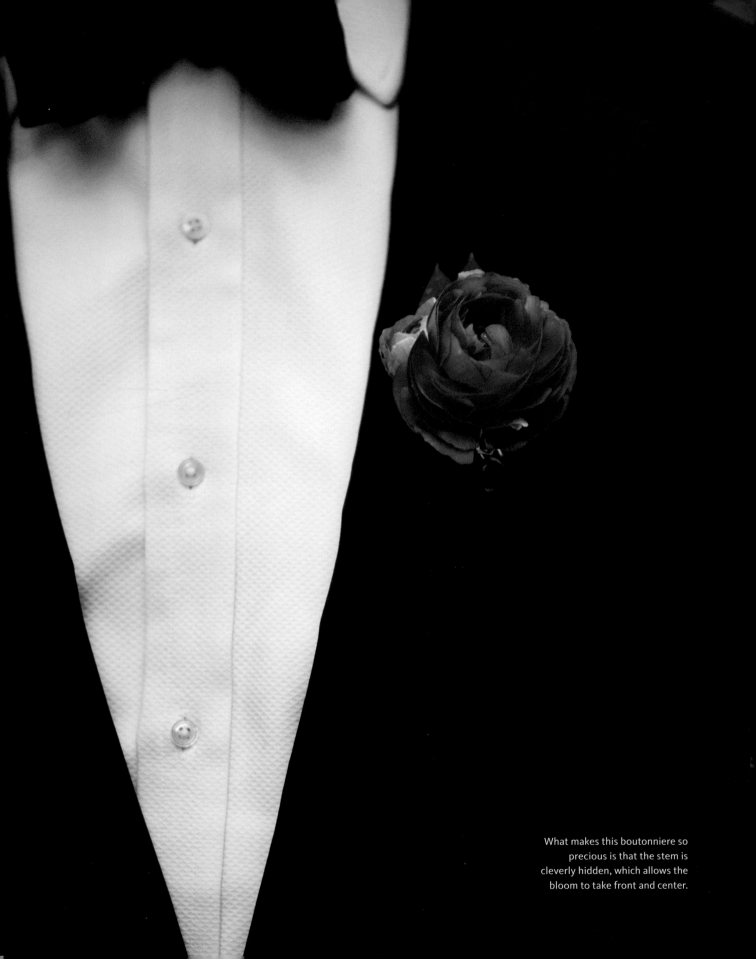

What makes this boutonniere so precious is that the stem is cleverly hidden, which allows the bloom to take front and center.

ℰ boutonnieres

Traditionally, the groom's bloom is supposed to be one "picked" from the bridal bouquet, but don't be afraid to break the rules, particularly to add a creative element.

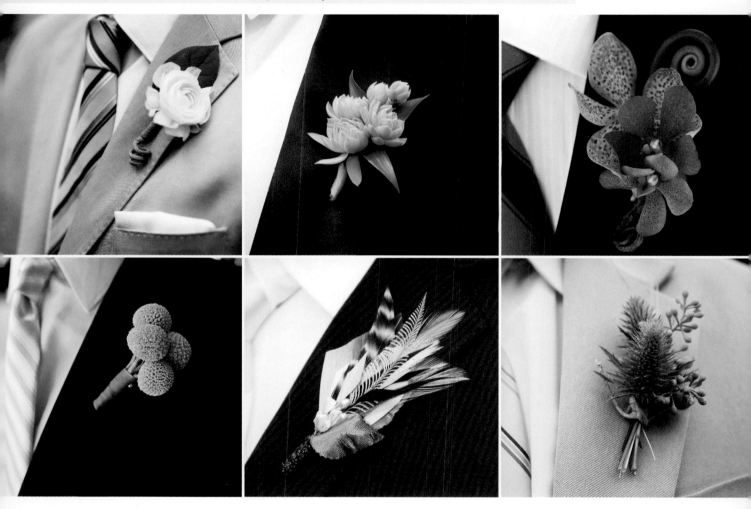

top For a summer wedding, a single white ranunculus bloom handsomely sets off a tan suit with a blue and brown striped tie. ▪ Fresh green succulents offer a nice alternative for a groom who'd rather do without the frills. ▪ Striking is the word that sums up this decidedly unclassic pair of tiger and coral Mokara orchids, set off by curvy fiddlehead ferns.

bottom They only look like pom-poms. They're actually blooms known as craspedia—a fuss-free option that adds a bit of pop to a dark lapel. ▪ A mix of pheasant, emu, and ostrich plumes features patterns almost like ones found in classic suiting, conveying a real sense of flair. ▪ The spiky texture of thistles, along with the round eucalyptus seeds, works nicely as part of a casual ensemble, particularly with the similarly hued stripes of the tie.

Think staying power

The bouquets will be handled frequently throughout the day. To keep them looking their best, consider sturdier flowers like roses, lilies, and peonies, rather than more delicate gardenias, poppies, and calla lilies. You might want to invest in two boutonnieres—one for the ceremony and one for the reception, particularly if you're using fragile blooms.

Be honest about your budget

A good florist can work with you no matter how much you can spend. Be upfront about your limit and be open to the kinds of flowers that are within your budget. If the florist keeps trying to convince you to increase your spending instead of offering creative ideas to meet your needs, go elsewhere.

Consider a nonfloral alternative

Want to buck tradition? Some brides opt to carry a religious symbol instead of a bouquet—like an heirloom rosary or a prayer book, either with blossoms decorating the cover or with a flower stem placed between the pages so that just the bloom is showing.

Choose big blooms

Large, full blossoms like cymbidium orchids and peonies cut down on the number of stems you need.

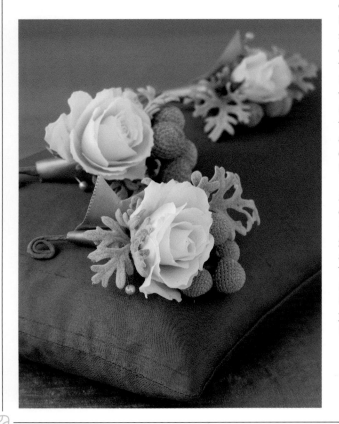

Stay in season

You can save 30–50 percent if you stick to flowers that are in bloom in your area during the season of your wedding.

Send your flowers to the right places

Have your florist deliver your and your bridesmaids' bouquets to wherever you're getting dressed. The boutonnieres should go to your groom's place. Hold on to the boxes the flowers come in so you can safely transport the bouquets and boutonnieres while you're on the way to the ceremony.

Prevent stains

Make sure your florist doesn't use flowers that will soil your dress (those little pollen-bearing anthers on the stamens are the actual culprits). The good news is that many flowers now come in pollen-free, nonstaining varieties. Tell the bridesmaids not to rest the bouquets on their dresses, and if the stems are soaked, make sure they're dried off well before anyone holds them.

Attach the boutonniere correctly

Each boutonniere goes on the guy's left lapel, the same side as the handkerchief pocket. The boutonniere can be pinned through the buttonhole, but if there isn't one, you'll have to make a small hole in the jacket.

Strike a pose

Many brides get nervous right before they walk down the aisle and end up holding their bouquet way too high, where it might obscure the beautiful bodice of their gown. For handheld bouquets, let your wrists fall above your hip bones and use both hands to hold the bouquet. For cascade bouquets, simply rest the arrangement on your forearm, and don't hold it so tightly that you smash it. Clasp your hands loosely, at hip bone height, if you're carrying a pomander.

Reuse the bouquets

After your entrance at the reception, the bouquets don't get much play. Instead of letting them go to waste, have them decorate the cake table or ask your florist to bring some extra vases and stick the bouquets in those.

Get photos of the bouquets early

No matter how talented your florist is, the bouquets won't look as stellar after you and your bridesmaids have been handling them for hours.

Want more bouquet or boutonniere ideas? Go to **TheKnot.com/flowers**

For an informal summer wedding, full-blown garden roses hand tied with twine and mixed with greenery have plenty of presence without seeming stuffy.

white

There's nothing like this wedding-day classic to cast a dreamy spell. It's an easy accent color, too!

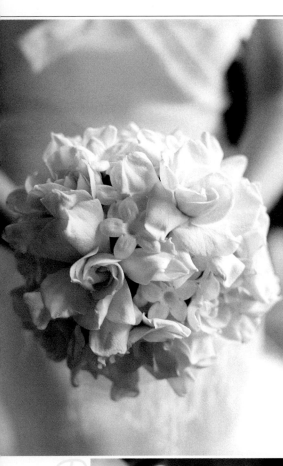

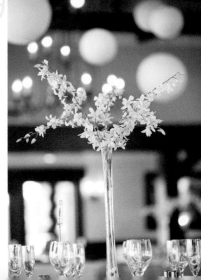

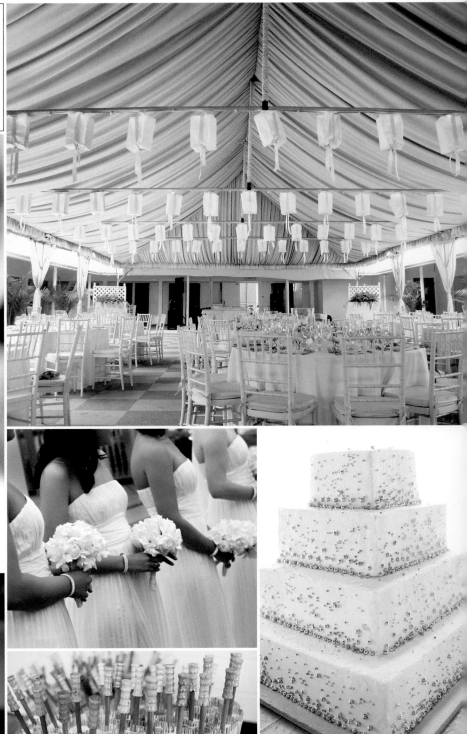

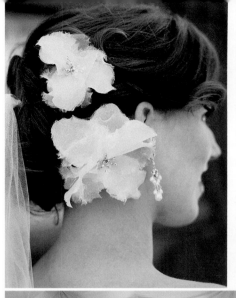

Flowers that come in white
Anemones
Calla lilies
Carnations
Gerbera daisies
Hydrangeas
Magnolias
Orchids
Peonies
Ranunculus
Roses
Stephanotis

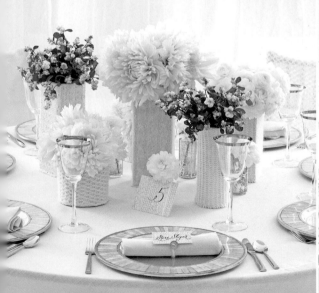

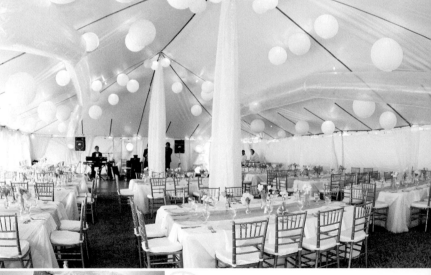

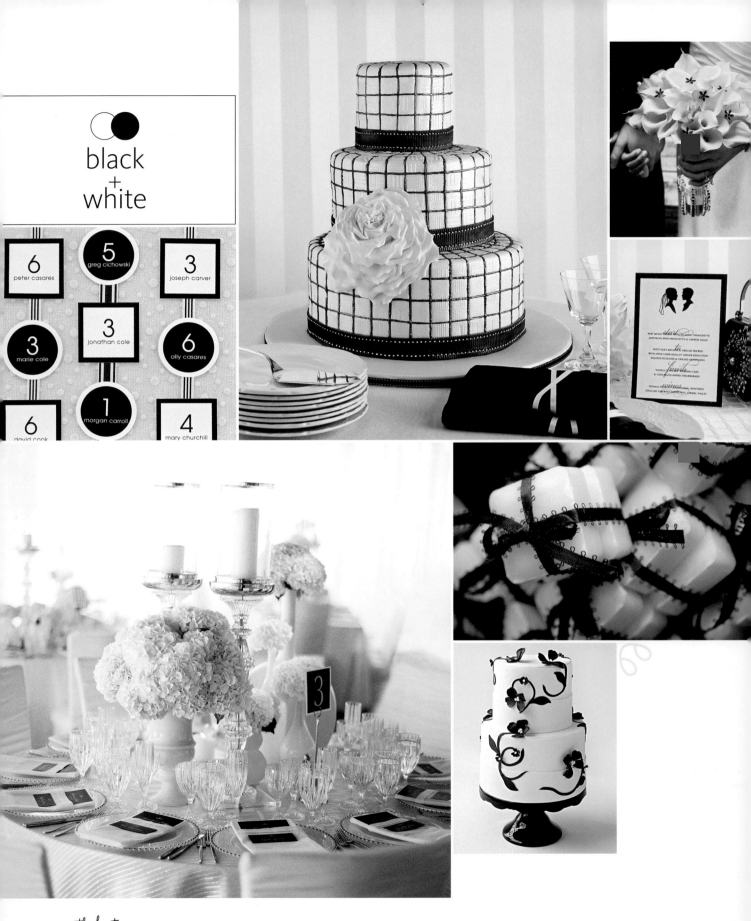

black
+
white

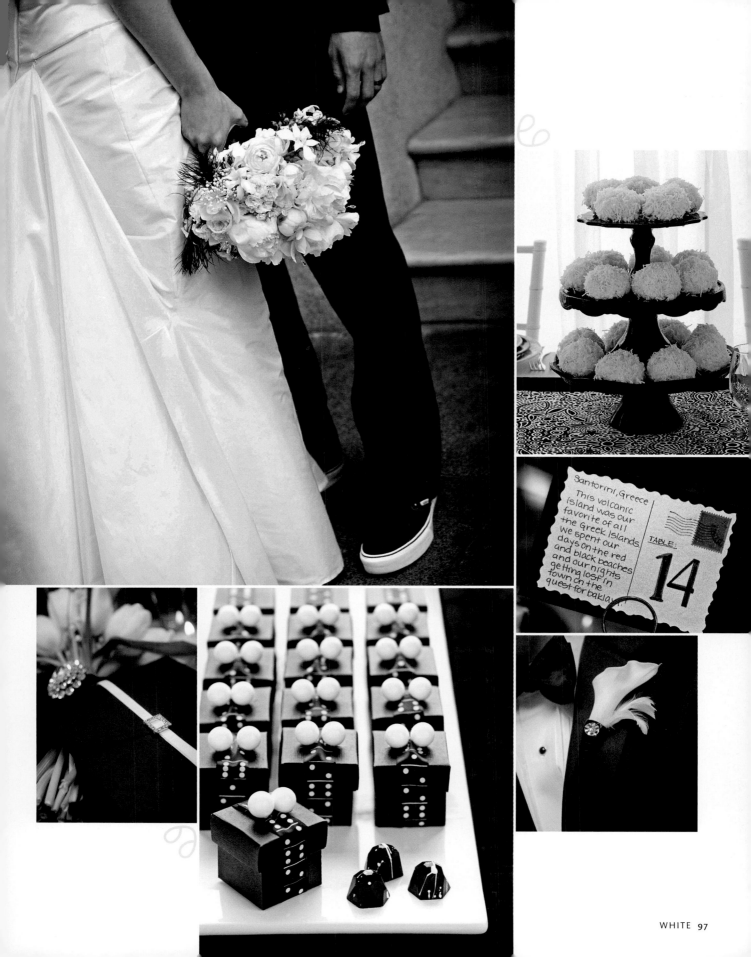

a spring wedding

Naomi and Larry's outdoor wedding combined a cheery palette with rustic touches that fit the venue—a private estate complete with rambling gardens and a renovated barn. Chandeliers hung from timber rafters, wrought-iron shepherds' hooks held the aisle decorations, the flower girls used a tin bucket and a watering can to hold their petals, and guests took home jars of homemade jam as favors.

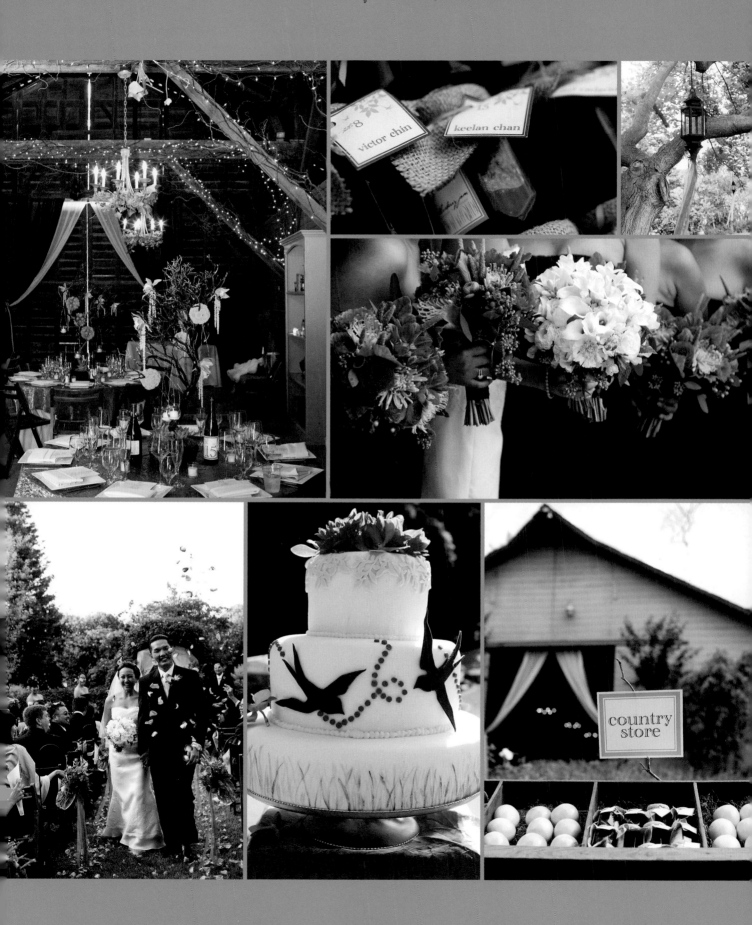

Every detail of the bride and groom's ensembles plays off each other and the level of formality is equal (his patent leather shoes and her dainty sandals both say "formal wedding").

opposite Sometimes, a few cleverly placed flowers are the only accents a bride's hair needs. This bride wears two white phalaenopsis orchids tucked into her chignon.

4

dressing up

your countdown

8+ months before:
Start shopping.

6 months before:
Order your dress; order
the bridesmaid dresses.

2 months before:
Have your first fitting.

1 month before:
Have your second fitting.

2–3 weeks before:
Have your final fitting.

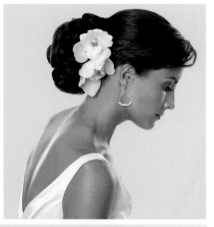

get inspired by
- Your grandmother's wedding gown
- The most beloved pieces of your wardrobe
- Celebrities' red-carpet looks
- The design of your engagement ring

Your wedding dress may very well be the most luxurious, most photographed piece of clothing you'll ever wear, so you'll want to find one that makes you feel pretty, comfortable, and glamorous all at once. (No pressure!) Your dress will also serve as the centerpiece of the day, a signature design gesture around which not only the entire bridal party—but also the rest of the wedding—will revolve.

Because there are thousands of wedding dresses out there, dress shopping may be a little overwhelming if you don't have an inkling of what you want. Before you start trying on options, narrow the field by putting together a list of the elements you're looking for. The style of your wedding, the season, your venue, your body type, and of course your own personal fashion taste are all factors that should help guide you.

your look The type of wedding or the venue doesn't have to dictate the kind of dress you'll wear, but it might help you narrow down your choices. If you're dreaming of a ball gown, though, don't be deterred just because your wedding will be a less formal, outdoor event at a vineyard. The choice you make for the silhouette, fabric, and even the color should be guided more by what you find most appealing than what seems most appropriate. After all, when you think about old wedding photographs you've seen—maybe your mother's and grandmother's—it's usually the couple shot, not all the details of the decor, that stands the test of time.

Luckily, there are ways to tie your dress in with almost any kind of venue. What matters most is that the dress fits and flatters your figure. Once you know the style and the basic shape you're after, browse hundreds of wedding dress photos online to get a feel for what's out there. If you see something you love, bookmark it and bring it to your bridal salon. Just be careful that you don't get stuck on a dress before you've tried it on. Photos are great for inspiration, but it's also important to try on a number of different gowns to figure out what looks best on you.

While you're trying on dresses, it's a good idea to consider whether you'll want to wear a veil. Slip one on since it will affect your look. When searching for veil options, just make sure they complement your gown, neckline, and proportions.

the bridesmaids and bridal party Once you've found your dress, you can start thinking about the bridesmaids' attire. Don't fall into the trap of confusing them with the decor, though. While your wedding colors might be lime green and orange, your bridesmaid dresses don't need to be a perfect match.

Another thing to consider is the fabric. If your dress is chiffon, you'll want the bridesmaids in a similar flowy fabric. Their neckline could also coordinate with yours, but what's most important is that the silhouette looks good on all body types. You might consider choosing a color or a specific fabric and then letting each maid pick a style that will best suit her.

Your bridesmaid dress can probably be customized for your flower girl, but that's not the only option. You could also put her in a white cotton dress with a sash that coordinates with your bridesmaid dresses. For a formal affair in a cooler season, find a silk dress with a full skirt and add a simple cardigan.

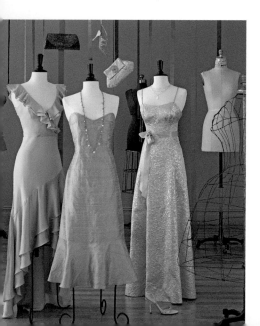

dress-shape glossary

A-line: Also referred to as a princess shape, this style hugs the torso and has a slightly flared skirt.

Ball gown: This shape is fitted at the waist, with a dramatic full skirt.

Sheath: This slim, form-fitting silhouette hugs the whole body.

Trumpet: The skirt in this style flares out toward the bottom of the skirt near the hem, like the bell of a trumpet.

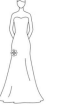

Mermaid: The skirt in this style gradually flares out at or below midthigh.

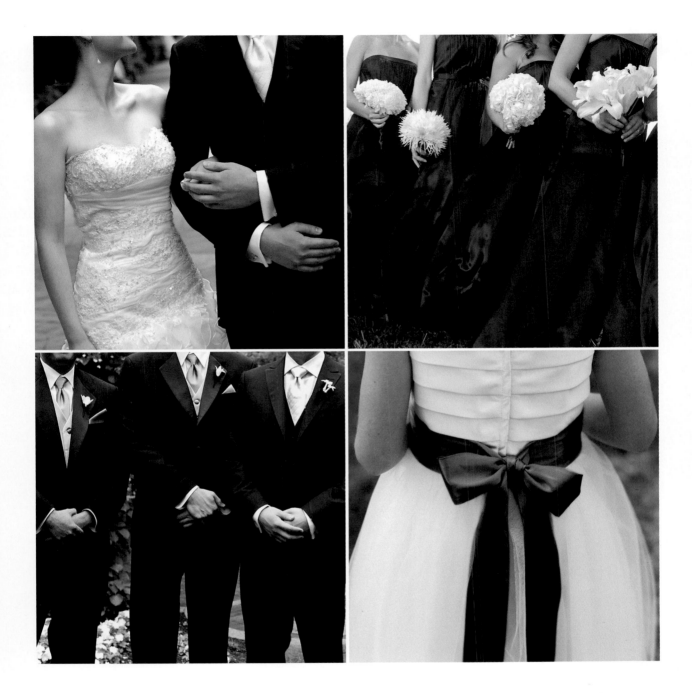

opposite Plain white and ivory aren't the only color choices for bridal gowns. Misty gray and almond-hued dresses are neutrals that still say "bride." Adding a champagne sash to an ivory dress adds a unique twist to a simple dress design and lends a luxe, layered look.

top The groom's white-on-white tie-and-shirt combo, accessorized with French cuffs, coordinates perfectly with the bride's elegant strapless dress. ▪ A bouquet can be the bridesmaids' most important accessory.

bottom This groom stands out in a white-on-white tie-and-shirt combo while his groomsmen go for soft gray ties and pocket squares. ▪ A pleated bodice and tulle skirt create a sweet flower-girl look.

the groom and groomsmen

Like the bride, the groom should start his wardrobe search by aiming to reflect the occasion. Whether for a suit or a classic tux, remember that there are a surprising number of choices to make when selecting a jacket and shirt collars. The groom's neckwear can also go a long way toward personalizing his look—from a classic, basic black bow tie to a silk tie in silver or blue, which will be dressy enough to stand up to a tux.

Once he's found the right style, he'll need to complete his look with accessories. From ties to cuff links, cummerbunds, boutonnieres, and shoes, it's the extras that will really finish the groom's look.

The groomsmen's formal wear should follow suit from the groom's attire. As for the ring bearer, opinions on attire vary. You may run into the "Please, no mini-tuxes" school, but if the groom and groomsmen are wearing tuxedos, then there's no reason why the little guy shouldn't dress to match. More traditional choices are suits, often in dark colors like navy or hunter green.

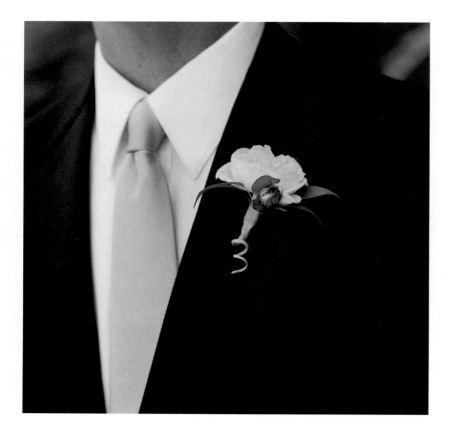

above A well-cut black suit and perfectly-in-place mercury silver tie looks as dashing and dressy as a classic tuxedo.

opposite Unique details on the back of a wedding gown make for a dramatic exit.

the lingo of formality

White tie: Men wear tuxedos, long black jackets with tails, white vests, and bow ties. Think: long gloves with formal, full-length ball gowns.

Black tie: Men wear tuxedos, bow ties, and cummerbunds, and the women wear cocktail dresses or long gowns. You could wear a ball gown or a full A-line dress with beading and embroidery.

Black-tie optional: Men can wear a tuxedo or dark suit and tie. Women should wear long dresses, dressy suits, or formal cocktail-length dresses. You can go with a simple ball gown or A-line or with an embellished sheath.

Semiformal: For evening, darker hues are apropos, but in the daytime, opt for lighter colors and fabrics. The men wear suits and ties, and the women wear cocktail dresses or dressy skirts and tops. You should skip the ball gown.

Casual: The men might wear seersucker suits or another light-material jacket with khakis. The women wear sundresses or skirts and tops. Light fabrics, like chiffon and cotton, are appropriate for your dress.

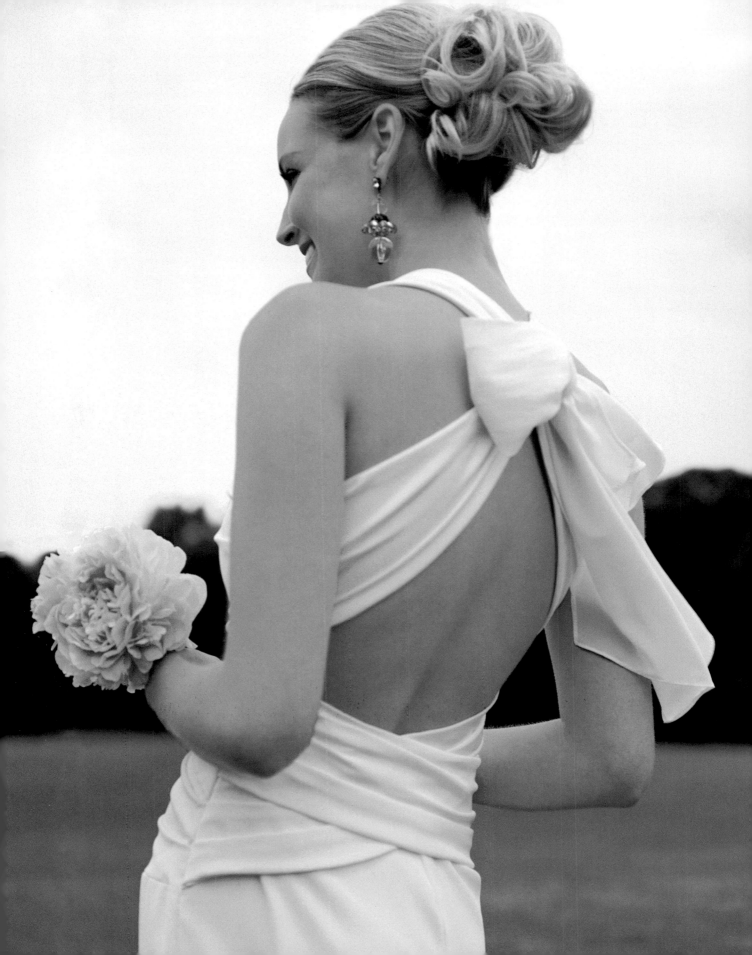

✐the bride

All of the elements of a bridal gown—from the silhouette to the neckline and other details like beading, buttons, bows, and lace—help to make that once-in-a-lifetime fashion statement.

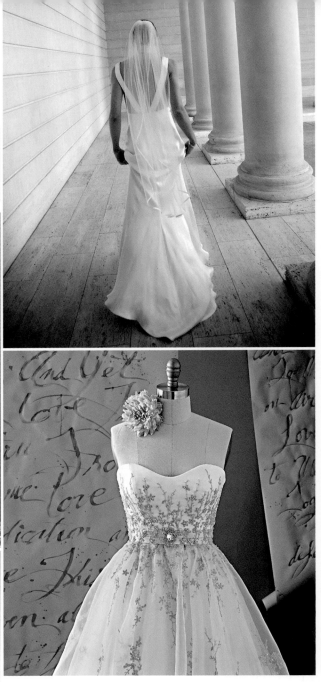

clockwise Sweetheart necklines create gently curved, flattering lines on two very different gowns: One is elegantly belted at the waist with a dramatic fabric flower, and the other is intricately detailed with beading and lace. ■ The angular lines of this bridal gown's deep V-back are mimicked in the train's pointed hem. ■ Cream-tinted floral embroidery, crystal beading, and a silvery jewel fastened to the satin belt lend a vintage vibe. ■ A flourish of three-dimensional details above a high waist can be just enough embellishment.

The strapless, chiffon A-line dress with a bejeweled bodice looks the epitome of laid-back elegance, perfect for a semiformal wedding. A lace sheath with a plunging neckline is a perfect choice for a swanky evening cocktail reception, while a sweet, dropped-waist A-line gown works best for a daytime garden event.

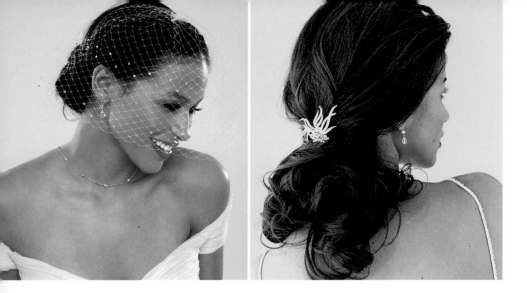

✎the accessories

It's the small details that pull together a bride's look from head to toe. Carefully choosing pieces that combine your personal fashion sense with the look and feel of your wedding gown will pay off.

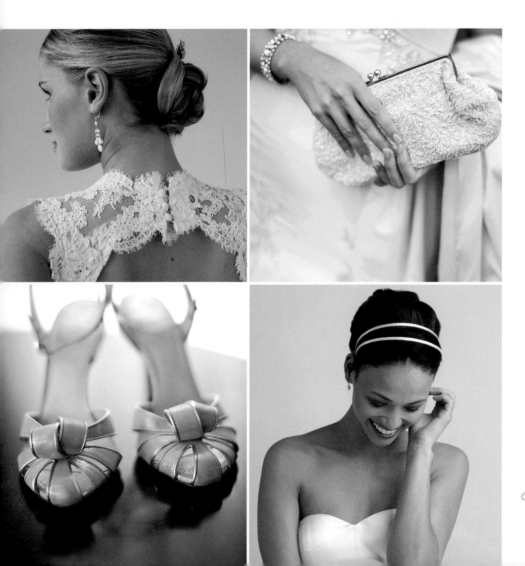

top A netted cage veil, like this one, shows off a modern sense of style. With a pulled-back chignon, the eye is drawn to the delicate, off-the-shoulder neckline. ■ A loosely gathered hairstyle calls for an accent with organic lines, like this metallic hairpin.

middle Simple details, such as a chignon and drop earrings, allow the gown's lace cutout back to command the attention. ■ Both lace and beading glam up this bride's clutch, and allow her to keep the essentials, like lip gloss and powder, on hand for touch-ups.

bottom Some say that no one will see a bride's shoes. Not so! Every time she sits or raises her skirt a bit to walk, they're bound to be admired. These gold-accented sling backs are inspired by looped satin ribbons—understated yet so feminine. ■ A pair of satin headbands is sleek and chic—the perfect complement to a polished chignon.

Capture timeless elegance with a retro style. Here, a feathered birdcage veil and pearl button–accented gloves enhance the vintage feel of an embroidered and beaded gown.

Ruffles, bows, and gathers accent these bridal party dresses. A turquoise tank dress is an adorable choice for a flower girl. The kelly green number is simple yet chic. A top that's embellished is a great way for the maid or matron of honor to stand out. This modern choice features a sheath with an oversized bow.

the bridesmaids

Whether all in the same style or color, the bridesmaid dresses are the supporting stars to the gown. As such, what the bridesmaids wear will reinforce the feel of the whole wedding.

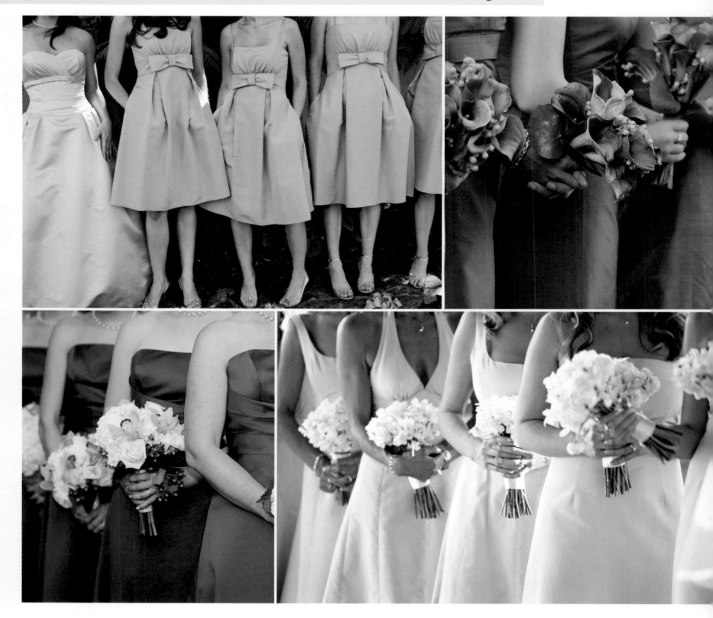

top The maids, like the bride, wear pleats and Empire waists, but their gowns also have their own special details: preppy bows, comfy pockets, and a soft mint hue. ■ The maid of honor can stand out from the crowd by wearing a slightly different shade. Here, the other bridesmaids don bright pink while she sports a salmon hue.

bottom Deep colors, like royal blue, are the most flattering on all skin tones, but they call for more subdued bouquets. ■ Bridesmaids like the flexibility of choosing their favorite neckline. Since they're the same hue, fabric, and length, they still look cohesive.

ℰthe groom

Suiting him up may seem simple, but actually a wealth of jacket, shirt, tie, shoe, and boutonniere choices exists for him to express his own taste and the formality of the event.

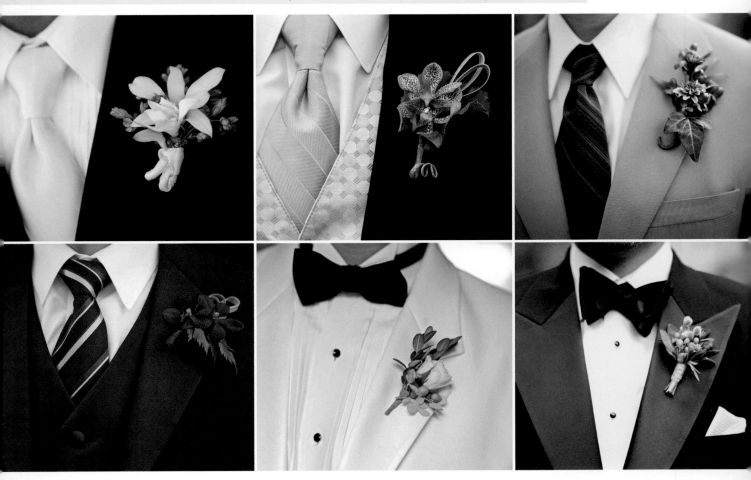

opposite A striped tie paired with a two-button suit is traditional and a bit relaxed. He'll do James Bond proud in a classic notch-collar tuxedo. If he's looking for the ultimate in white-tie formality, a tailcoat with a white tie and vest should do the trick.

top A white orchid boutonniere paired with a white tie is simply handsome. ■ To stand up to a yellow vest and tie, a boutonniere with an equally vibrant orchid is almost required. ■ This look is perfect for an early autumn fête: a tan suit, a striped tie, and a marigold and hypericum berry boutonniere.

bottom This groom complements his pink shirt with a striped tie. His red orchid boutonniere makes the pink feel less flamboyant. ■ Nothing says old-world elegance like a formal white tuxedo accented with a monochromatic white rose. ■ A peaked lapel feels almost over the top, but the more traditional white pussy willows dial it back a bit.

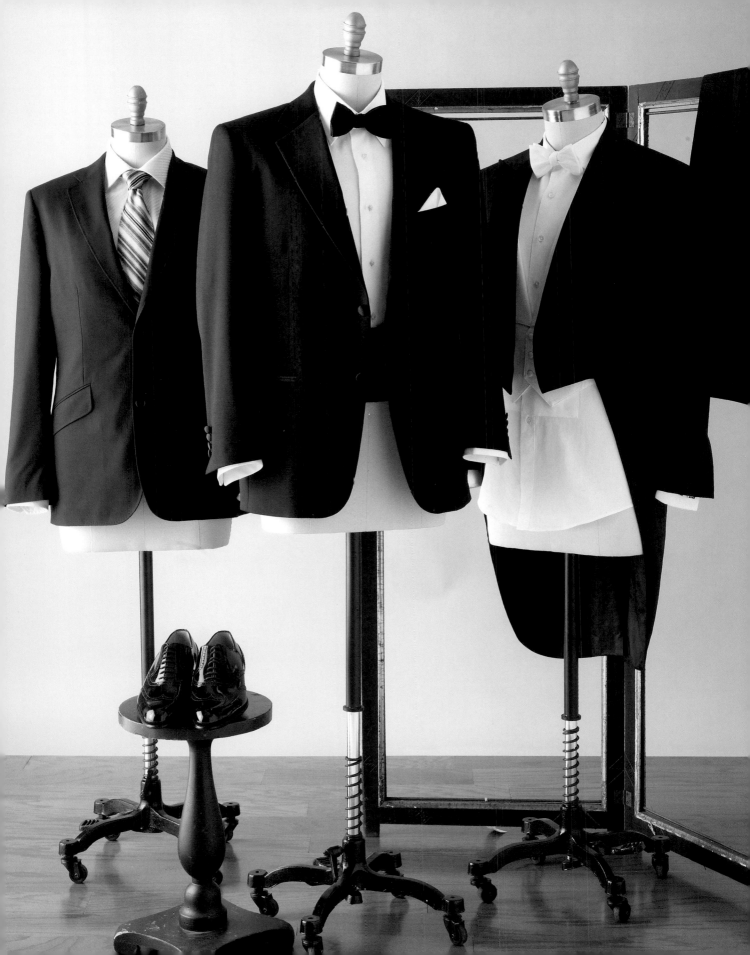

Shop during the week
The weekend is more convenient, but bridal salons are packed then. Even if you have an appointment, the atmosphere won't be relaxed in a crowded store.

Check out sample sales
In December and May you can luck out and get as much as 80 percent off original gown prices. You'll need to factor in dry-cleaning and alteration costs, though, since these gowns (used as try-on models) are usually sold "as is." Also, choices are often limited to sample sizes.

Choose your co-shoppers wisely
It's tempting to invite all of your bridesmaids along, but too many opinions can stress you out. Bring your mom and two fashionable but honest bridesmaids to help you make your pick.

Come prepared
Show up with a strapless bra, heels, and other undergarments you may wear, too, like a slimmer. You should also bring the jewelry you plan to wear on your wedding day to your first fitting so you can see how it all works together.

Leave your modesty at the door
Many bridal consultants will come into the dressing room with you to help you into the gowns. If you don't want them to, politely say so. You can always invite them in when it's time to get zipped up.

Have a (somewhat) open mind
You may love a gown you find online or in a magazine, but it might not look so great when you try it on. Don't despair: Figure out what you like about the dress and then ask a consultant to show you other gowns with those details.

Go simple
Choosing a classic gown without embellishments may lower the price tag significantly (often up to 25 percent). If you love ornamentation, opt for it in moderation. You can have gorgeous lace and beading on the bodice, but go simple on the hem and waistline to cut costs; you may not need to wear as much jewelry, also saving you money.

Size up
If you're usually a size 8 in everyday clothes, expect to order a wedding dress in a 10 or a 12, depending on the designer's sizing chart. Wedding dresses are sized about one or two sizes up from street clothes.

Move around
Get an idea of how you'll feel walking around in the dress, sitting for dinner in it, and even dancing in it. If you're a little uncomfortable in those five minutes, imagine how you'll feel after wearing it for ten hours!

Practice the bustle
If your dress has a train, appoint a trusted bridesmaid or family member to bustle it between the ceremony and reception. When you pick up the dress after your final fitting, have her come with you to practice. That way, the seamstress will be there to give her pointers.

Work the veil
Make sure the veil works with the style of your dress. A two-and-a-half-yard-long chapel-style veil is ultraformal. Something shorter, like a flyaway—which brushes the shoulders—fits with a breezier gown like a relaxed sheath or a flowing chiffon dress. A lacy, face-framing, Spanish-style mantilla offers a traditional old-world bridal look.

Avoid custom alterations
Making special changes to couture gowns, such as changing the shape of the neckline or altering the sleeves, can cost up to $300 per adjustment.

Don't buy a *wedding* dress
You can find a great dress that's wedding-appropriate even if it's not branded as a wedding gown. Check out department stores and other stores that sell formal wear that's less pricey, but still stunning.

Questions to ask at your bridal salon
1. How long will it take for the dress to arrive?
Leave yourself at least two months before the wedding date to do all the necessary fittings.

2. How much do dress alterations cost, and can I get a written estimate for alterations?
Sometimes, minor adjustments are included in the price or are discounted. If not, you can comparison-shop for the alterations.

3. How much does shipping cost?
Beware of hidden fees like this one, which could cost you $50 to $100! Others to watch for: delivery charges, state taxes, and extra fabric.

4. How much is the deposit, and is it refundable?
It's usually 20 percent of the total cost. Make the deposit using a credit card—and don't pay more than the minimum until you see the gown and are satisfied. Often, deposits are nonrefundable.

5. How many fittings can I have?
Three is the norm, but you can request and pay for extras.

Find your wedding gown at TheKnot.com/fashion

Natalie and Kyle
May 24, 2008

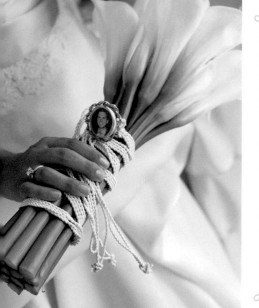

get personal

The most meaningful accessories are often the tiniest details. What makes these so noteworthy is that they express whimsical personal style, sentimentality, or both, such as the custom label inside of the bride's gown (*top, middle*) or the crystal initials adorning the bottoms of the bride's shoes (*top, right*).

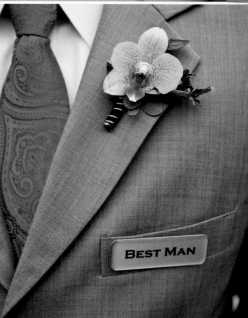

BEST MAN

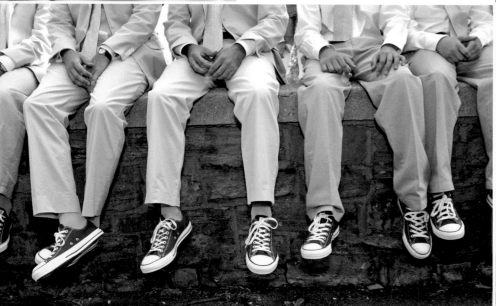

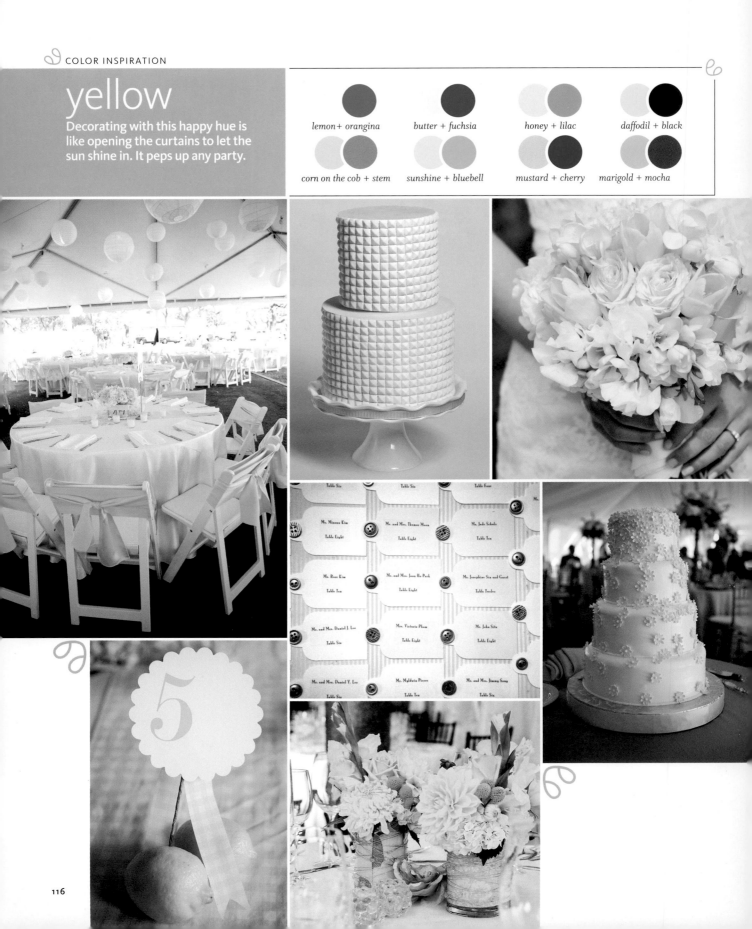

yellow

Decorating with this happy hue is like opening the curtains to let the sun shine in. It peps up any party.

lemon + orangina

butter + fuchsia

honey + lilac

daffodil + black

corn on the cob + stem

sunshine + bluebell

mustard + cherry

marigold + mocha

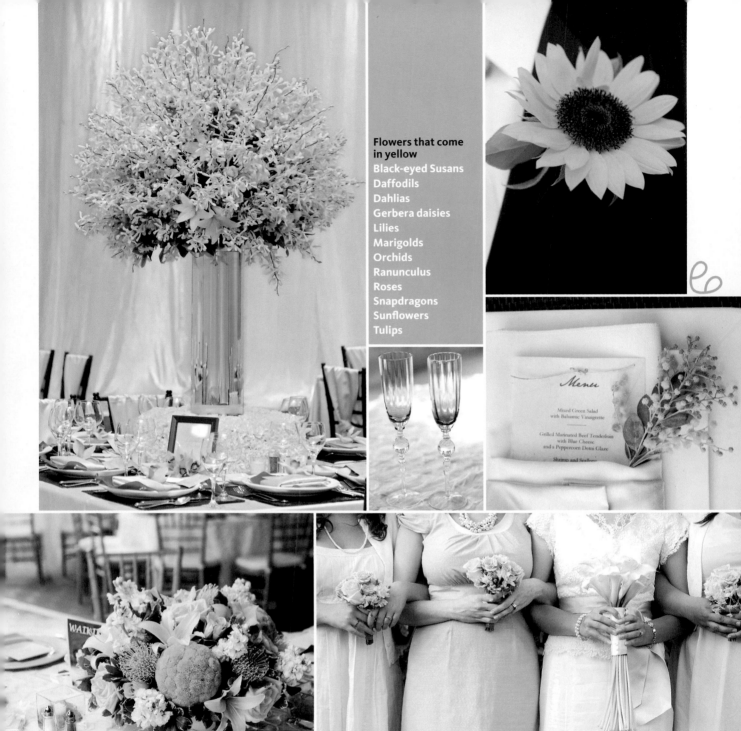

Flowers that come in yellow

Black-eyed Susans
Daffodils
Dahlias
Gerbera daisies
Lilies
Marigolds
Orchids
Ranunculus
Roses
Snapdragons
Sunflowers
Tulips

Menu

Mixed Green Salad
with Balsamic Vinaigrette

Grilled Marinated Beef Tenderloin
with Blue Cheese
and a Peppercorn Demi Glaze

Shrimp and Scallops

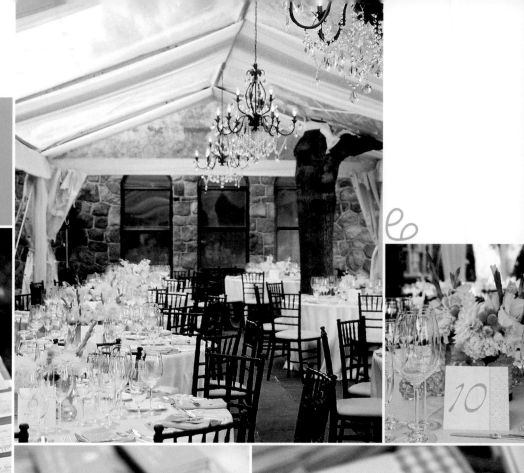

sunshine + bluebell

10

Rob and Jo
October 25, 2008

A Tissue For Your Tears

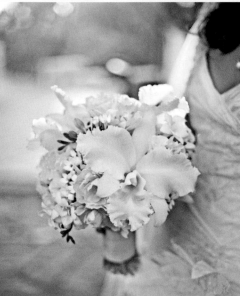

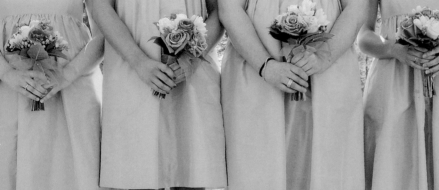

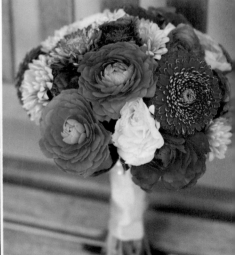

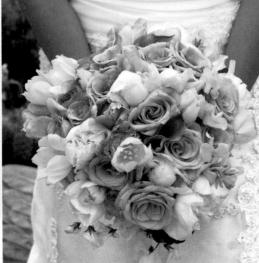

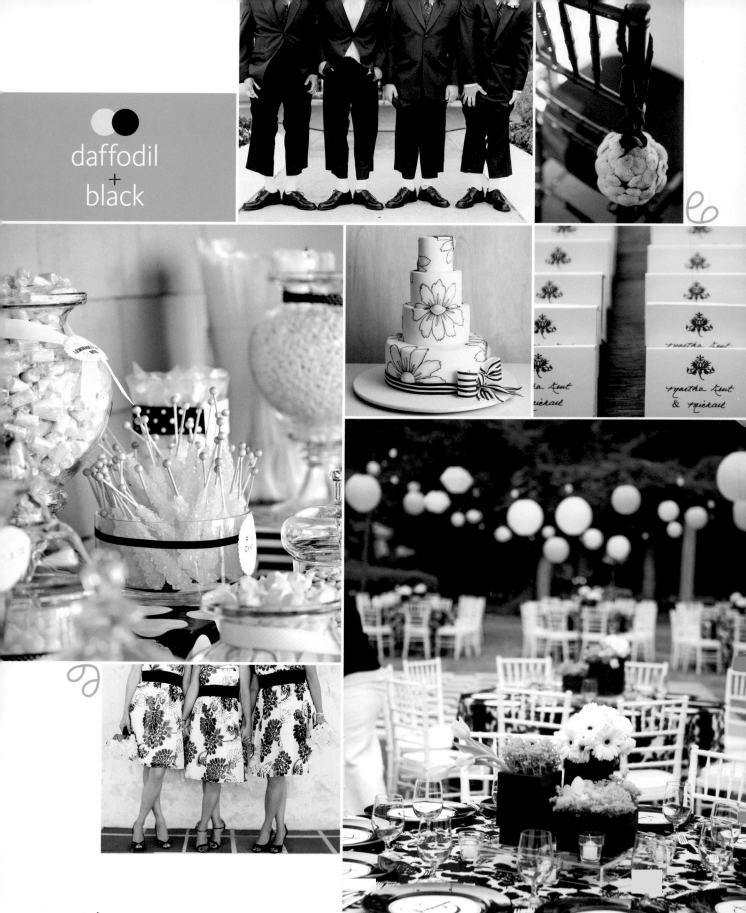

daffodil
+
black

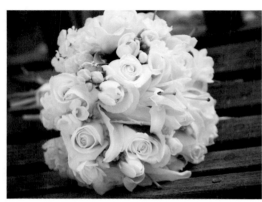

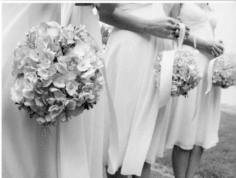

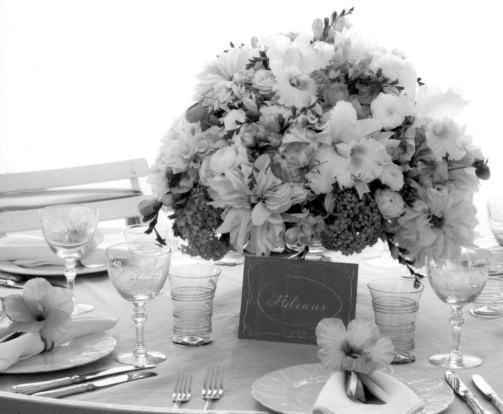

Hibiscus

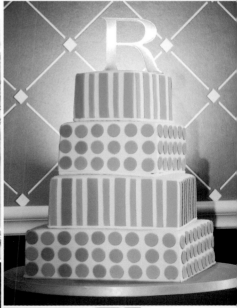

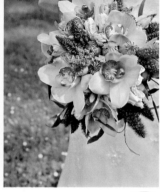

LOUISA + JOHN

an eco-wedding

Louisa and John wanted a big day that made a minimal impact on the environment, so they chose earth-friendly details, like invitations on recycled paper printed with soy ink. The setting, a friend's home, was embellished with planted flowers, nature-inspired decor items, and energy-saving LED lights. Even the food was organic and locally grown. By making the extra effort, the couple proved that a wedding can be beautiful *and* ecologically responsible.

——— ◠◠ ———

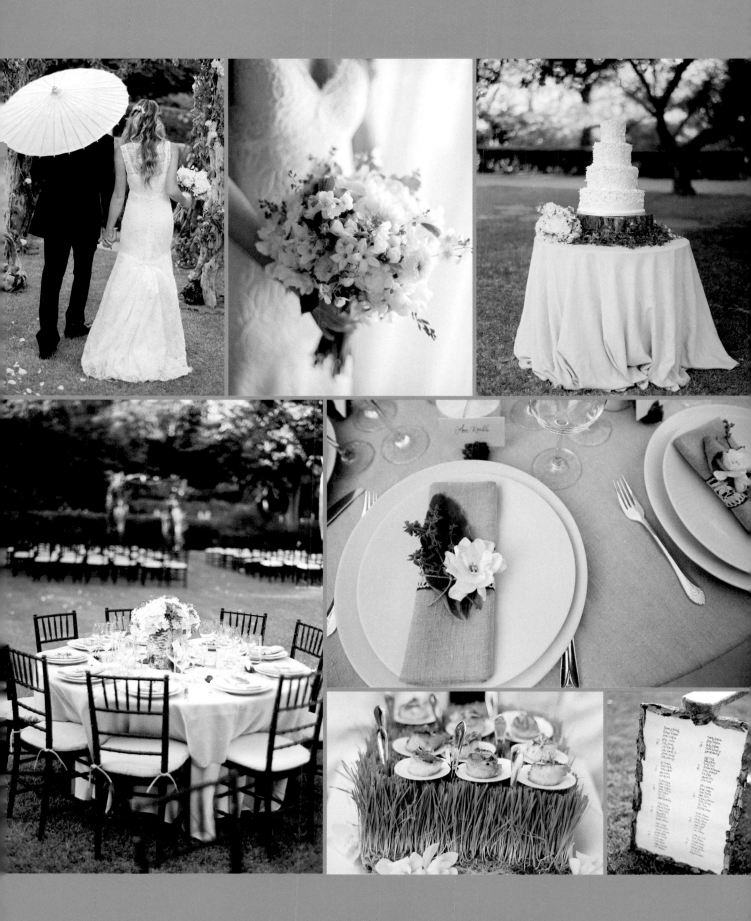

A signature cocktail becomes part of the decor when its hues match those of the wedding palette. Here, pink lemonade is garnished with fresh mint and pink paper flags displaying the couple's names for a clever twist on a preppy color combo.

the cocktail hour

Decor that is inherent to the space, such as a fountain, creates a focal point for the party.

The cocktail hour is when you finally get to kick up your heels and kick off your party. These sixty to ninety minutes are your chance to charm your guests (as well as refresh them) once the pomp and circumstance of the ceremony are over. The reality is you'll likely miss most of the cocktail hour because you'll be off taking photos, and in the meantime, you'll want your guests to feel well taken care of. Reinforce the vibe with delicious food and drink, some music, a place to lounge, and perhaps a few easy-to-do activities (such as photo booths) or conversation-starters. It's also the perfect time to incorporate unique, personal touches.

the scene

Begin your planning by thinking about the space. A separate area for the cocktail hour is a must—even if it's just a screened-off section away from the main room or an outdoor patio. The division will give your catering crew time to set up the dining area and allows for the "big reveal" of your reception space for dinner. If you have the room and the flexibility, consider having comfy furniture arranged in intimate groups along with tall cocktail tables. This allows for more of a living-room-cum-nightclub feel where guests can unwind and chat without having to balance their glass in one hand and their plate in the other.

The bar will often be a focal point of the room, so plan to make it a showstopper. Want to feature a signature flower? Have a special bar top built and cover it with your blooms. Or let the barware do the work: Set out rows of highball glasses on lacquered trays.

One way to keep things interesting for the cocktail hour is to reverse the color scheme of your reception. For instance, if your wedding colors are fuchsia with orange accents, consider making orange the dominant hue at the cocktail fête with a few hints of hot pink. Another decor trick is using candles—they can go a long way in setting the laid-back mood.

the food and drink

The first thing on your guests' minds will be . . . a cocktail! Make sure servers are waiting at the entrance holding trays of beverages. As for the bar itself, an open bar—unlimited liquor with top-shelf brands—is the most gracious option. But if you need to limit the choices, serving beer, wine, champagne, soft drinks, and one specialty cocktail is an alternative. A signature cocktail with a special name adds flair to the event. Start with a standard spirit—vodka, rum, and champagne are crowd-pleasers—and add seasonal or favorite ingredients. For inspiration, think of your venue—mint juleps for a Southern-themed fête or tequila sunrises for your destination wedding in Los Cabos.

After sitting through the ceremony, guests will no doubt be ready to dig in. There are three ways you can go with your food service: passed hors d'oeuvres, food stations, or a combination of the two. Stations are the cocktail-hour equivalent of a dinner buffet, whereas passed hors d'oeuvres are more similar to, and just as formal as, plated dinner service.

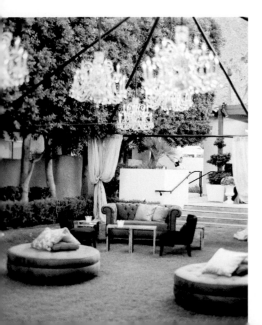

cocktails by color

Have your bartender concoct something that plays off your palette.

Red/Pink
Cosmopolitan
Pink grapefruit mojito
Pomegranate martini

Orange/Peach
Orange slice martini
Tangerini
Tequila sunrise

Yellow/Gold
Honey sidecar
Lemongrass ginger martini
Bellini

Green
Margarita
Mojito
Sour apple martini

Blue
Blue Hawaiian
Blue martini
Wild blueberry martini

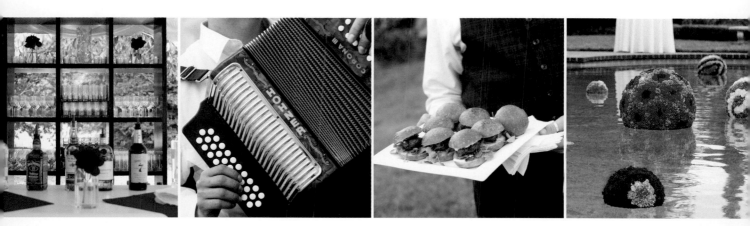

opposite It's the extra touches that make the cocktail hour special. Bringing indoor furniture, such as crystal chandeliers, plush ottomans, and a scroll-back sofa, outside (or outdoor furniture inside) is an unexpected way to make the cocktail-hour space unique.

top The decor can be simple and understated. Here, bottles of liquor lined up along the bar juxtaposed with a single oversized bloom create a minimal look that's also functional.
■ Music is essential at a cocktail hour, and while you can certainly go the playlist route, there's something about live musicians that gets a crowd in the mood. ■ The most popular hors d'oeuvres are filling and easy to eat.
■ Bright pink pomanders floating in a pool add a touch of whimsy.

The main drawback to passed hors d'oeuvres is that guests have to wait for their favorites to come to them. With stations, your guests can indulge as needed—but be aware that this will up your total bill. Since you have no control over the portions, as you do with passed appetizers, the food stations will need to stay stocked no matter how much guests actually eat. If you have space for stations around the room, as well as waiters milling about with hors d'oeuvres, you can get the best of both worlds, although the cost can end up being higher.

the entertainment Great music gets the party started. Some planners say that this portion of the event lends itself perfectly to a playlist of preset tunes; others prefer the excitement of a live entertainer. Whatever you choose, try to keep the music mellow and distinct from what you'll hear at the reception. Cocktail-hour music is meant to stay in the background.

Remember that as you kick things off, guests will notice even the smallest details—everything from the hibiscus blossoms strewn across the silver serving trays to the swizzle sticks in the signature cocktails. Another way to get guests chatting is by putting a twist on tradition with the guest-book and escort-card display. A bit of creativity will ensure your cocktail hour is worth toasting.

About ten minutes before the cocktail hour ends, your musicians and waitstaff should encourage guests to make their way to the reception area. An announcement is the simple way to do this, but subtle cues, like having your musicians play softer songs and ending passed hors d'oeuvres service, will also send the message. A surefire way to get guests into the reception space is to close the bar.

A modern white couch and glass coffee table give an edge to a garden party.

the setting

Since the cocktail hour is the prelude to the reception, the space, the decor, and even the bar itself should foreshadow what's to come.

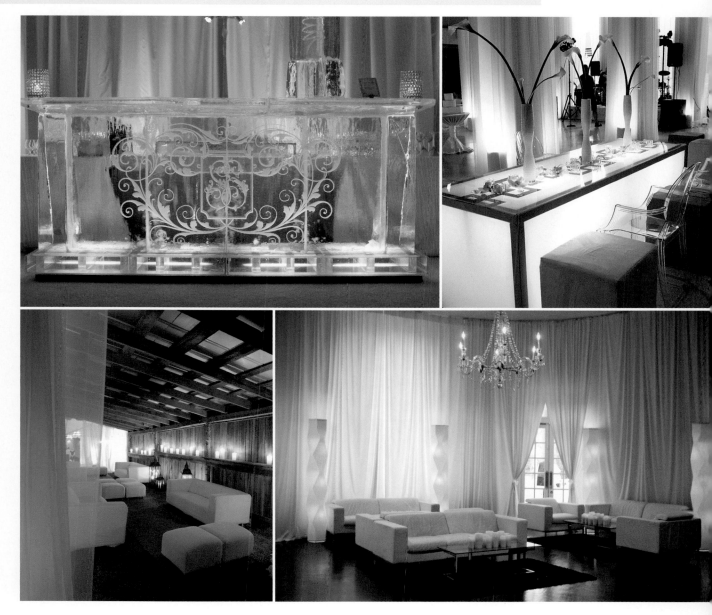

top This Lucite bar mimics the look of an ice sculpture and creates a cool focal point. ■ An illuminated rectangular table already cool unto itself gets an edgy upgrade by alternating ottomans and ghost chairs.

bottom Adding pink lighting and dozens of luminaries transforms this cocktail space into a more loungelike setting. ■ A chic sitting area with white leather couches, candle-covered coffee tables, and shag carpeting is lit by a glowing crystal chandelier and surrounded by ethereal drapery.

Champagne flutes flaunt a paper "garnish" emblazoned with the couple's names and a note on the bubbly's significance.

❧ the bar's open

A well-stocked, dazzlingly decorated bar along with a signature cocktail will surely get guests into the swing of things.

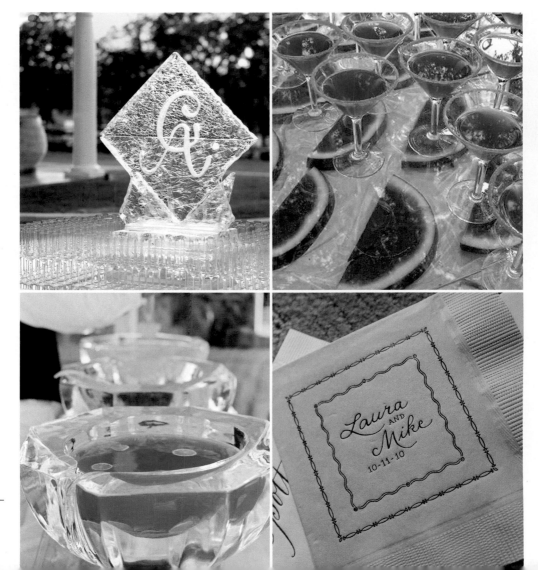

top You can choose a signature cocktail in one of the colors of your palette or go for two in both of your hues. ■ A fun way to personalize a signature cocktail is to give it a name like this one: "The Perfect Pear."

middle An ice sculpture doesn't have to be a pair of swans in the shape of a heart. This stylish monogram makes a statement on a minimally arranged bar table. ■ Presenting cocktails in eye-catching ways can be simple. Here, a sheet of glass sits atop rows of watermelon slices.

bottom In lieu of passed cocktails, crystal bowls of punch not only dress up the bar but also allow guests to serve themselves (read: fewer waiters needed). ■ Cocktail napkins with your names and wedding date are a classic.

౭hors d'oeuvres

Tasty food—and plenty of it—is essential to a great cocktail hour. But it's *how* you serve the food that makes the biggest impression.

top A dollop of tuna tartare topped with caviar seems so decadent, especially when offered in an elegant spoon. ▪ Fancy flatbreads with herbs and cheese make a pretty presentation—and are easy to eat. ▪ One impressive option at cocktail hour is serving stations. Guests will feel pampered when offered made-to-order treats high on the drama.

bottom One sweet and inexpensive way to serve your appetizers is in plain white Chinese take-out containers adorned with your brand-new monogram. ▪ These cones of raw tuna look almost like flowers. ▪ Presentation is everything, and these neatly assembled appetizers prove the point.

The classic combo—soup and a sandwich—is served here with a twist: in shot glasses with the sandwich "predunked."

A lovely and unexpected take on the classic guest book relies on two urns filled with topiaries that display a banner printed with the couple's names. Pencils and notecards are nearby to allow guests to write their good wishes.

ꝋ personal touches

All the little things that define you as a couple can spell the difference between marking an occasion and truly celebrating it.

top A board hung with escort cards takes on special meaning when adorned with sweetly framed wedding photos from your and your groom's families. ▪ A cool-looking vintage typewriter invites guests to tap out their good wishes.

middle Little library card pockets with each attendee's name are decorated in the wedding-day colors and glued into the pages of a guest book. ▪ Even something as basic as a sign can make an impression when you put some thought into it. Here, the mismatched letters and rough-hewn planks are an adorable choice.

bottom Family wedding photos can be tons of fun, particularly when displayed in offbeat ways like in mason jars. ▪ Setting up a photo booth and having guests write something to go along with their portraits puts a fun spin on an ordinary guest book.

escort cards

Don't let your creativity stop after you've picked the perfect pattern, motif, or paper. Make the actual display a statement in and of itself.

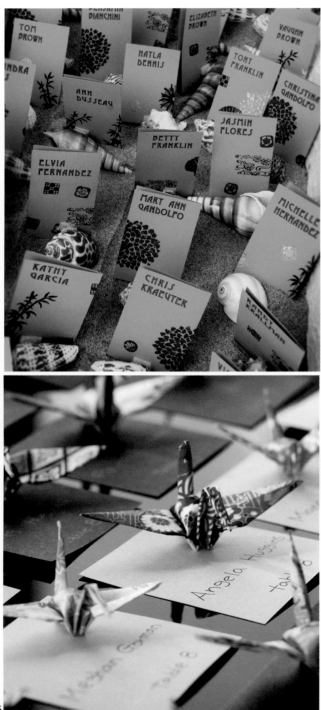

clockwise Escort cards at a beach-themed wedding sit on a bed of sand strewn with seashells. ■ Lady apples anchor these simply designed escort cards, hinting at the wedding's outdoor theme and season while echoing the lush floral arrangement on the table. ■ The season inspired this couple when they chose their escort-card table decor. Fall in New England called for pinecones lined up on either side of tented pink cards. ■ Origami birds made of colorful Japanese paper dress up the escort-card display at this Asian-themed wedding. They also double as favors.

This escort-card display is as pretty as it is practical. To help guests find their cards, set up separate trees—one for friends and one for family, for instance—and hang the cards in alphabetical order, putting *A*s at the top and working your way down.

Staff up
Use the rule of thumb that you'll need one bartender per fifty guests if you want everyone to be served in a timely manner. It's one of those little details that won't cost you much more in the end but will ensure the crowd stays happy.

Raise the bar
Don't hide your bar in the corner. Rent four forty-two-inch-high tables and set them up in the center of the room in a square with the middle open for the bartender. It gives a nice focal point to the room and lets guests get drinks from all four sides.

Set the fee
Try to negotiate a bar fee that charges per head rather than per drink. Whether a guest drinks the whole glass or takes one sip, you'll be charged for the entire beverage if a per-drink clause is in your contract.

Save the showing off
Don't bother trucking in fancy wines and paying a corkage fee for the cocktail hour. If you're a wine enthusiast, bring in the special bottles for dinner when a waiter can show off the bottle with a flourish. When they're just washing down hors d'oeuvres, most can't tell the difference between a $12 bottle and a $200 one.

Mix up the menu
Try to hit all the bases with your appetizer medley: beef, seafood, poultry, and vegetables. And mix it up—sushi, cheese puffs, short ribs—rather than trying to go with a theme here. Few would want to eat mini-pizzas and meatballs when the dinner to follow is Italian! Variety is key to an interesting menu.

Think mini-meals
Everyone offers some kind of hors d'oeuvres at the cocktail hour. Make yours special by pairing them together. Instead of a lone crab cake, offer one on a tiny plate speared with an asparagus stalk along with a dollop of risotto and serve it with a fork. Consider this option especially if you're extending the cocktail hour.

Dabble in multiple drinks
Think about putting small drink stations around the cocktail area in addition to your full bar. This keeps the lines at the bar short and lets guests have fun exploring the entire room.

Check the fine print
Because of union rules in certain cities, contracts will sometimes stipulate an extra, nonnegotiable charge for bartenders, food station chefs, and coat-check staff beyond your basic catering fee. The latter typically covers service staff, kitchen staff, a maître d' (if you have one), and the cleaning crew.

Be smart about sampling
Keep in mind that you probably won't have a chance to taste your appetizers ahead of time. Tiny treats are too labor intensive (and cost prohibitive) to be handed out for free at tastings. Bottom line: Use your dinner tasting to judge your caterer's talents, and if there are items you're iffy about—will the shrimp scampi be so garlicky you'll need to offer breath mints?—leave them off the menu.

Know if it's a raw deal
A sushi station is a crowd-pleaser, but because your caterer will almost always have to outsource it, you'll have to pony up to have one on-site.

Make your signature known
When it comes to your signature drink, ask for passed trays as well as a large offering on display at the bar with a sign that identifies it. Too often, guests don't even know there's a special drink unless it's spelled out for them.

Think portion control
Figure about six to eight hors d'oeuvres per person if a full meal is being served afterward and more like a dozen per person if you're throwing a cocktail reception.

Offer filling foods
Starchy foods, like pasta and potatoes, fill you up fast, but even in mass quantities, they're not that pricey. A station with a few different types of each will entertain *and* satisfy your guests.

Offer virgin cocktails, too
Nixing alcohol altogether might be ill advised, but a virgin signature drink can be just as appealing to many guests as a booze-filled one.

Gauging the bar
Even when the catering company is taking care of the bar, it's still important to have an idea of how much liquor you'll need. If you have a full open bar for one hundred guests, here's the breakdown:

- Beer: 5–6 cases
- Whiskey: 1 liter
- Bourbon: 1 liter
- Gin: 2–3 liters
- Scotch: 2 liters
- Light rum: 1 liter
- Vodka: 5 liters
- Tequila: 1 liter
- Champagne: 1–1½ cases
- Red wine: 2 cases
- White wine: 3½ cases
- Dry vermouth: 1 bottle
- Sweet vermouth: 1 bottle

Want even more ideas?
Go to
TheKnot.com/cocktailhour

Candleholders of varying sizes and finishes clustered around a pool create vignettes.

pink

This hue can be feminine or sophisticated, depending on the intensity and how you pair it.

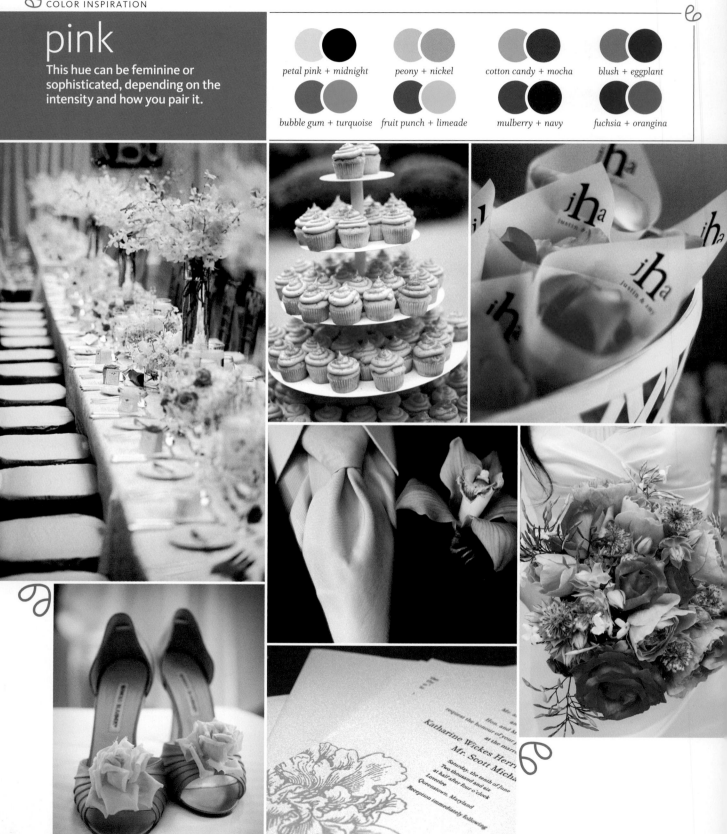

petal pink + midnight

peony + nickel

cotton candy + mocha

blush + eggplant

bubble gum + turquoise

fruit punch + limeade

mulberry + navy

fuchsia + orangina

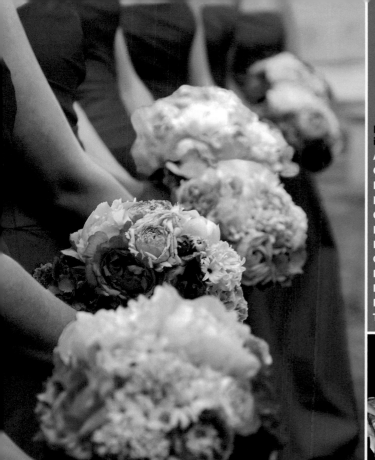

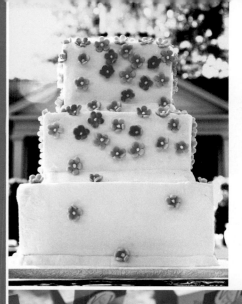

Flowers that come in pink

Anemones
Cosmos
Daffodils
Dahlias
Gerbera daisies
Lilacs
Lilies
Orchids
Peonies
Ranunculus
Roses
Tulips

petal pink
+
midnight

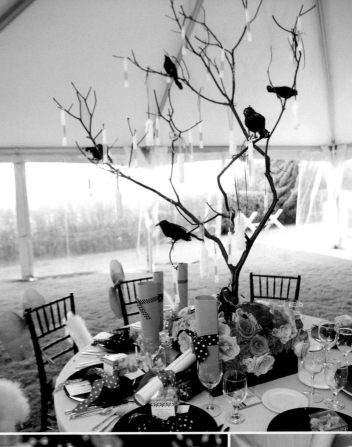

PLEASE KICK OFF YOUR SHOES!
women's sizes 8 – 9

Jaclyn + Dan

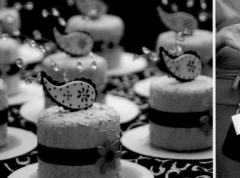

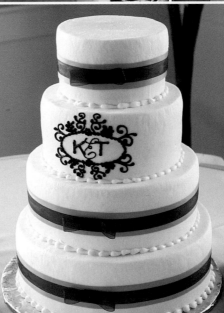

Adryana Jade Cortez
and
Patrick Anthony Courriclehe

SEPTEMBER 13, 2003

YAMASHIRO
HOLLYWOOD, CALIFORNIA

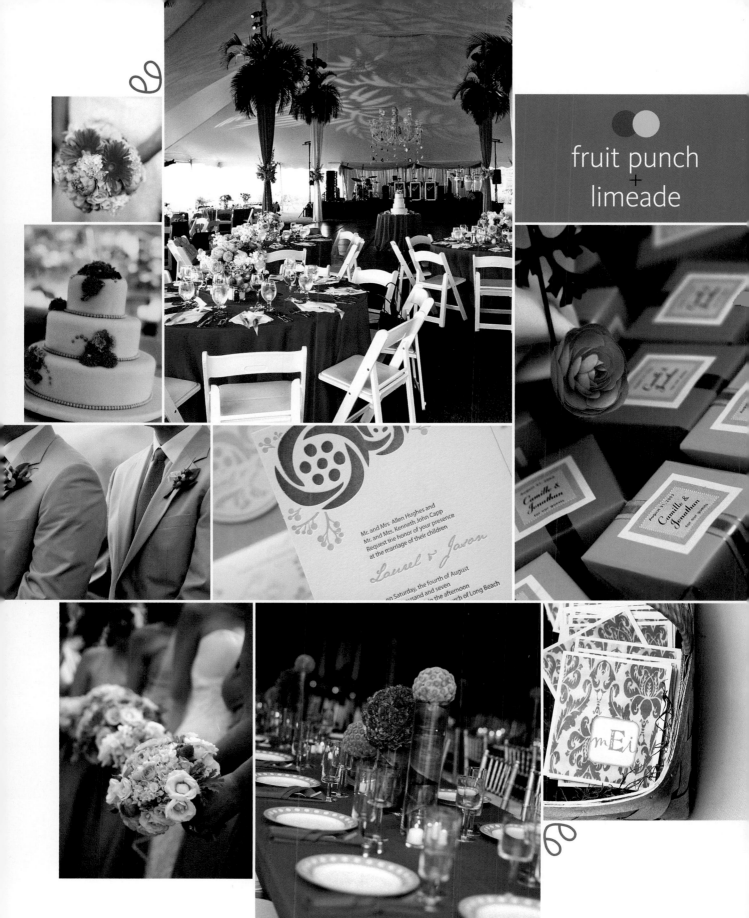

fruit punch
+
limeade

Mr. and Mrs. Allen Hughes and
Mr. and Mrs. Kenneth John Capp
Request the honor of your presence
at the marriage of their children

Laurel & Jason

on Saturday, the fourth of August
two thousand and seven
in the afternoon
...rch of Long Beach

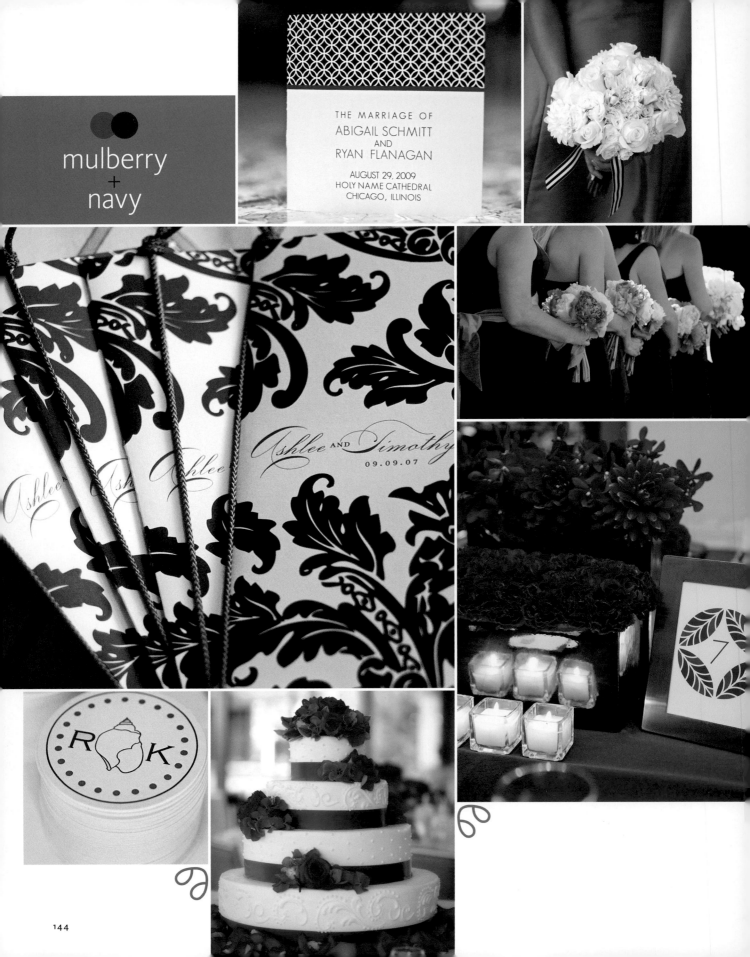

mulberry
+
navy

THE MARRIAGE OF
ABIGAIL SCHMITT
AND
RYAN FLANAGAN

AUGUST 29, 2009
HOLY NAME CATHEDRAL
CHICAGO, ILLINOIS

Ashlee AND *Timothy*
09.09.07

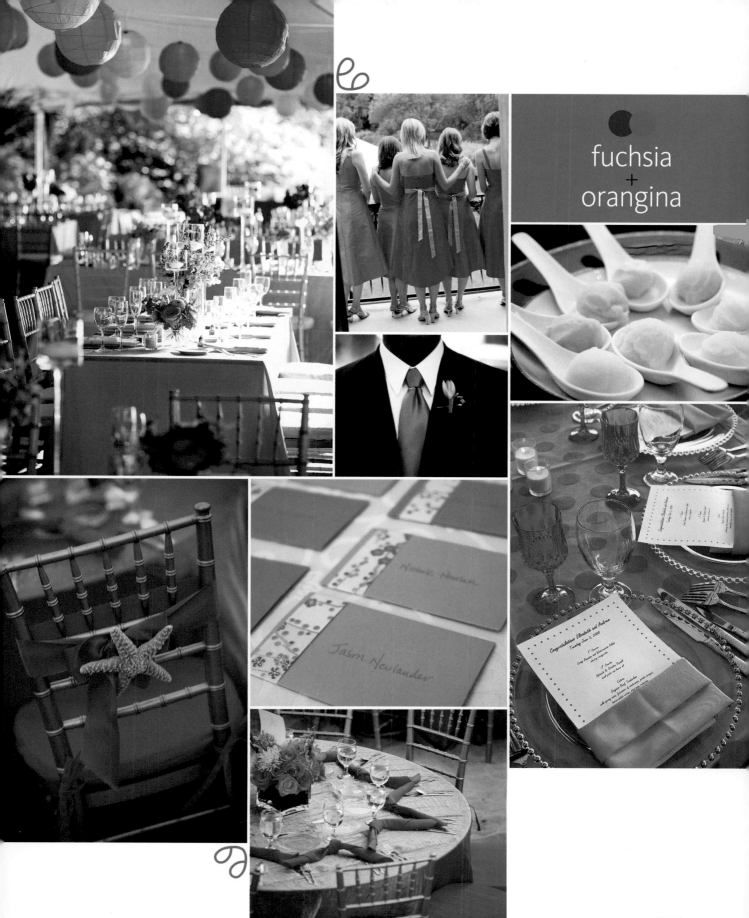

fuchsia
+
orangina

a cultural wedding

To honor their Chinese heritage, Tao and Jo started with traditional families-only tea ceremonies at the parents' homes, followed by a soiree for 180 guests at a chic restaurant. The space was outfitted with paper lanterns and more than 450 red origami cranes for the occasion. The bride wore a red *qipao*, escort cards were origami flowers, and guests took home cupcakes (served in lieu of wedding cake) in Chinese take-out containers.

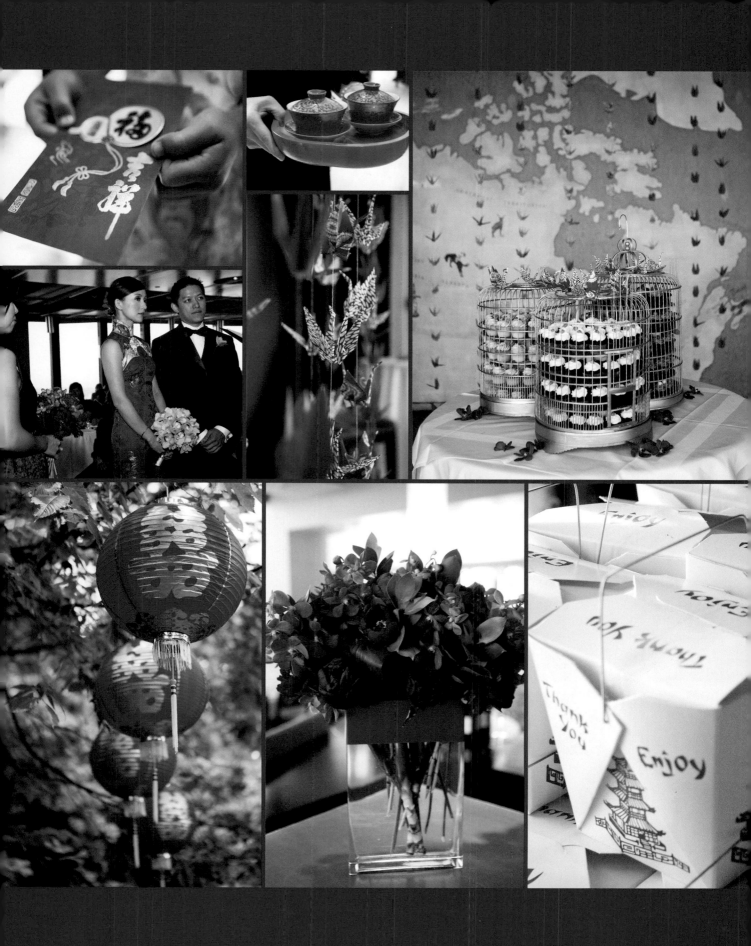

A grand setting, like this estate, doesn't need big, distracting decor. Instead, white linens, small centerpieces, and hanging lanterns dress up the site without overpowering it.

6

reception style

your countdown

9–12 months before:
Book your venue.

4–5 months before:
Reserve tables, chairs,
and/or any other rental
equipment, like lighting
and other decor elements.

1–2 weeks before:
Confirm all details with
the reception manager.

Even the tiniest details can get special treatment, like this simple white napkin accented with a sweet, dainty button mum and tied with brown satin ribbon.

Your choice of venue will drive your reception style. Select the type of venue that best exemplifies the look, feel, and spirit you envision for the party, and let specific decor ideas flow from there. Some spaces, like open lofts or even classic country-club ballrooms, are designed to be more of a blank slate and will require added decor, such as draping, lighting, and other details, to personalize the space; others, such as historic mansions and castles, exude a certain style through the architecture and permanent fixtures, like fireplaces, wall sconces, and chandeliers. These spaces generally drive your decor choices in a more channeled direction. Outdoor spaces, just by virtue of being out in the open, take their style cue from the environment.

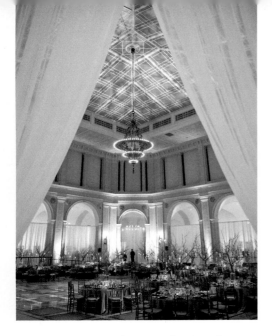

finding the inspiration

If you think that less is less and more is really more, you're a ballroom bride at heart and probably will like the look of a big, fancy hotel ballroom—they're glamorous, dramatic, and opulent. Create a look of abundance by keeping the color scheme monochromatic. Table linens, place settings, and tall centerpieces make the biggest impact because they're what guests will be looking directly at anytime they're seated or mingling.

A formal wedding at a unique historic mansion also calls for grandeur but with a bit of homey intimacy. When it comes to decor, candlelight is key. Hydrangeas or peonies will play up the old-fashioned romance of your setting, and elegant china that looks like treasured family heirlooms will echo the intimacy of the setting.

Lofts and galleries have lots of room and a sleek vibe, but not much decoration, meaning that you'll probably have to rent a lot of decor items to dress up such a space. You can go stark, with a black-and-white color scheme and lots of edgy, geometric details, like square plates and clear Lucite chairs. Bright, contrasting colors, like turquoise and orange, can also create a contemporary look, and they really pop against white walls.

Weddings in the great outdoors are rich with texture. The natural elements create a beautiful backdrop. If your event will take place in a garden, plenty of flowers, green plants, and maybe a stone fountain will already be within your surroundings.

designing your space

Not only does the style of your decor affect the feel of your fête, but your table and chair configuration does, too. For traditional seating, opt for the standard round shape, or look for square tables, which lend a more contemporary feel. Long banquet tables work well for family-style meals.

You'll also want your reception to have plenty of room for the fanfare and for guests to circulate as well as intimate spaces conducive to conversation. Since guests tend to crowd around the bar, you may want to set it away from the dance floor to encourage movement around the entire room. If your venue doesn't already provide sitting-room furniture, think about renting plush couches and armchairs to set aside for lounging.

a typical reception timeline

7:00 PM: Guests head from cocktail hour into reception.

7:15 PM: Emcee introduces wedding party, starting with your parents.

7:20 PM: First dance.

7:25 PM: A welcome speech or a blessing. If not either, begin toasts now—best man followed by maid of honor.

7:30 PM: Dinner.

8:00 PM: Music volume increases gradually to get people onto the dance floor.

8:30 PM: Father-daugher dance, followed by mother-son dance.

8:35 PM: A dance set with upbeat songs.

8:45 PM: A couple of slow songs play.

8:50 PM: More upbeat songs play.

9:30 PM: Cake cutting.

9:35 PM: Mid-paced music plays as cake is served.

9:45 PM: Guests seated for cake.

10:10 PM: Final dance set.

10:55 PM: Grand exit.

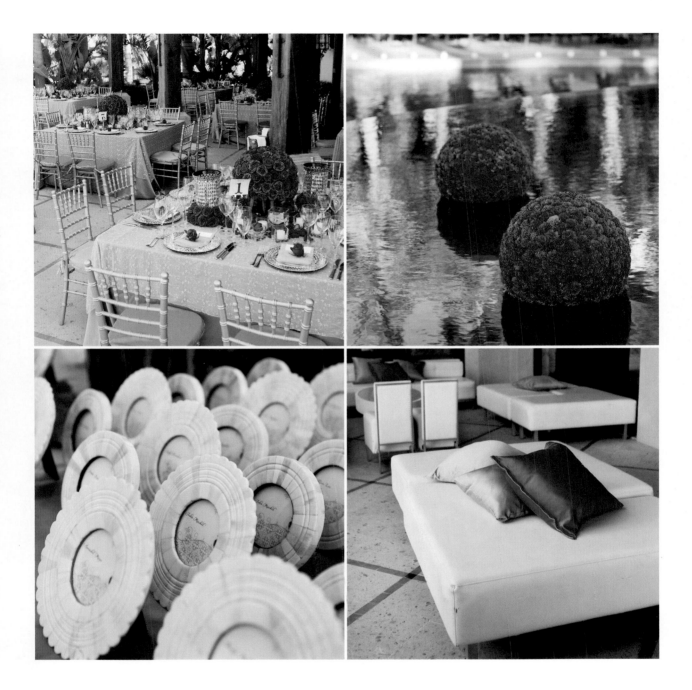

opposite Soft ivory and pink lighting creates an elegant glow in any ballroom.

top A strong color scheme, like fuchsia and metallic gray, keeps everything cohesive. The trick to working with any color combination is not to use both colors equally, as in these tables, where gray dominates and fuchsia accents. ■ Even a nearby pool can be used as a decor element.

bottom White picture-frame favors are neutral so they don't introduce a new color into the scheme. ■ The color scheme easily carries over to the lounge area with just a few silver and fuchsia pillows.

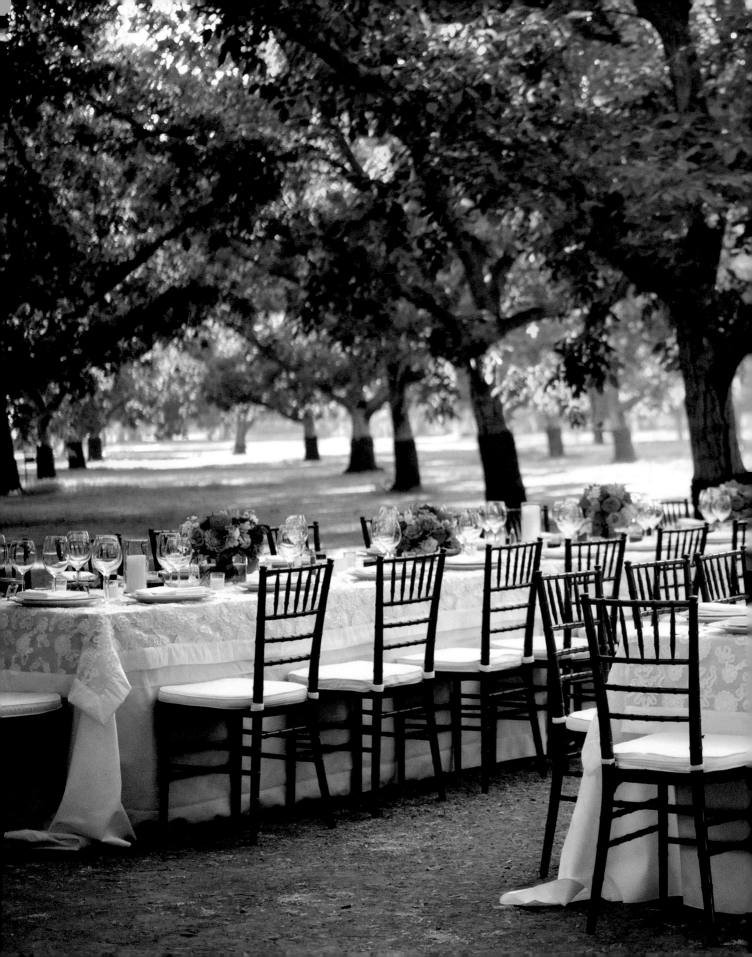

A reception in a park can feel formal and still suit the outdoor setting. Linens with intricate overlays up the elegance while wooden chiavari chairs and colorful centerpieces nod to nature.

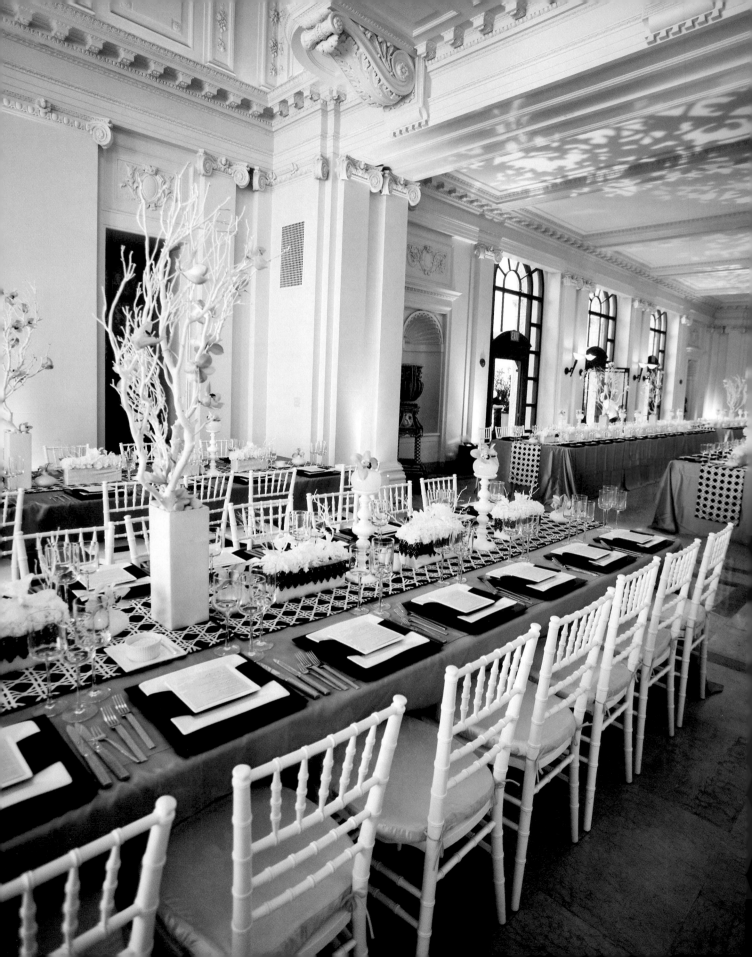

vintage meets modern

Though a historic space gives the sense of decades of dinner parties past, the decor can evoke a more recent era. The high-contrast black and yellow color combo modernizes the space while eclectic elements exude quirky French flea-market appeal.

opposite A new take on the idea of a tall, attention-grabbing centerpiece: Instead of being lush and opulent, the drama comes from the sparseness and the unique silhouette of each arrangement.

top Silhouettes of the bride and groom in rococo-esque frames signify that these seats are reserved. ▪ A golden calligraphed card with a pattern of white birds and branches identifies this table as the Pont Neuf table, named for a bridge in Paris to nod to the French theme.

middle Vintage-style picture frames make inventive displays for the escort cards.

bottom Simple yet elegant bud vases of cymbidium orchids line guests' tables and lead up to the main attraction: a tall centerpiece with several branches. ▪ A pomander of yellow button mums hangs in an unexpected place: a bronzed birdcage.

blushing ballroom

The epitome of grandeur and formality, a ballroom sets the scene for an elegant soiree, rich with lush flowers and gilded details. The addition of pink lighting casts a glow and gives the space a more contemporary look.

top A candy bar filled with sweet treats is appropriately all pink, white, and black. Guests are encouraged to fill take-out containers with goodies as favors to bring home.

middle Black is used as a contrasting hue in details like this RESERVED sign. ▪ Here's a stylish take on a traditional ice sculpture: A shrimp cocktail bar is made of ice and etched with the monogram motif.

bottom Plush couches and ottomans, a sleek, rectangular coffee table, and throw pillows with a stylish damask print set apart the more relaxed lounge area from the formal dinner tables.

A gobo spotlight can be used to project the bride and groom's initials on the wall—or anywhere—in the reception room.

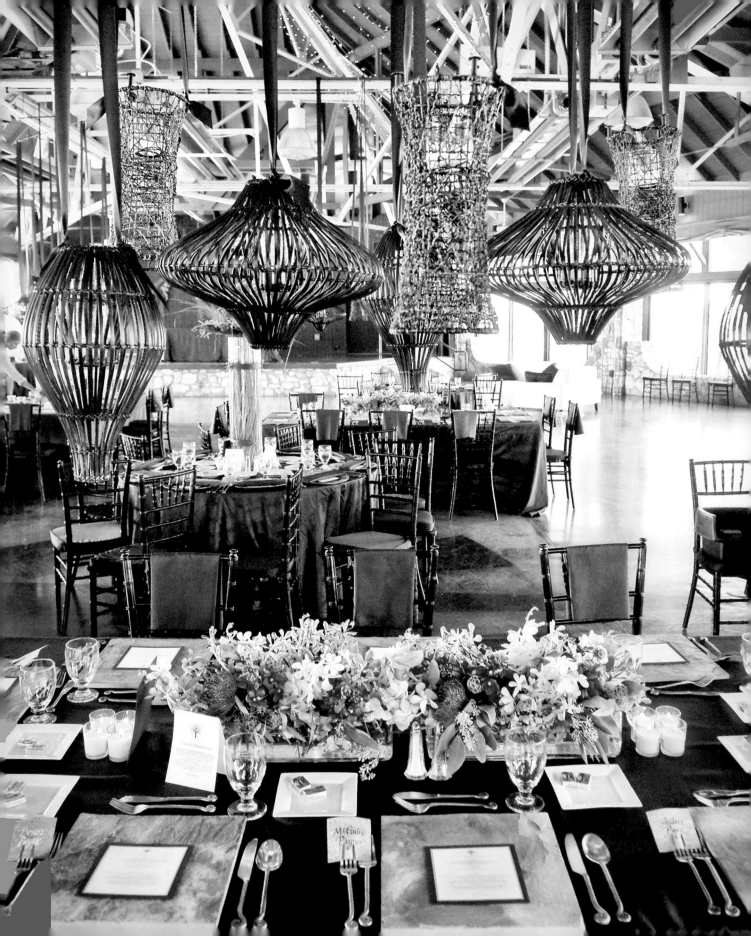

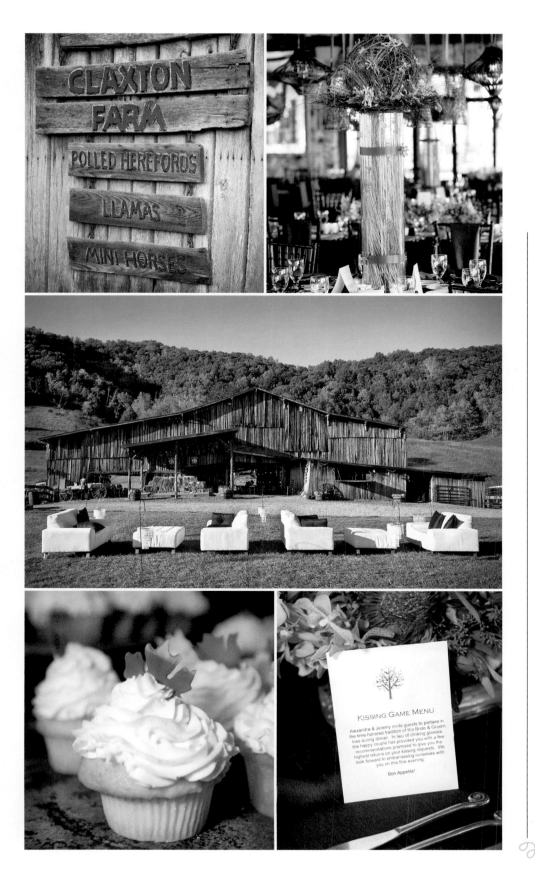

barnyard charm

Even the most down-home setting can feel luxurious with the right mix of elegance and earthiness.

opposite Hanging lanterns made of natural materials and harvest-toned flowers dress up the space without looking out of place.

top The farm's existing signs bring rustic charm to the wedding. ■ A centerpiece of vanda orchids and twigs in a tall glass cylinder creates drama that befits the rest of the environment.

middle The juxta-position of sleek white sofas in this rural setting ups the sophistication and the comfort level.

bottom The perfect nod to the fall season: cupcakes accented with colorful maple leaves. ■ A pretty, tree-adorned card explains how guests can get the bride and groom to kiss: by reciting a limerick.

Guests will find their vivid red escort cards on an all-white table accented with red orchids.

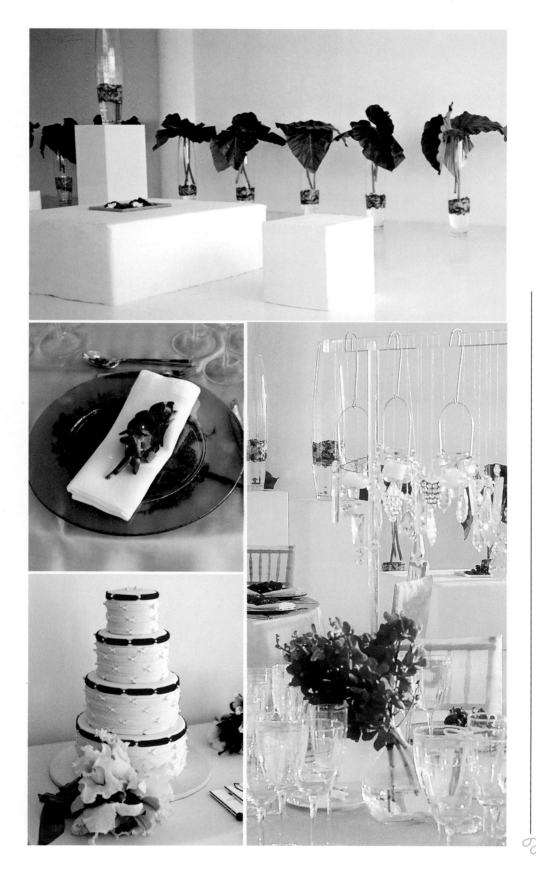

modern art

The simplicity of a loft creates a blank canvas for any wedding look, but it's especially ideal for sleek, contemporary fêtes.

clockwise

Oversized elephant ear leaves and floating flower petals in glass columns add interest along a blank wall near the lounge area. ▪ A glass structure with hanging votive candles is a unique twist on a reception centerpiece. Glass vases are filled with unfussy bouquets of crimson vanda orchids. ▪ Red ribbons wrap around each tier of the white cake. Its table is accented with the bridal bouquet of white orchids. ▪ Layering the place settings with textures and colors keeps the minimal room from feeling too sparse. Together, an orchid branch, a white napkin, and a colored glass charger create a rich effect.

by the vineyard

With French provincial style and a carefree, festive spirit, these details say "wedding," yet in an unusual and intriguing way. Guests are treated to tasteful details and a scenic view of the property's landscape.

top A chocolate-iced cake tempts guests and lends an earthy feel to the rustic setting. Fresh roses, the perfect feminine accent, render this cake fit for a wedding reception.

■ Floral centerpieces aren't the only table decor. Each table in the room is graced by chic table cards—this one named for one of the couple's favorite restaurants—"planted" in tiny flowerpots and tiny brown favor boxes tied with blue ribbon.

middle As guests enjoy cocktails, celebratory ribbons, hung from branches, blow in the breeze.

bottom Simple cards hanging from clothesline play up the carefree feeling of the outdoor event. ■ A VIP must be sitting here: A decorative vine and a simple white ribbon set this chair apart from the rest—no sign necessary.

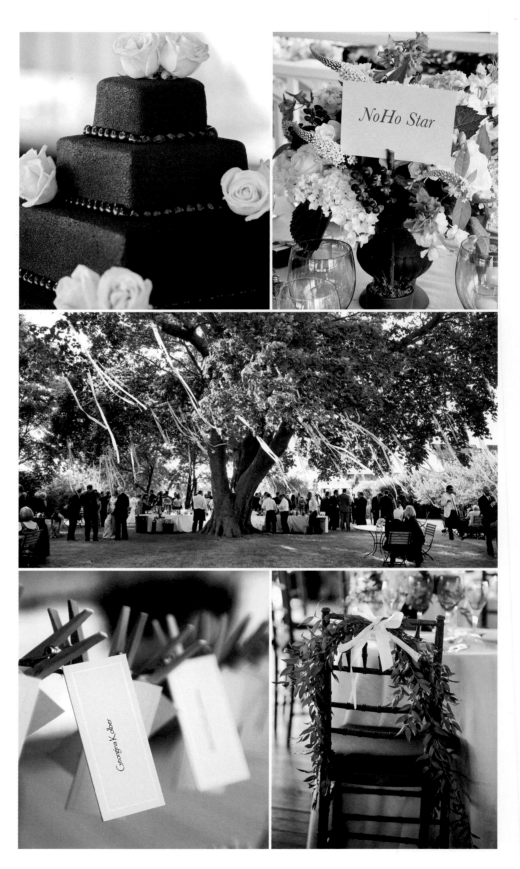

Textured centerpieces of roses, hydrangeas, delphiniums, and veronica in Tuscan-style vases top off elegantly set tables.

Asian paper lanterns and
long banquet-style tables
convert an ordinary patio,
making the space feel as
important as the day.

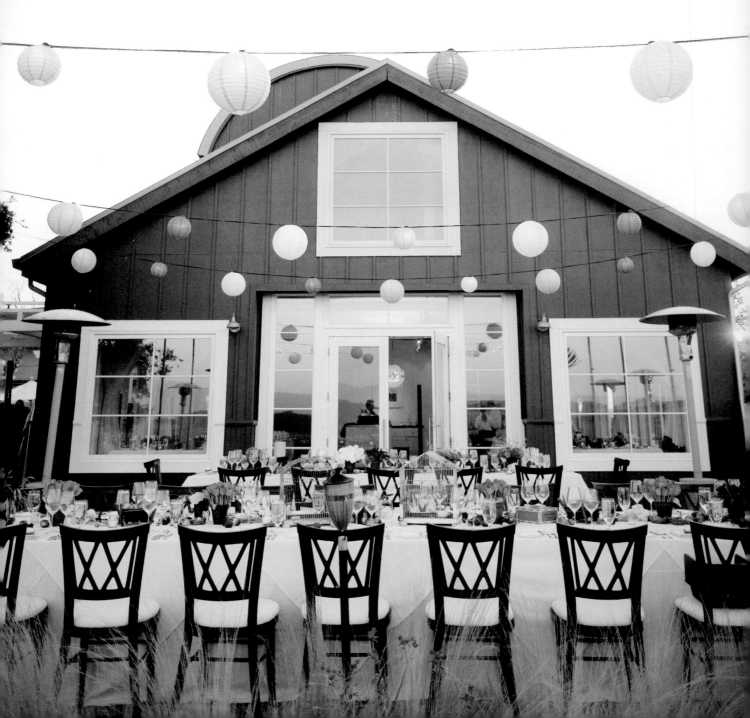

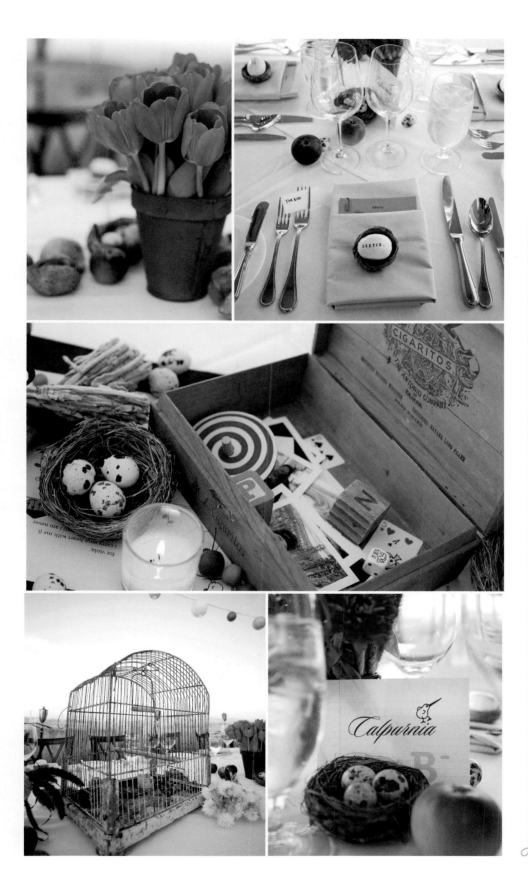

right at home

Celebrating in a personal setting means infusing meaningful details throughout the reception. Bright, jaunty hues, bird-inspired details, and fun-filled touches keep the vibe casually chic and seasonal, too.

top Vibrant tulips—symbols of spring—are displayed in a rustic terra-cotta pot, conjuring images of an at-home garden. ■ Even more homespun details for guests to take in: crab apples scattered about, an egg-shaped place card, and a pocket-fold napkin with a paper-clip-adorned menu card.

middle At guests' tables, a cigar box filled with vintage toys adds to the whimsical decor and entertains guests of all ages.

bottom An antique birdcage is a quaint place for guests to drop their greeting cards with wedding gifts inside. ■ Birds inspired the motif on the table cards as well as the charming table accents: nests holding ceramic eggs.

country time

If the weather allows, nature can offer the most beautiful decor, and vintage-chic details add an air of nostalgia for the perfect wedding reception accents.

clockwise A wooden crate makes an unexpected resting place for escort cards adorned with sheep and tree motifs perched on dried stalks of miniature bamboo. ■ A lounge area, set beneath a "roof" of branches and leaves, is lit with pretty lanterns for an escape from the action that is simply serene. ■ This chalkboard serves many functions—directing guests to the reception, calling attention to the guest-book area, and announcing the menu or signature drinks. One side describes the bride's favorite, and the other, the groom's. ■ In a rustic farm setting, jars of local preserves make excellent treats for guests to take home. ■ More crates! These contain elegant items: favor boxes tied with ribbons and arrangements brimming with roses, amaranthus, and berries.

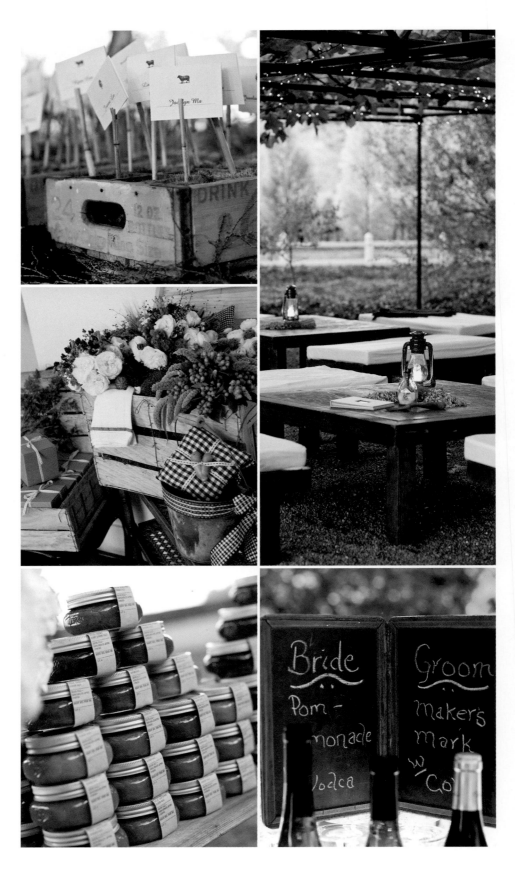

White tablecloths, simple chairs, low centerpieces, and hanging paper lanterns are subtly chic touches.

Mexican paper banners hang from this tent, immediately telegraphing the theme. Striped tablecloths echo the bold hues and reinforce the south-of-the-border feel.

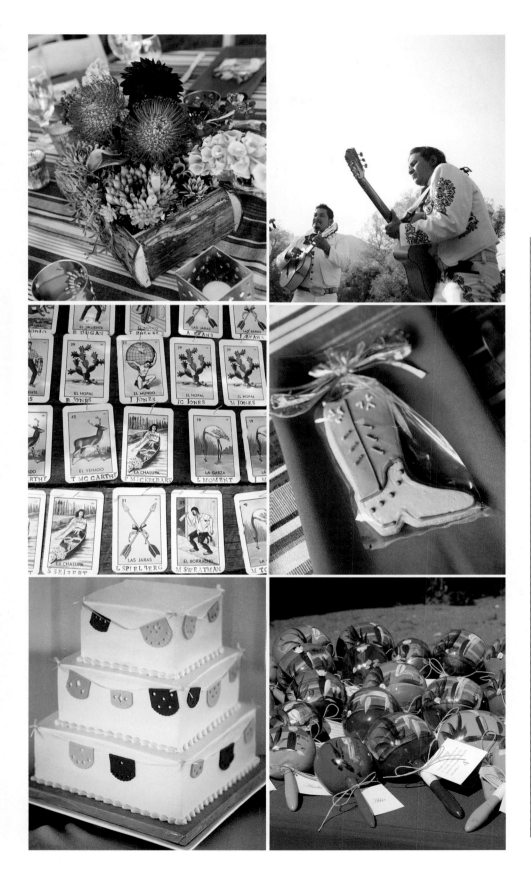

fabulous fiesta

When guests step into the reception area, they're ready for a party. Southwestern decor, bright colors, and mariachi music further encourage guests to let loose.

top Exotic-looking pincushion proteas are arranged in a wooden box, a nod to the hot southwestern climate. ■ In keeping with the cultural mood, a mariachi band entertains guests at the reception.

middle This creative couple made their escort cards with a deck from a Spanish card game. ■ Edible favors are always a hit, and they go over even bigger when they fit the theme as well as these cowboy-boot cookies do.

bottom Instead of flowers, fondant designs mimicking Mexican *papel picado* crafts add color to this cake. ■ Maracas make fun favors—and let guests shake things up.

❧transforming the space

Swathing your reception space in luxe fabric, bringing in special lighting, or adding unique accents adds panache.

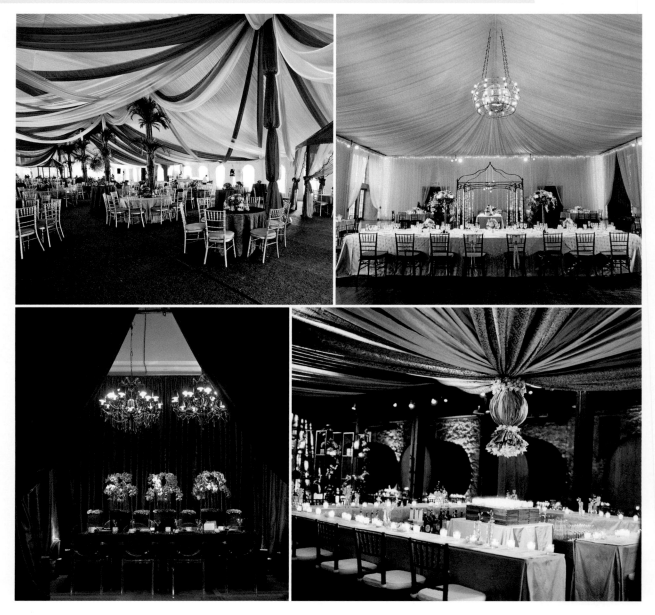

top Brightly colored fabric gives this festive tent exotic flair. The drapery is even echoed to highlight the head table. ▪ To make a big, empty space feel more intimate, just add drapery. Elegantly swathed fabric makes this venue cozy and sophisticated.

bottom Sheer fuchsia curtains make a spectacular display and create elegance and intimacy for a head table. ▪ Gathering this olive green fabric in the middle creates a unique and dramatic focal point in the room. Who needs a chandelier?

White drapes can be used to disguise colorful ballroom walls in order to keep the decor monochromatic and the ambience elegant.

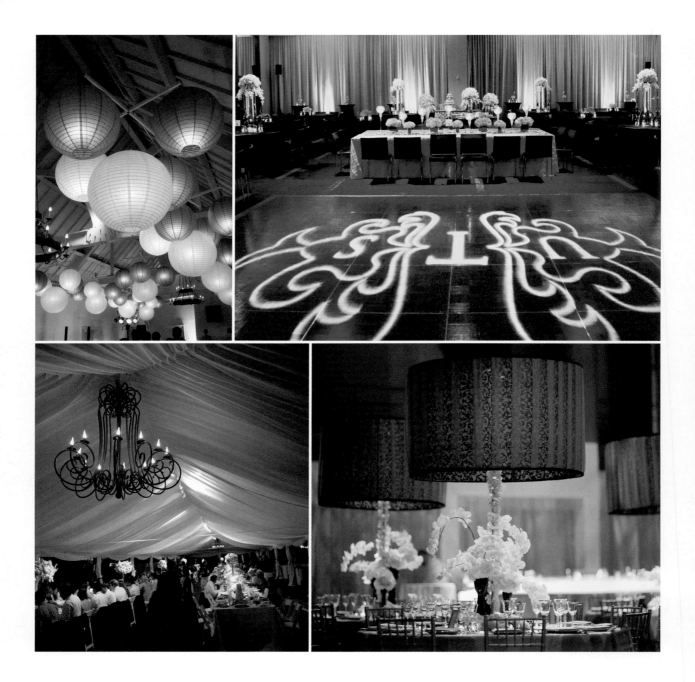

top Glowing Asian paper lanterns are appropriate for both casual and formal fêtes when they're way up high. They can increase the intimacy of either. ■ Here, a gobo spotlight is used to project the couple's monogram onto the dance floor for extra personalization.

bottom This outdoor tent feels homier adorned with a vintage-style wrought-iron chandelier. ■ Oversized shaded lamps make spectacular centerpieces. These fixtures add an element of grandeur, as well as a soft, appealing glow.

Candlelight is the original special effect and will always be a no-fail option. Here, votives hang from tall centerpieces and larger candles cast flattering illumination from tabletops.

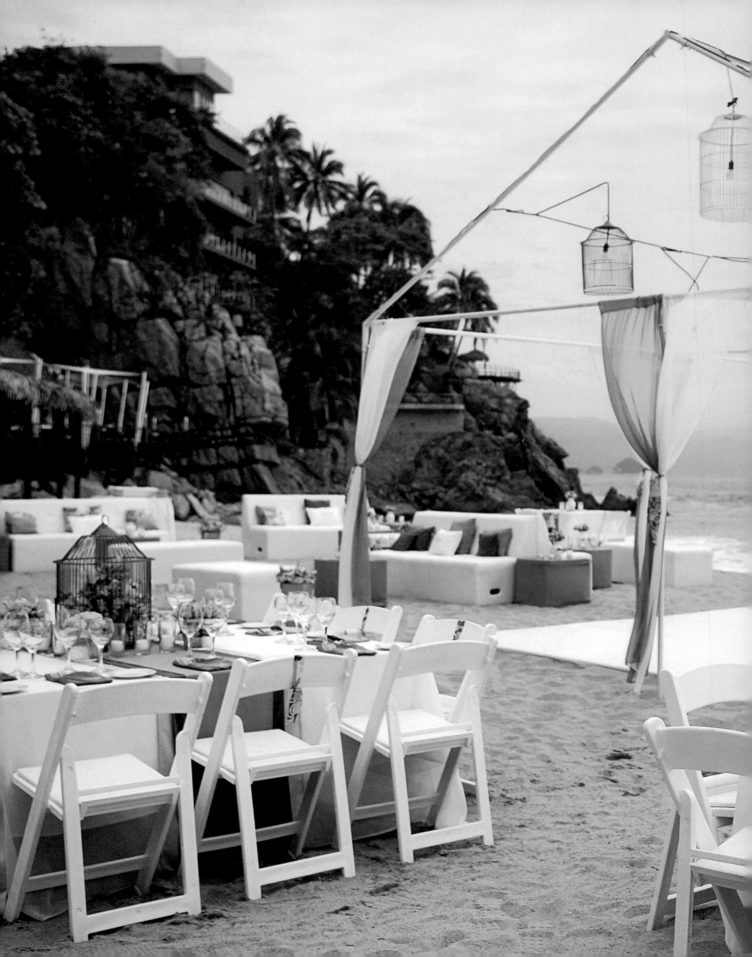

Oversized square tables and a sturdy dance floor transform a beach into a ballroom. Wire birdcages hold bright blooms for a modern spin on a vintage idea.

An eclectic table configuration adds interest to the room. Here, the bridal party's long banquet-style table is surrounded by round ones so all of the guests feel close to the VIPs.

the seating

The size, shape, and setup of the tables can maximize your space and encourage lots of mixing and mingling.

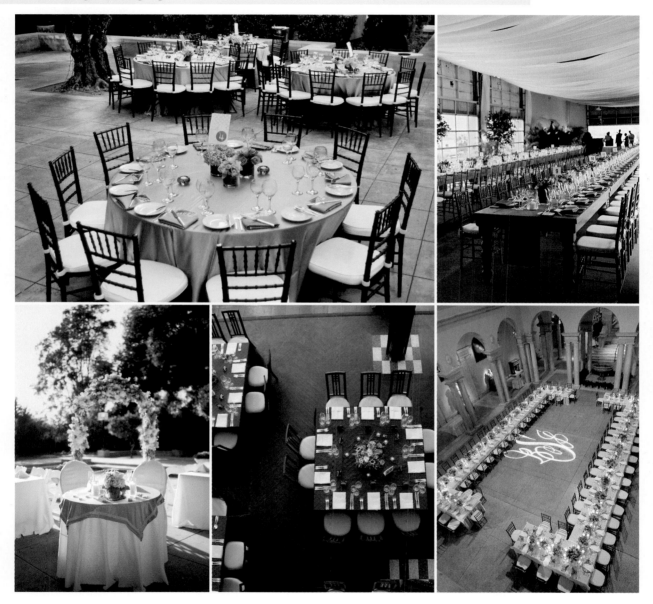

top Round tables are a classic choice. Everyone sitting here can easily partake in the conversation. ■ Long farmhouse tables are a fresh, communal approach. A simple table runner and low centerpieces make the most sense for this setup—tall arrangements and busy designs look fussy on tables this long.

bottom Setting up a two-seater sweetheart table for you and your groom, instead of the typical head table, is romantic and practical—it'll give you some guaranteed alone time! This one is framed by the floral arch used at the ceremony. ■ Square tables are contemporary and chic and give even a traditional room a funkier feel. ■ You'll find even more options when you configure rectangular tables in an L-shape. In this vast room, surrounding the dance floor with dinner tables literally puts it center stage.

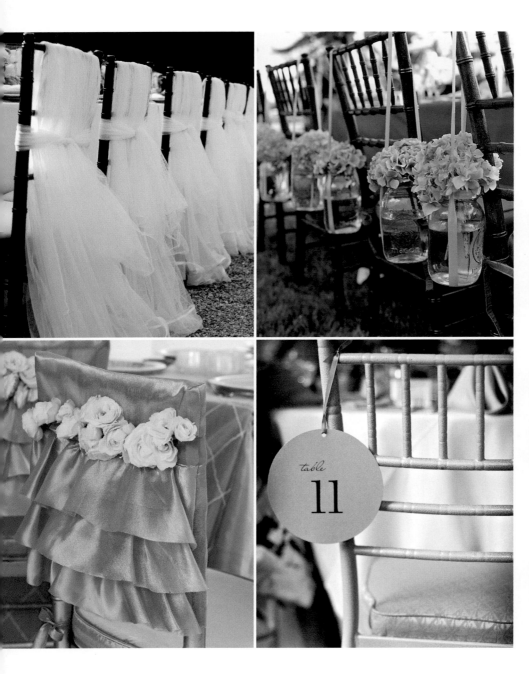

sweetheart tables

Even if all the other chairs are simple, it's still okay to play up the bride and groom's seats, as long as they fit the overall style of the wedding.

Large fabric flowers are an inexpensive and surprising alternative to fresh ones.

The couple's charming bamboo chairs feature pretty signs with their names, tied with ribbon for a semiformal look.

Initials made out of flowers coordinate with the garden setting and offer original accents for the newly married couple's seats.

top Tulle accents dress up black chiavari chairs. Tying the fabric tightly on chair backs and letting it billow in the breeze gives the classic bridal fabric an updated look and an ethereal quality. ▪ Tables aren't the only place to have fun. Jars of hydrangeas hanging from chairs dress up the seats in a big way.

bottom For chairs with feminine flair, tiers of satin ruffles are draped over a seat back and secured with a row of roses on a ribbon. ▪ Simply moving table cards from tabletops to chair backs makes a seating setup feel fresher—and it still guides guests to their assigned spots.

opposite Wrought-iron chairs with an intricate vintage design lend the feel of an elegant French patio.

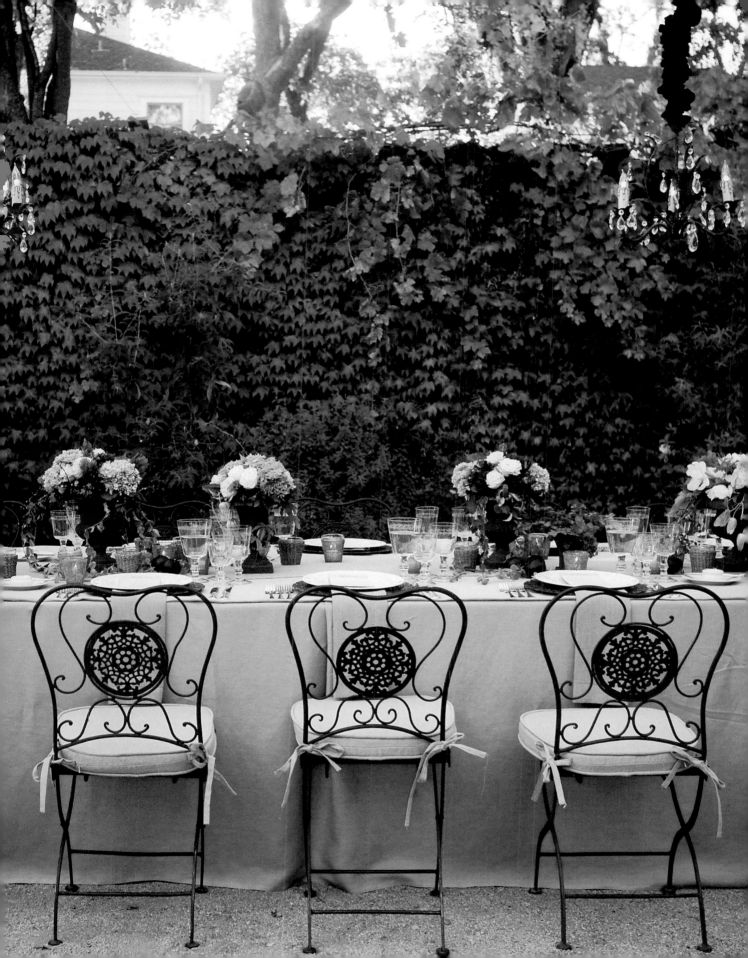

To complete the romantic pink and white look, delicate lace peeps out from beneath plates and covers chair backs.

❧ setting the table

Tablecloths, napkins, dishes, and other details work together to make each place setting a treat to see when guests find their seats.

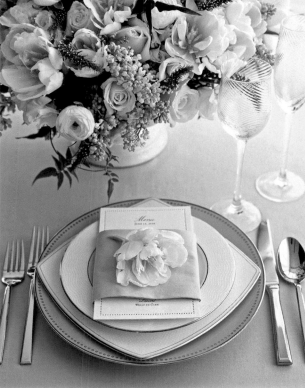

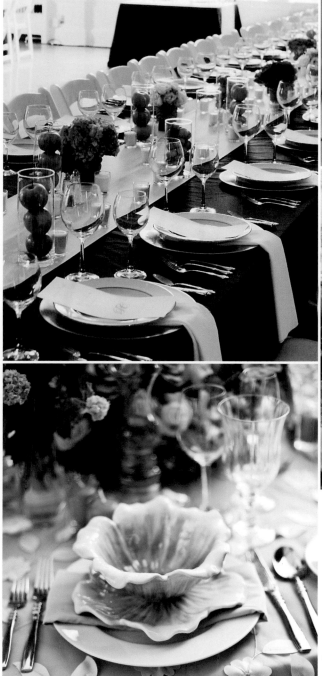

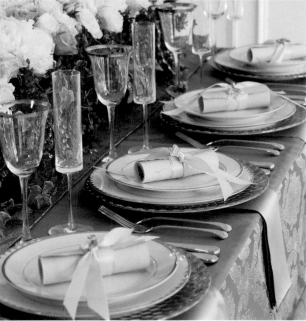

clockwise Gold chargers top purple tablecloths, and gold-rimmed plates, unfolded and draped napkins, and menu cards offer refined accents. ■ A classic place setting gets a twist when a modified square plate is added to the mix. The finishing touch: a feminine white parrot tulip. ■ Metallics lend an air of luxury. A touch of gold rims the glasses and plates, graces the flatware, and crops up subtly in the tablecloth's pattern. ■ Verdant botanicals inspired this place setting.

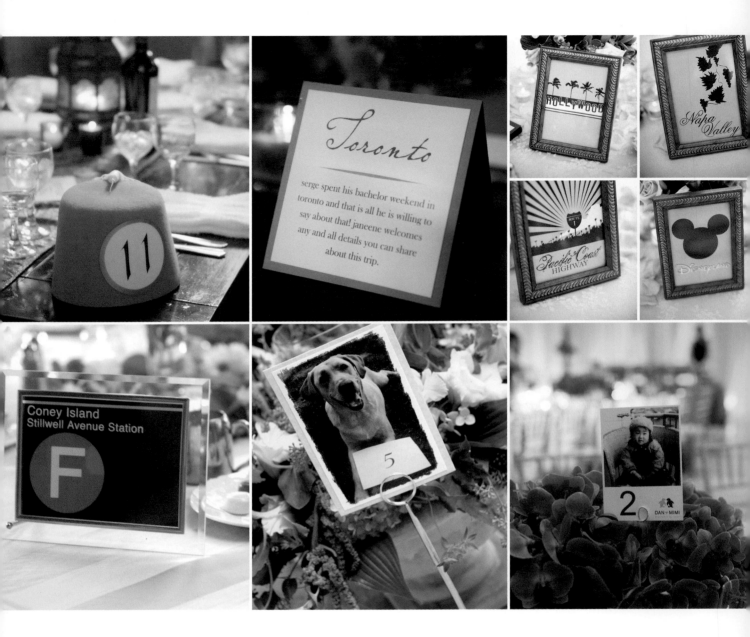

top An orange fez denotes table 11—a creative idea for a Moroccan event. ■ Table markers can literally tell a story. Each table here marks a place and an event in the couple's history. ■ Slipping funky tone-on-tone prints into more classic frames is a fun way to carry out a destination theme; in this case, the prints represent areas of California where the bride and groom have visited.

bottom Even ordinary symbols can take on new meaning. A couple marrying in New York City dubs their tables after the subway stops near their favorite spots. ■ A pet-lover's pick: Table markers with photographs of the family dog in playful poses strike a fun, personal chord. ■ Tucked into an orchid centerpiece, a photo of the bride as a child encourages a trip down memory lane. Thanks to the simple design—and clever illustration in the corner—the idea of the baby picture as a table marker takes on a new level of cool.

The Septima table is named for one of the couple's favorite brands of wine. Green script matches the centerpieces, and a clever cork stand plays up the wine theme.

Septima

Presentation can be an art form. Spinach and endive salad, topped with goat cheese and dried cranberries, is given an unexpected finishing touch: a pyramid made of breadsticks.

the menu

Of course, the meal is meant to be delicious, but it can also add a dose of flair to your decor. Even the choices of food or the way they're served should be stylish.

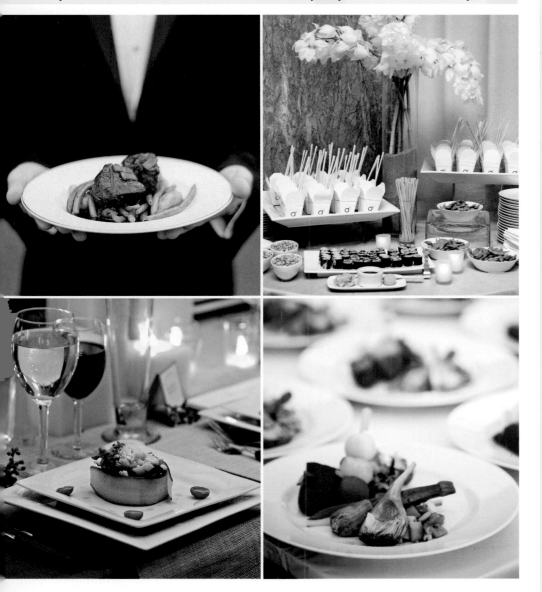

top Guests feel pampered when tuxedo-clad servers bring the entrees to them. ■ Guests can help themselves at an Asian-themed station where sushi, edamame, and other treats are served. Chinese take-out containers prefilled with rice add quirky flair to the spread.

bottom A good caterer can come up with creative food presentations, like this modern-looking fare. The layered square plates make it ultracontemporary. ■ Vegetarian meals are anything but boring. Vibrant, multicolored menu selections add to the enjoyment of all guests—not just the vegetarians!

food-service glossary

Plated: All courses arrive on plates at guests' seats. It works for semiformal and formal events.

French: Servers bring out the food on silver platters and serve guests individually. The servers control how the food is presented and how much guests get. It's best for more formal weddings.

Russian: Servers bring the food to tables on silver platters, but guests serve themselves and control their portion sizes.

Family-style: All courses arrive on platters and are placed in the middle of the table. Guests pass the platters around and serve themselves, so it's best for casual and semiformal dinners.

Buffet: Guests serve themselves. For casual celebrations, buffets make sense.

Stations: Guests pick up food from spots around the room. Also called a cocktail-grazing buffet, this can be a cocktail hour for a formal wedding or the main event at a semiformal affair.

cake displays

Canopies, lighting, linens, and ornate pedestal displays can be employed to give a special cake the VIP treatment.

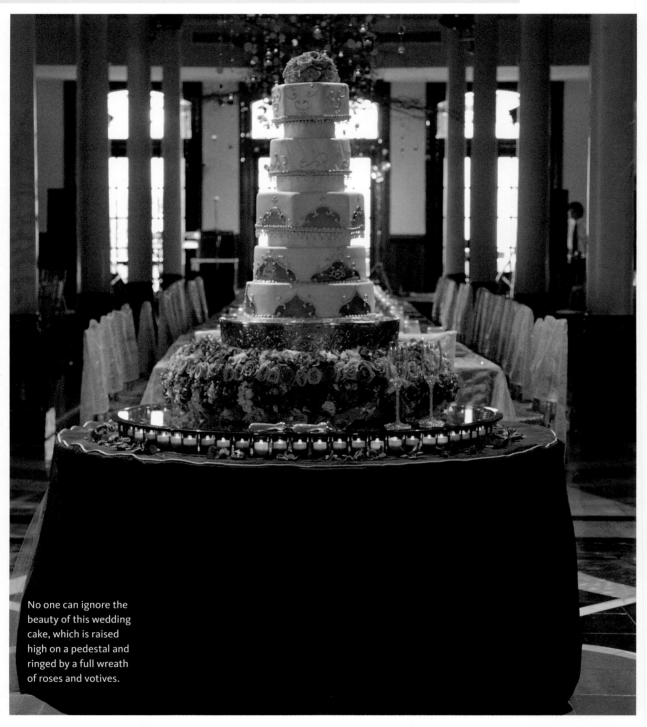

No one can ignore the beauty of this wedding cake, which is raised high on a pedestal and ringed by a full wreath of roses and votives.

A cascading canopy is embellished with daisy accents, echoing the blooms on the cake. The lavish look and its center-stage placement make the confection the focal point of the reception.

This secluded spot features uniquely shaped furniture, soft pillows, and ambient lighting, giving it an air of mystery and intrigue.

lounges

It's not just about bringing in comfy sofas and ottomans for guests to rest their feet and mingle. The lounge is another way to create a sense of fantasy.

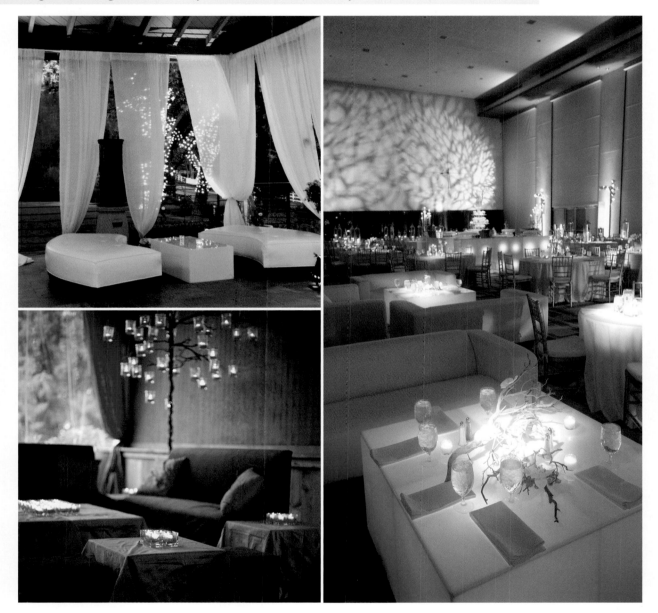

clockwise Sheer curtains billow with the evening breezes, making this lounge area feel sexy and atmospheric. ▪ This lounge area is set right in the middle of the reception space, which could make it the hub of activity after dinner. ▪ A rustic corner is given plenty of glowing candlelight, courtesy of the "tree" of votives and clusters of tabletop candles.

Amaze with color
Obviously, choosing a color palette for your day is a standard practice, but pay attention to the unexpected places where you can infuse your hues. Add dashes of brilliance not only in the flowers and linens but maybe in the guest book, the candlesticks, the handle of the cake knife, or the cocktails, too.

Light it right
When hosting an evening affair, lighting goes a long way to set the mood. You can hire a lighting designer to highlight different areas of the room or to provide special effects, like an overall tint (amber creates a warm, inviting glow) and a cleverly shaped spotlight effect for the dance floor (your new monogram, perhaps). You can

also DIY: Strategically place candles, hang lit Chinese paper lanterns, or line a walkway with luminaria—paper bags weighted with sand and filled with votives.

Honor your love story
Draw on meaningful moments you and your husband-to-be have shared. Forgo the table number system and name them after your all-time favorite movies, mountains you've climbed together, neighborhoods in which you've lived, or some other meaningful connection you share. Take the idea up a notch by adding photos from those moments.

Assign seats
Unless you're having a very small event with a buffet meal, you'll want to make sure everyone's assigned to a

specific table. People like to be given direction in a large room. They also feel more comfortable if it's a place that you've thoughtfully chosen: a table with other college friends for your former sorority sister or a table away from the loud DJ speakers for your elderly aunt, for example. It's especially helpful if you're serving several different entree choices; the caterer and waitstaff will want to know beforehand exactly how many chicken, filet, or veggie dishes a given table gets. Visit TheKnot.com to create your own virtual seating chart.

Get organized
Deciding who sits where can be tricky. Insert a column into your guest list spreadsheet categorizing all the invitees by relationship: bride's friend; bride's family; groom's friend; groom's family; bride's family friend; groom's family friend. This way, you'll be able to easily sort the list by category. Then use the categories as a guide to logically break the list into distinct tables.

Be considerate
Traditionally, your parents and your sweetie's parents sit at the same table, along with grandparents, siblings not in the wedding party, and the officiant and his or her spouse if they attend the reception. But the parent-seating situation is a flexible one. If your or his parents are divorced and are uncomfortable about sitting next to each other, you might want to let each set of parents host their own table of close family and/or friends.

Questions to ask your site coordinator

1. Can I check out the place during another wedding?
Getting a feel for the space with a bar, tables, and maybe even a crowd can give you the best idea of how your own party will fit.

2. Will there be another wedding or event held here on my wedding day?
If another reception is taking place at your site, ask what steps the staff takes to keep the parties separate.

3. What restrictions do you have?
Some sites restrict practices like throwing rice or confetti or bringing in outside beverages or rental items.

4. What is and is not included in my package?
Ask about extra items that could mean add-on costs, such as a corkage fee. Also, ask to eliminate features in your package that you don't want. If they can be taken off the list, ask for a discounted price.

5. What other vendors do you recommend?
Your site probably works closely with certain cake bakers, rental companies, photographers, and wedding planners. If they recommend a vendor, it means the vendor already knows the lay of the land and has a good working relationship with your site manager.

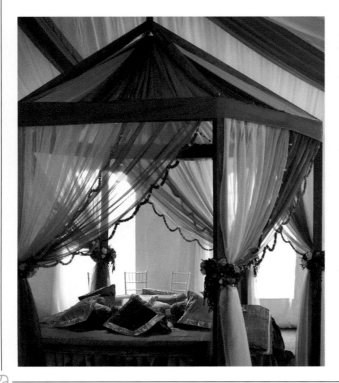

A vivid color scheme makes a big impact if it's everywhere guests look. Here, even the chair backs are woven with fuchsia fabric to match the napkins and flower arrangements. Paper lanterns and tablecloths coordinate with pops of orange.

orange

This fruity hue sets a laid-back, festive vibe. It's best used to create a look that's upbeat and full of fun.

cantaloupe + stem green

apricot + butter yellow

tangelo + watermelon

mandarin + cobalt

sweet potato + cocoa

pumpkin + baby pink

persimmon + violet

burnt orange + sky blue

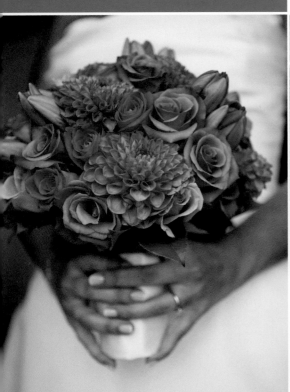

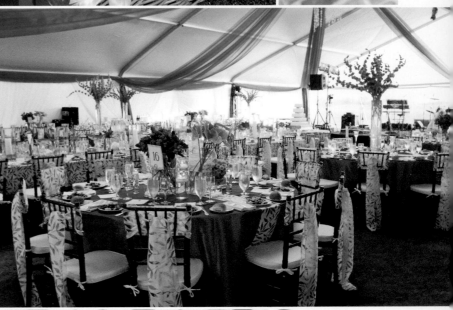

Flowers that come in orange
Calla lilies
Daffodils
Gerbera daisies
Mokara orchids
Nerine lilies
Parrot tulips
Poppies
Ranunculus
Roses
Tulips

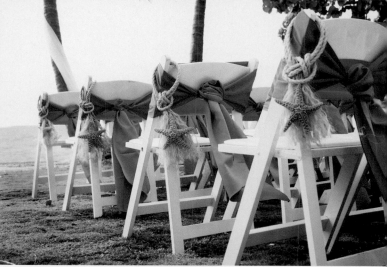

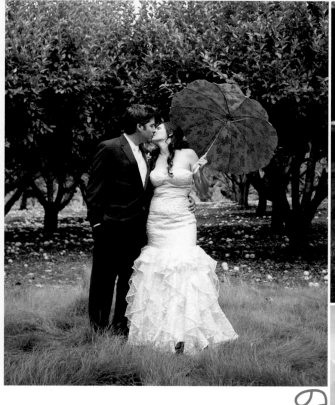

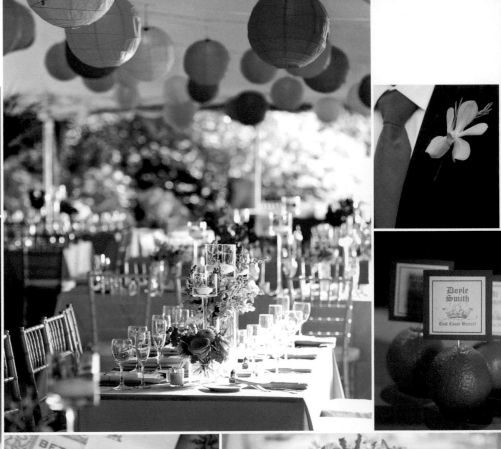

tangelo
+
watermelon

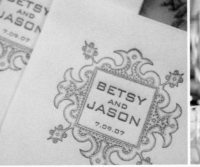

BETSY
AND
JASON
7.09.07

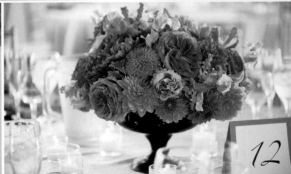

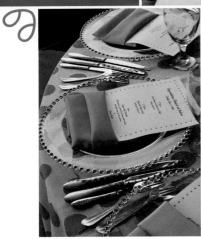

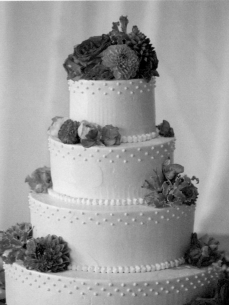

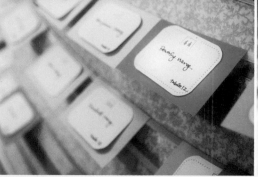

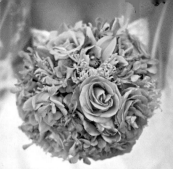

KDS

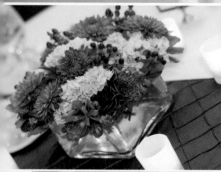

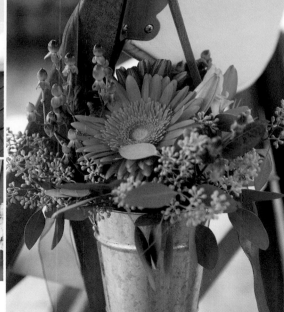

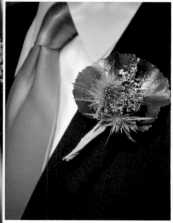

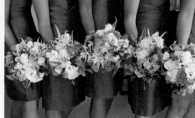

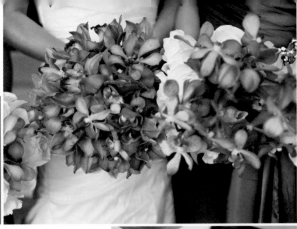

mandarin
+ cobalt

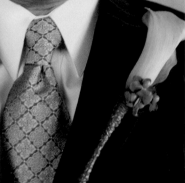

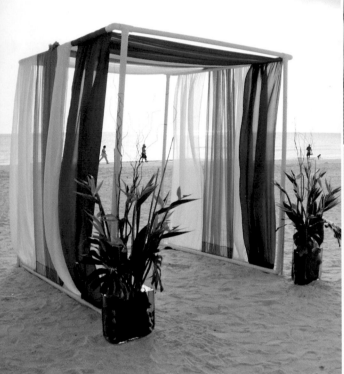

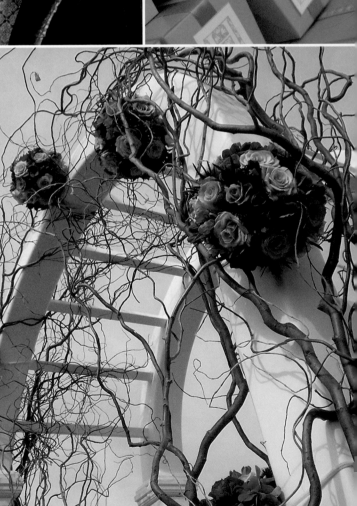

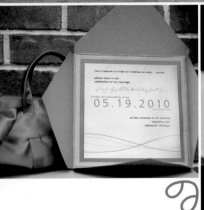

05.19.2010

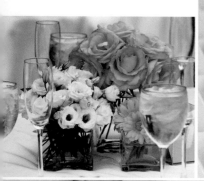

apricot
+
butter yellow

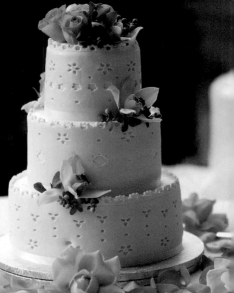

ASHLEY + PATRICK

a winter wedding

Ashley loves aqua and Patrick has been flying planes since he was 15 so their colors and theme easily fell into place. The couple knew they wanted a destination wedding but opted for a snowy locale instead of the typical beach scene. They created a warm affair with natural elements (pine cones and berries), twinkling lights, and even a hot chocolate bar.

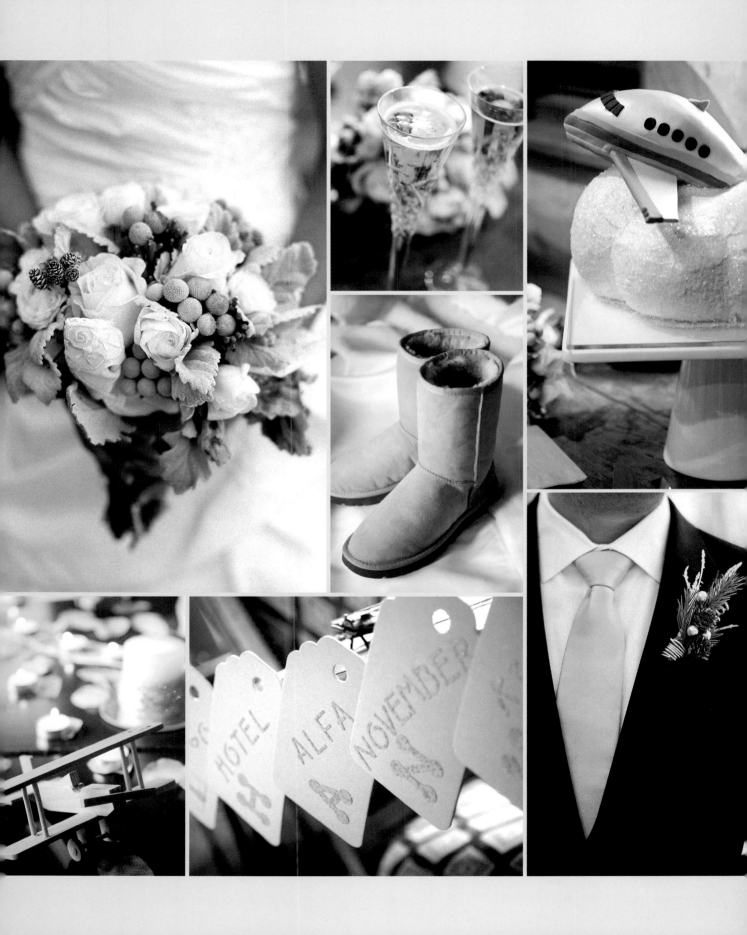

A modern take on more traditional table-lamp-style centerpieces are these tall Lucite candelabra with sleek white shades. A row of several lined up on a long rectangular table creates an even greater impact.

opposite Vintage-looking milk glass vases can be mixed and matched. The best part: They look great holding any assortment of flowers.

7

the centerpieces

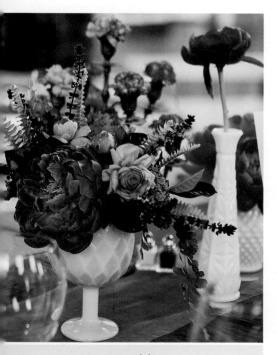

get inspired by

- The details of your venue, like the wallpaper pattern or chandelier shapes
- A favorite still-life painting: That fruit bowl can lead to something extraordinary!
- The centerpieces at your parents' or grandparents' wedding

Your centerpieces are the single most important design element in your reception space: More than any other detail, they create the wow factor when guests walk into the room and then serve as the eye-level interest once everyone takes their seats. And it's about not just the types and colors of the flowers they feature, but their shape, whether geometric or more organic, and their size—high, low, or a combination of the two. Want to give your flowers some extra pop? Nonfloral elements, such as candles, crystals, or Christmas tree ornaments, when set around the centerpieces, provide a nice contrast against the blooms' soft petals. Or you could skip the flowers completely and top your tables with rustic lanterns, vintage lamps, or an edible display of little desserts.

decide on the scale

Your centerpieces should match the scale of the venue. Tall arrangements can work as long as you use vessels that allow room for guests to converse beneath them. Generally, the taller the ceilings, the taller your centerpieces should be. Tall centerpieces usually have a lot more flowers than what's included in bouquets—a small grouping will look inadequate on top of a tall vase. In a small space with low ceilings, your centerpieces can have some height, but full, lofty arrangements can be claustrophobic.

Another element to factor in? The size and shape of your tables. For large, round ones, three to five bubble vases each containing a single kind of flower will fill out the table nicely. Blooms with distinctly different shapes, like roses and calla lilies or tulips and peonies, make the biggest impact. Low centerpieces can be the way to go on long banquet tables, allowing guests more ease in conversing than wide, round centerpieces would. Because there's a certain visual rhythm created by the rows of arrangements, it's advisable to break things up by alternating the designs.

For good reason, many brides like the look of having both low and tall centerpieces at their reception. If all are tall or all are low, the centerpieces can look stuffy or predictable; combining them breaks up the uniformity and relaxes the mood. A mixture of centerpieces also adds texture to a room, which is especially important in plainer spaces, and variety can encourage guests to walk around and mingle while checking out the other arrangements. The shorter arrangements can be identical to one another or slightly different, but they all need to relate to the tall centerpiece, whether by a shared color or type of flower.

take a cue from the venue

First, decide what your goal is: Do you want the arrangements to highlight your space or transform it? At a historic estate filled with old-fashioned details, the former makes sense. Perhaps you love the gilded columns in the centuries-old castle where your wedding is being held. Then don't hesitate to maintain that look with your centerpieces. Tall, richly hued floral arrangements with golden baubles mixed in will play off the columns' color and old-world charm. Similarly, in the dining space at a modern-art museum, a single branch of phalaenopsis orchids growing out of a simple pot placed on each table sets the right tone.

On the other hand, if your venue is a blank slate, like a loft, your centerpieces are crucial for filling out the space. The good news is that you have more room to play here. Structured, white centerpieces with just one or two kinds of blooms will play off the clean lines of the space and the brightness of the white walls. While towering, colorful centerpieces will make the venue look festive and tropical.

centerpiece-shape glossary

Breakaway: This consists of a few short or medium-height arrangements each containing different flowers grouped together to make a single centerpiece.

Globe: Flowers are tightly packed into a sphere.

Pedestal: The word describes the vessel (an urnlike vase set on top of a platform) but also implies the arrangement it often holds: massive and overflowing with blooms, often ones that trail down the sides of the vase.

Trumpet: Flowers are arranged somewhere between a perfect circle and a cone, with a slightly narrower top, typically contained in a tall, skinny vase.

Candelabra: Taper candles, usually four to six of them, extend beyond the flowers in this taller arrangement.

Tiered: This refers to any taller centerpiece, like a pedestal, trumpet, or candelabra, with an additional layer of flowers encircling the base.

The lampshade shape coupled with the sheer height of this arrangement makes it a showstopper, but the leilike strands of orchids lend it a welcoming, tropical feel.

think beyond flowers

Centerpieces aren't limited to flowers. Candles have long been a part of this decor element, whether as tea lights surrounding a vase or as tapers emerging from blooms in a candelabra arrangement. To be a bit more daring, downplay the flowers and play up the sources of illumination from lamps to lanterns. Rent collections of antique vases for a vintage look.

Don't be afraid to move the centerpieces from the center of the table—in fact, they don't have to sit on a table at all. Suspending them chandelier-style from the ceiling makes a dramatic impression and frees up table space. Dangling them at different heights over the tables has a similar softening effect to a mix of tall and low centerpieces.

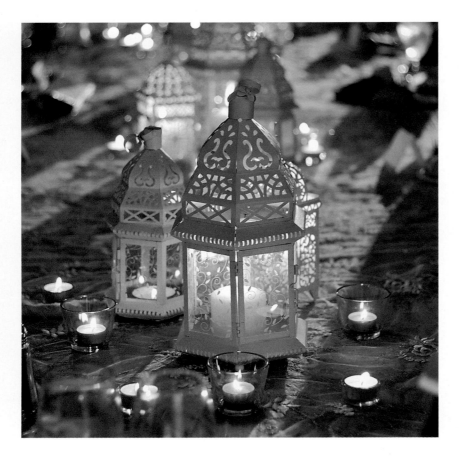

above There's not a single flower in sight, but it doesn't matter. Elaborate detailing in these punched tin lanterns provides the sort of visual interest delicate blooms would, but more fetchingly.

opposite Just a few white flowers bloom from these branches, but the tables are far from boring. Dense groupings of tulips and hydrangeas sit below candles hanging from the branches. The neutral flower colors let the cobalt-hued glasses shine.

vase glossary

 Bubble: A popular choice for casual receptions, this vase has a spherical shape. A line of them along a rectangular banquet table can look lovely, no matter the formality.

Cube: This modern shape can hold its own in the middle of a table, but a few small ones around a tall, slim vase are ultrachic.

Pilsner: Named for the narrow-bottomed, wide-mouthed beer glass it resembles, this vase usually holds flowers loosely packed in a round shape.

 Pedestal: Midway between tall and short, this vase features a shape similar to a trophy's. It looks great with flowers and greenery dripping down its sides.

 Cylinder: The tube-like shape is ideal for showing off submerged blooms.

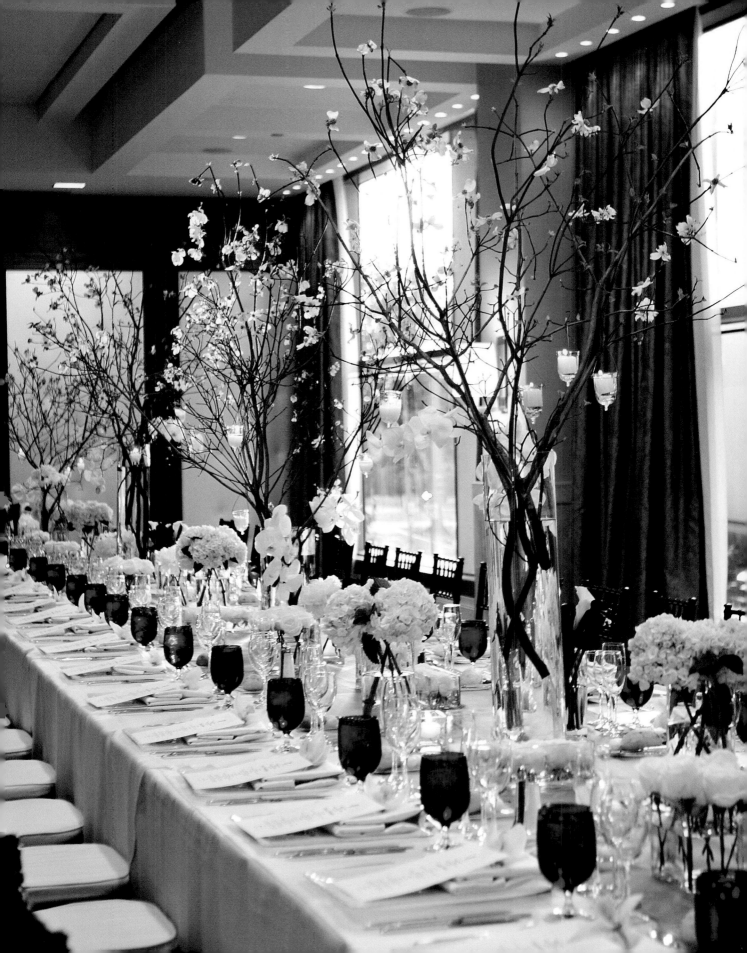

Various flowers in shades of pink, white, and green add a soft, girly touch to an otherwise masculine brown tablecloth.

sweet + low centerpieces

Whether your venue has low ceilings or you just want to keep it simple, short centerpieces, standing alone or in groups, can be all the embellishment tables need.

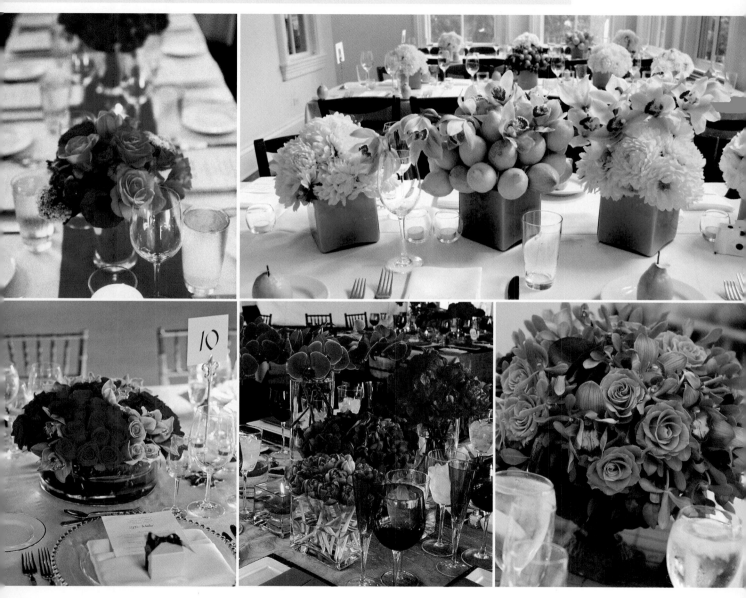

top Simple vases and glassware allow the flowers—anemones, roses, ranunculus, and hydrangeas—to take center stage along a rectangular table. The bright orange runner adds to the bold contrast. ■ For a different beat—and to give your budget a break—fresh fruit can be mixed in with your flowers.

bottom A shallow bowl with a romantic mix of roses and cymbidium orchids mimics the size and shape of the nearby chargers. ■ A riotous mix of phalaenopsis orchids, peonies, tulips, and hydrangeas is anything but jarring when grouped by bloom and placed in unfussy glass vases. ■ A weathered urn lends an air of old-world charm to this monochromatic rose, cymbidium orchid, Mokara orchid, and calla lily centerpiece.

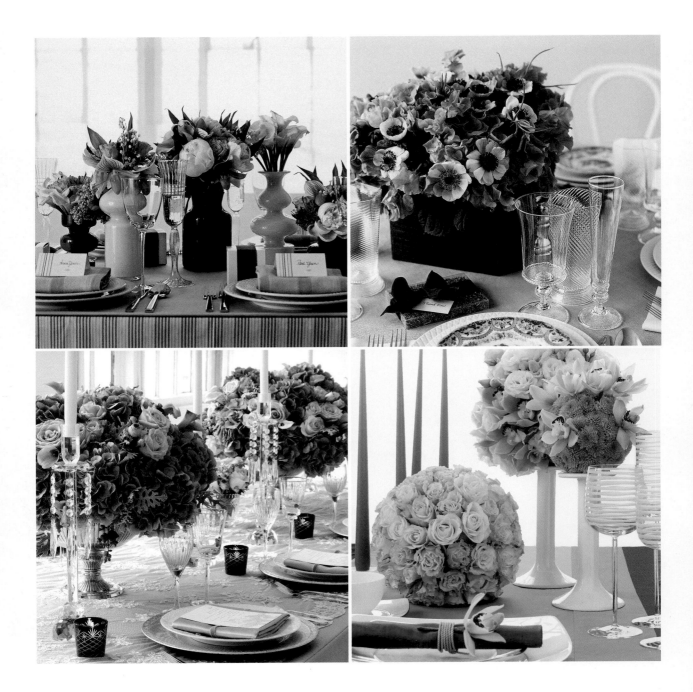

top Opaque vases in interesting shapes give any arrangement a contemporary quality, even ones with classic blooms like these peonies, calla lilies, lilies of the valley, and lady's mantle. Green-striped lady's slipper orchids coordinate with the emerald and white vessels that contain them. ▪ Lavender sweet peas pick up the color of the Victorian plates while white anemones and greenery give the arrangement a just-picked look befitting a sunny daytime wedding.

bottom Romance meets royalty with these silver pedestals overflowing with pastel roses, mini–calla lilies, and hydrangeas. Candleholders with dangling crystals add glitz. ▪ When roses, cymbidium orchids, and button mums are massed in full, round shapes and varying heights, the result has a decidedly modern edge.

opposite Subtle details can really make a difference. This square centerpiece mimics the parallel lines of the table and the same geometry is picked up again in the candles, chargers, and menus.

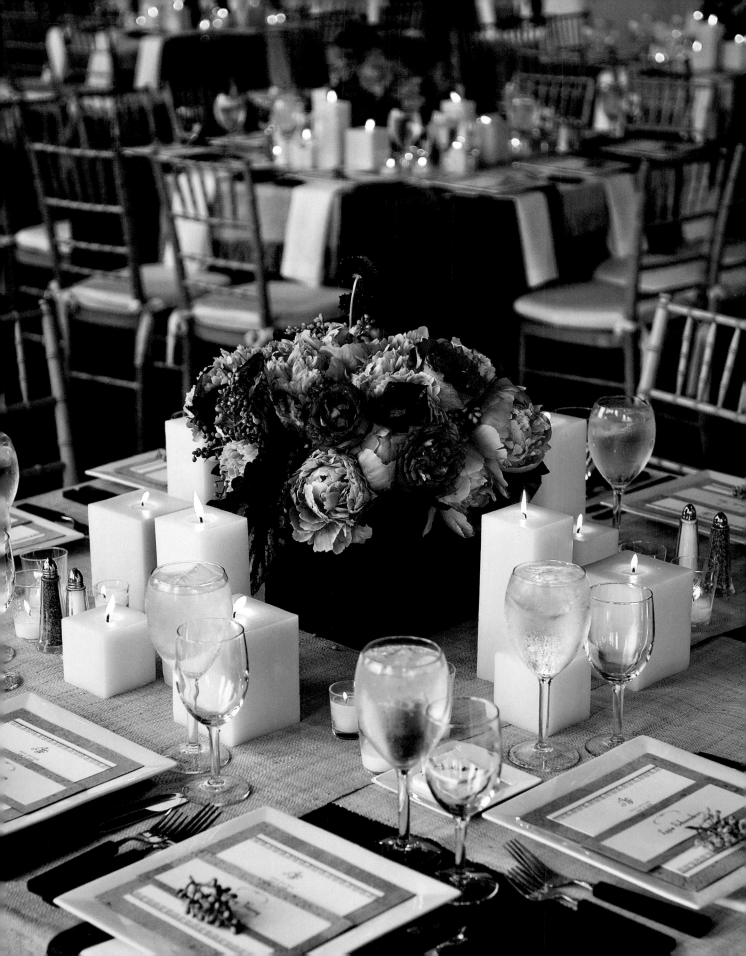

high + mighty centerpieces

Tall flower arrangements are essential in a room with high ceilings, but it's helpful to include very low votive candles and small, complementary arrangements to add interest at eye level.

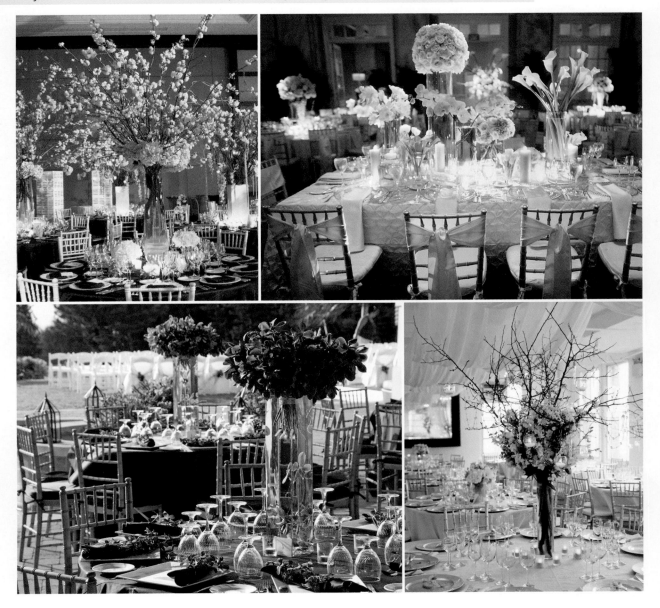

top A few magnificently towering centerpieces among subtler like-hued arrangements result in decor that's grand, not grandiose. ■ Many centerpieces, each with a single type of bloom, can be more exciting than a single arrangement of different kinds of flowers. The trick is to keep the color consistent.

bottom If you don't want the centerpieces at your outdoor wedding to blend in with the green background go with a flower in a color that doesn't appear nearby, and opt for a tall vase to add height to the surroundings. ■ Mostly white arrangements help maintain the dazzling look of a bright venue. Branches add drama and height to the tall centerpieces and contrast sharply against the snowy backdrop.

Tall centerpieces are always a smart choice for dressing up a cavernous tent. An opulent but still garden-fresh feel is attained with an abundance of hydrangeas, Casablanca lilies, roses, and greenery.

clockwise Spheres of spiky cymbidium orchids atop cylinder vases are dramatic on their own, but in a bed of floating candles they look spectacular. ■ A towering glass vase can be filled with whole small fruits and slices that echo the warm-colored hydrangea, poppy, and orchid arrangement above. ■ On longer tables, alternating tall centerpieces, like this arrangement of white lilies, with shorter ones contributes to a visually pleasing composition. ■ A perfect complement to a castle wedding, flowers in reds and burgundies bunched together in a candelabra evoke medieval romance. Delicate twigs tucked into the arrangement prevent the look from seeming too contrived.

Centerpieces in a series don't have to stay separate from each other. Long-stemmed calla lilies and cymbidium orchid branches crisscross at the top. Fuchsia orchids float in the vases below for even more color.

Placing lampshades where flowers usually go can be risky but well worth it. The graphic shape and solid color instantly modernize a traditional venue. For a classic touch, clusters of conventional blooms surround the vase.

table vignettes

When a vase and blooms aren't quite unexpected enough, decorating your tables with anything that's beautiful to you, be it lamps or lanterns, sand or sailboats, will personalize your space.

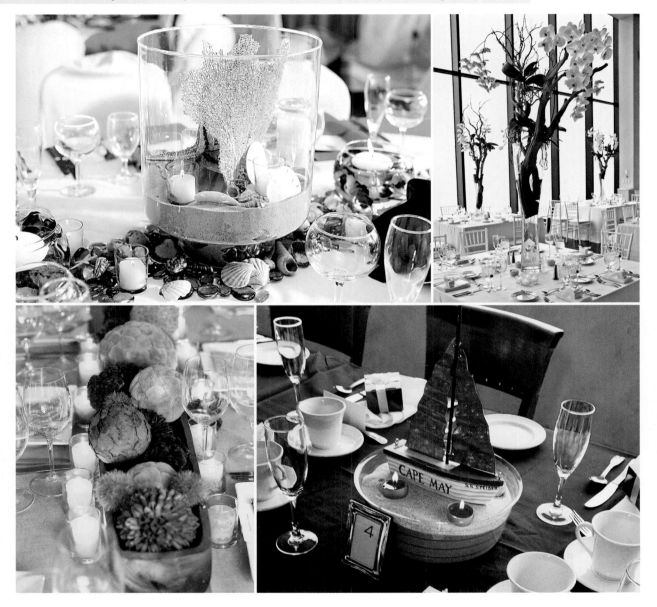

top Candles surrounded by sand and shells are logical accents to a seaside wedding, but they can be fairly monochromatic. Here they're perked up by sea glass in cobalt and teal ocean tones. ■ The height of this tree centerpiece makes it distinctive, but it becomes even more so when wired with blooms like these exotic white cymbidium orchids.

bottom A row of brightly colored globes covered in blooms like cockscomb and button mums creates a fanciful effect. Though it wouldn't work on a round table, a long, wooden vessel highlights the length of a rectangular table. ■ After a ceremony on the beach, guests will be delighted to see small-scale sailboats floating in a bowl of sand. This couple named the sailboats after shore towns they visited when they were dating.

Stick to your season
Blooming branches, like cherry blossoms and dogwood, are a favorite for dramatic centerpieces, but they're only available for a limited time in the spring, so don't get your heart set on them for any season, or work with your florist to mimic the dreamy look with other flowers. Rosebuds wired to curly willow may fit the bill.

Factor in the fragrance
Your guests will be eating in close proximity to your centerpieces. Overpowering scents from flowers like lilies don't mix too well with filet.

Give examples
Bring in photos from magazines or websites. Telling your florist that you want pink and romantic can result in hundreds of variations, many of which you may not like.

Reuse the bouquets
During the cocktail hour, have a bridesmaid collect the bouquets and place each of them into vases. Be sure to order extra vases. If the bouquets will be wrapped in ribbon, consider ordering opaque vases so the reuse is not obvious.

Get the details
Make sure your contract is specific. It should list the exact flowers, vases, and other elements that will be in each arrangement.

See a trial of an entire table
If you're going with anything other than plain white linens and plates, you need to look at the big picture. As long as you have signed a contract and put down a deposit, any reputable florist will offer to make you a sample centerpiece for free. See if you can borrow or rent a tablecloth

and a place setting for the same day that your florist does a dry run of the centerpiece. You may decide to tweak some of your picks once you see them all together.

Get a count
You won't know exactly who's attending your wedding when you book your florist, but try to figure out how many tables you may need so you know what types of centerpieces are within your budget. Ask your venue or the rental company how many people can sit at your tables (usually eight to ten) and calculate accordingly. Leave a little wiggle room in your budget in case more guests than you predicted accept your invite.

Decorate the other tables
You know you'll need centerpieces at the guest tables, but don't forget the escort-card, guest-book, cake, and gift tables. Tall arrangements here aren't necessary, but they can guarantee that these tables look as dressed up as the others. You'll especially want to focus on these tables if they're at the entrance to your reception.

Questions to ask your florist

1. Is delivery and pickup included in the price quote?
When you get your quote for design, labor, and the cost of the blooms themselves, find out if there's an extra charge for dropping centerpieces off and picking them up.

2. If you can't get my flowers, what substitutes will you use?
Make sure you'll be happy with the alternatives.

3. Who will design my centerpieces?
The florist's portfolio may feature many different designers on staff, and unless you see what your specific designer can do, you can't tell if you'll like the outcome.

4. How far in advance do you make the centerpieces?
The best answer: that morning. But if you're having a huge wedding—or one early in the day—they will need to start working the night before.

5. Do we have to return the vases after the reception?
The answer tends to be yes. Your florist will probably coordinate with your venue on a pickup time.

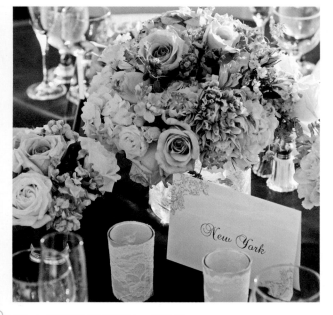

Want even more centerpiece ideas? Go to TheKnot.com/centerpieces

Soaring centerpieces serve as a dramatic focal point at this all-white reception. Phalaenopsis orchids are perfect for such cascading arrangements. The rest of the table is accented with just a few votive candles.

red

Part romance, part fun, one thing's for sure: This hue is rich in color and meaning.

peppermint + aqua

strawberry + lime

pomegranate + chocolate

bordeaux + olive

fire engine + peony

ruby + navy

punch buggy red + marigold

cranberry + plum

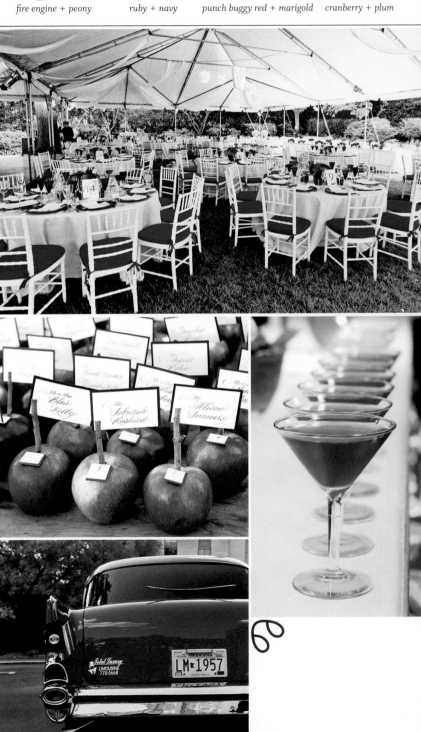

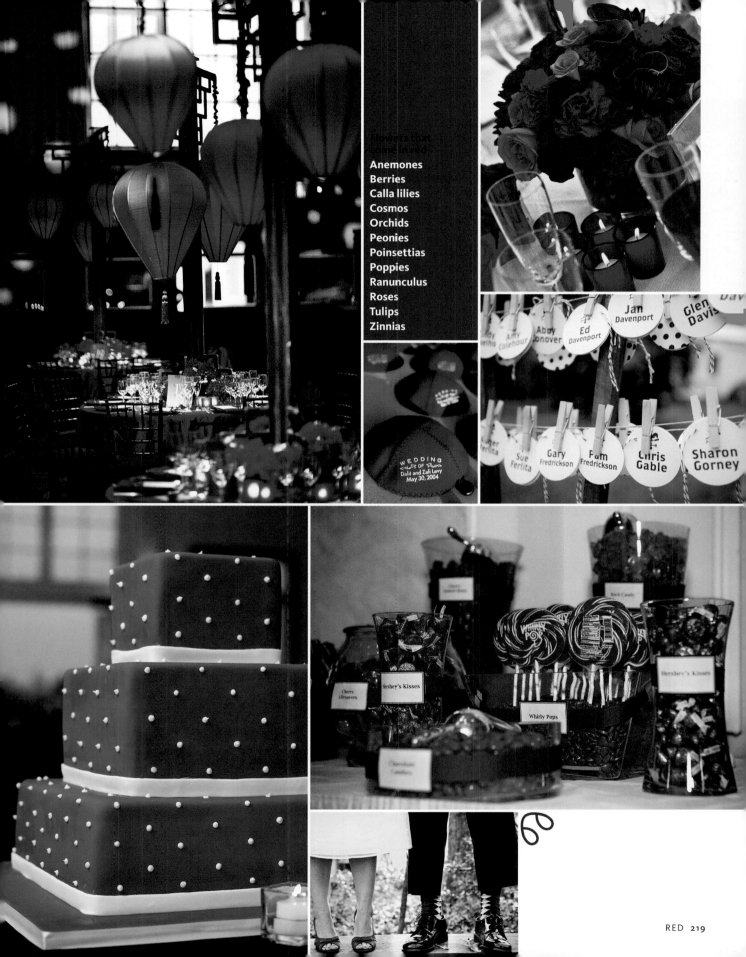

Flowers that come in red

Anemones
Berries
Calla lilies
Cosmos
Orchids
Peonies
Poinsettias
Poppies
Ranunculus
Roses
Tulips
Zinnias

WEDDING OF
Dalit and Zali Levy
May 30, 2004

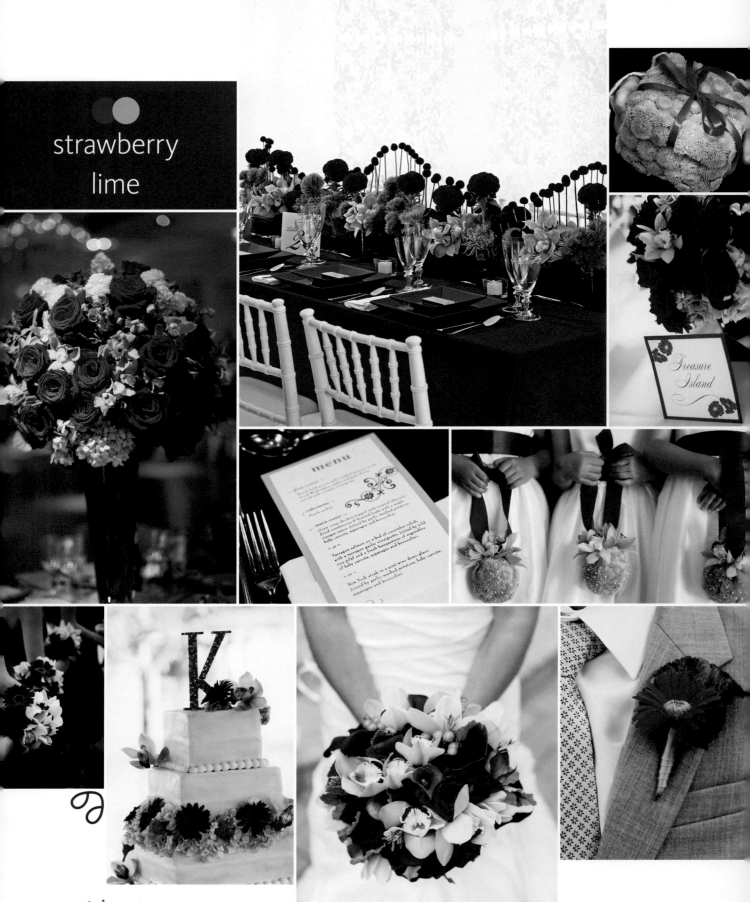

strawberry
lime

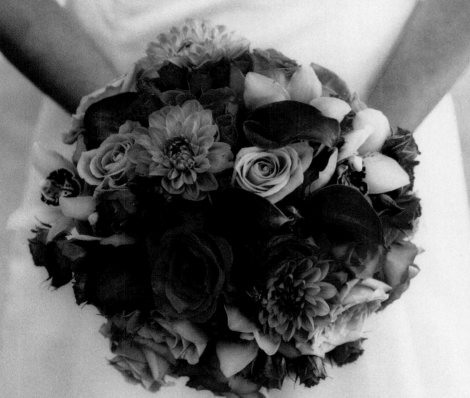

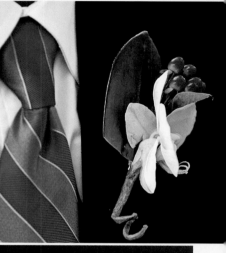

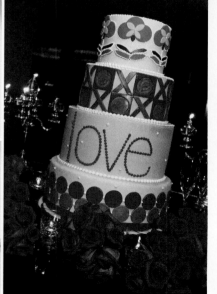

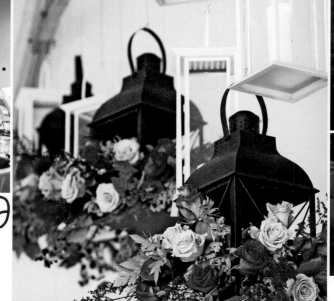

punch buggy red
marigold

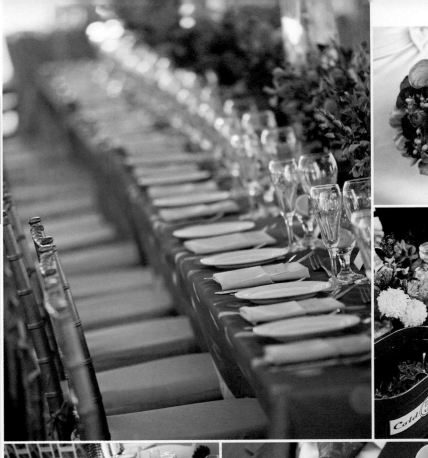

DG CV

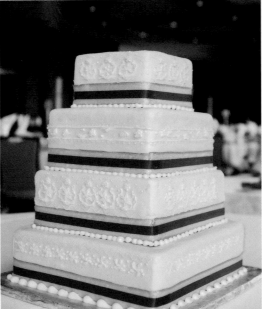

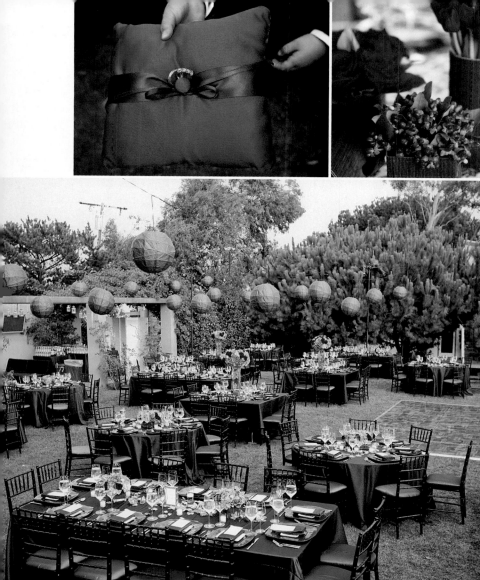

pomegranate
chocolate

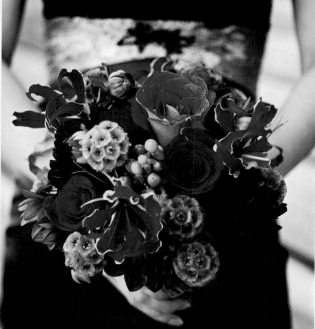

a destination wedding

For their laid-back wedding, Lindsay and Hank turned to Cabo San Lucas, paying homage to the Mexican location by offering maracas in the welcome bags and serving local favorites like seviche and cervezas. To let the natural seaside scenery shine, the color palette consisted only of beige, khaki, and white, with beachy accents such as seashell place-card holders, starfish favors, and sandy centerpieces. All of the elements combined to epitomize tropical sophistication.

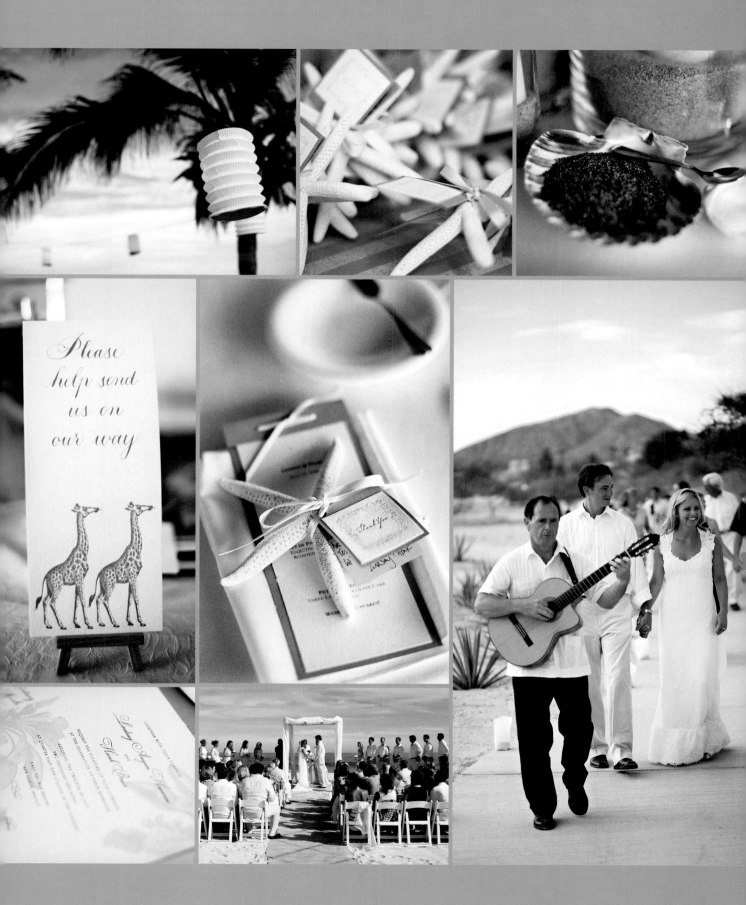

Toying between tailored and romantic? Here, a somewhat austere white cake wound with a simple ribbon of navy icing gets a surprising update in the form of a full, frothy layer of all-white sugar flowers.

opposite A monogram gives your cake or mini-cakes an extra personal touch. A formal wedding calls for a scripted font; roman letters work well at a more modern affair.

the wedding cake

your countdown

5–6 months before:
Schedule your tastings.

4–5 months before:
Order cake and determine display.

3 months before:
Make final payment and confirm delivery details.

1–2 weeks before:
Check with your venue to make sure they have all delivery info and that there is a refrigerator designated for the cake.

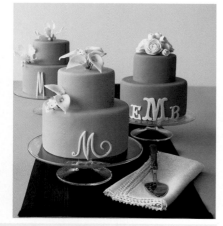

get inspired by
- A painting you love
- An architectural detail at your reception site: the ceiling, the molding, the Art Deco sconces
- A wallpaper pattern
- Stationery
- Your mother's cake

Your wedding cake isn't just a dessert at the end of a great reception; it's the style exclamation point on your whole wedding, the sugary grand finale. Your choices of color, flavor, shape, and motif will come together to create a highly personal, showstopping symbol of your brand-new partnership.

Don't be hemmed in by tradition—a white cake isn't your only option. And there are so many ways to get creative with your cake—from the shape to the filling or even the topper. The only real guideline you should follow is to make sure your vision for the cake somehow fits with your wedding theme. And, don't worry, there's flexibility here—just because your wedding is in a contemporary art museum doesn't mean your cake can't have some traditional elements.

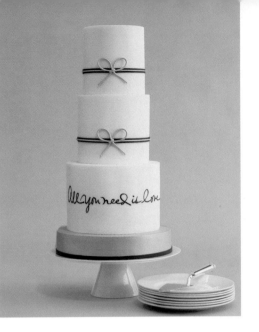

define your vision

Let the location of your wedding inform the details. If you already know where you're getting married, this is easy. A seaside wedding in Martha's Vineyard might call for a hint of a nautical theme, like a few simple blue bands around the base of a square cake or a textured frosting rope wrapped along the bottom. If you're getting married outside in a garden, you might want to pick up the greenery or have branches molded out of fondant. A whimsical cake with layers set charmingly askew could feel slightly out of place in the middle of a grand ballroom, but a tower of stately round tiers, sprayed with tiny pearls or embellished with flowing script, would be perfect. If your reception is going to be in a sparse loft space, why not consider a bold graphic cake to really make a statement without having to worry about whether or not it competes with the rest of the decor? Try a two-tone damask pattern or something a little poppier like dots or oversized stenciled flowers.

One of the other big factors to consider is the time of year the event will be held. While some cake styles are absolutely seasonless, others, like a white-on-white quilted pattern, are ideal for winter. Bright colors usually feel right in the spring and summer, and rich, dark accents add a nice touch in the cooler seasons. A dense chocolate cake might make less sense at a summer garden ceremony than a lemon curd one, and some kinds of frosting and fillings won't stand up to a long day in the sun.

coordinate with your flowers

Early on, your cake baker will want to know what kind of flowers you're thinking about using as these, too, can influence the design, color, and style of the cake. If you're planning to carry a Biedermeier bouquet composed of masses of white roses at your black-tie wedding, a quilted cake covered in sugar replicas, accented with edible crystals and topped with a dome of tightly packed fresh roses might fit your scheme seamlessly.

And don't assume you need to go with a grand theme. You can find inspiration in *anything*. Show any motif you love to your baker and ask if she can re-create it using stencils, transfers, or piping. Or you might want to incorporate a poem or song, spelled out in icing on each tier.

cake-frosting showdown: buttercream versus fondant

Fondant: This is a thin, hard icing that's rolled out and draped over the cake. It will give your cake a beautiful, smooth finish, and you can get it in almost any color. Another plus is that it won't melt in warmer temperatures. The main drawback: Because it doesn't contain rich butter, fondant can be a little bland and even unpleasantly grainy in texture.

Buttercream: Richer and much tastier than fondant, this icing is made of the ingredients you'd expect: creamy butter and sugar. It has a fluffy appearance and is easily shaped into piped swags, borders, and flowers (though because it's so soft, it's not the right choice for transfers, stencils, and embossing). The downside is that it tends to melt on very hot days.

One fitting motif to consider: a detail from your wedding dress. An eyelet design makes this cake pop, and the girlish fabric takes on a sassy edge when translated into frosting.

opposite A favorite song can even provide some inspiration. The Beatles' "All You Need Is Love" is written along the bottom tier.

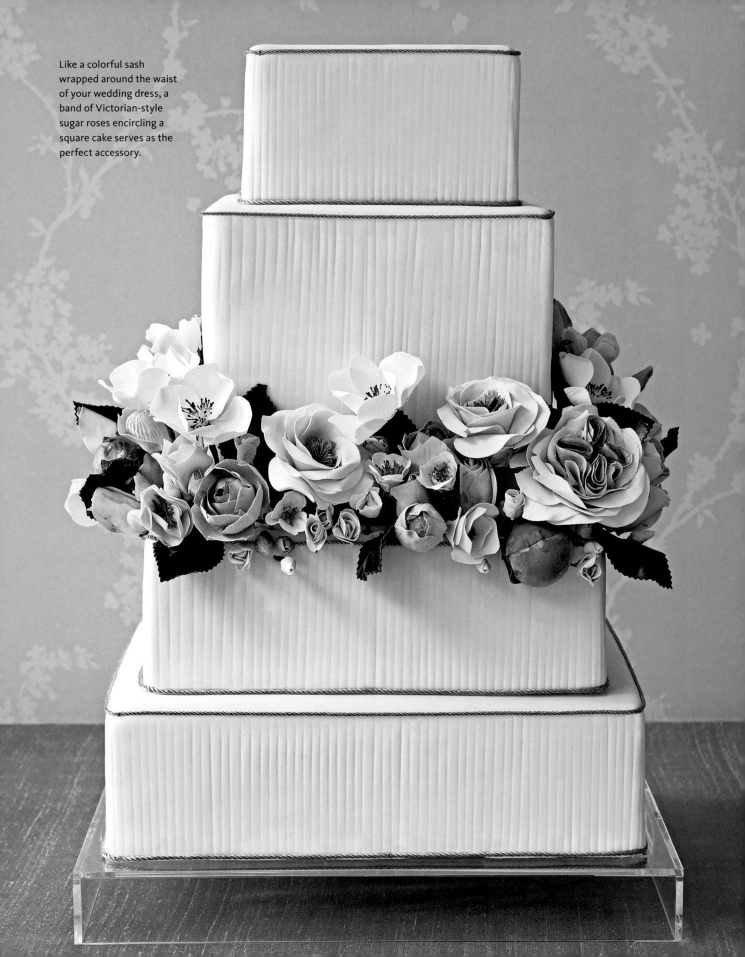

Like a colorful sash wrapped around the waist of your wedding dress, a band of Victorian-style sugar roses encircling a square cake serves as the perfect accessory.

✑ classic cakes

Classic doesn't have to be boring. It's the fresh details, like simple bows, pretty flowers, and tiny pearls, that make these chic, not stuffy.

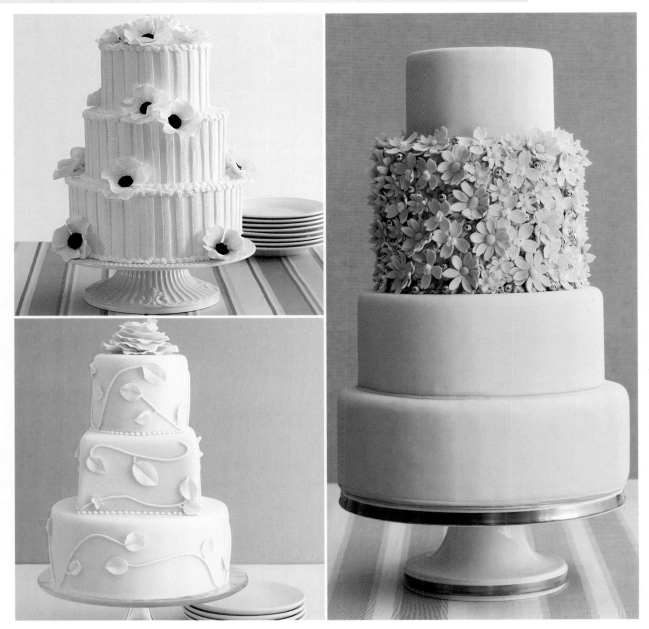

clockwise There's something so dreamy about this cake, and yet, thanks to the fist-sized sugar anemones, with their deep black centers, and the boldly textured tiers, it hardly fades into the background. ■ One way to make a round cake feel a little more unique is to highlight just one of the layers by coating it with some three-dimensional detail like flowers and dragées. ■ If you change the shape even subtly of just one tier (here, a center square) the result is a subtle twist on a traditional choice.

A round cake gets a
couture treatment with
allover quilted fondant,
bold lavender bands, and
a burst of sugar flowers.

Two knockout sprays of
sugar flowers make an
otherwise ordinary cake
a true statement.

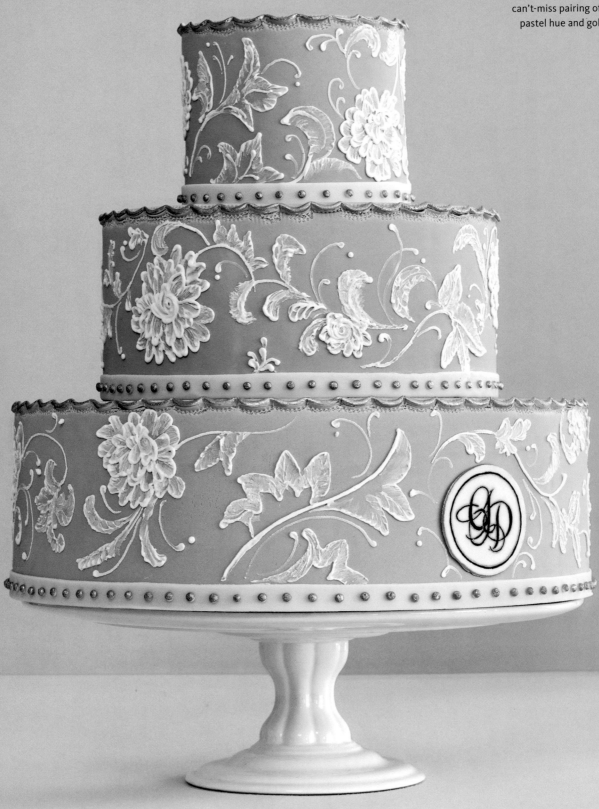

For a richly patterned design, there's the can't-miss pairing of a pastel hue and gold.

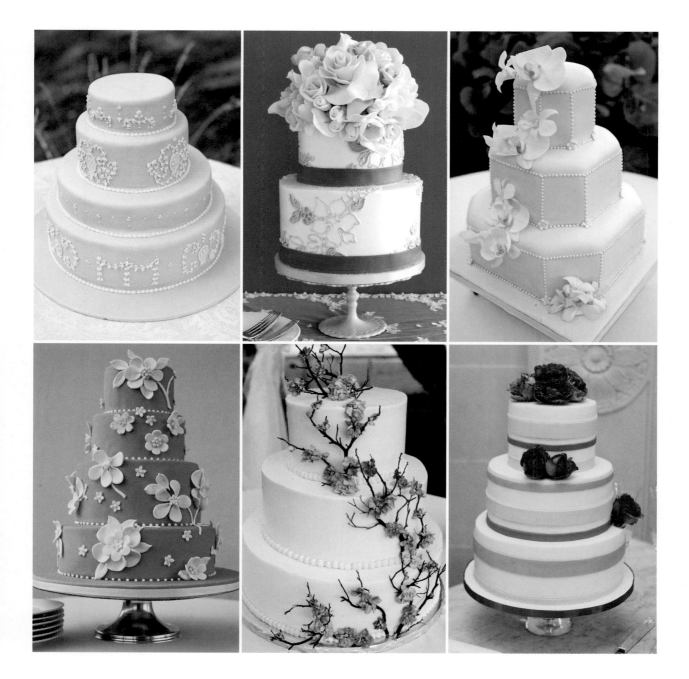

top Small, delicate flowers like this have a 1940s feel, but the way these are sporadically sprinkled is very modern. ■ An intimate celebration calls for a petite, two-tiered wedding cake that still has plenty of presence. ■ Tiny white iced dots trace all eight sides of each tier to subtly emphasize the lines of an octagonal cake. Fresh white orchids cascading down the side add lush dimension to the linear design.

bottom Various sizes of white fondant flowers make this four-tiered round cake playful but still pretty. ■ Decor elements that have an organic, sculptural quality are another way to create a one-of-a-kind design. These twisting branches of cherry blossoms seem almost to be growing around the tiers of the cake. ■ If your mantra is "less is more," you'll no doubt be tempted by this pared-down combination of strong color, simple banding, and a handful of scattered flowers.

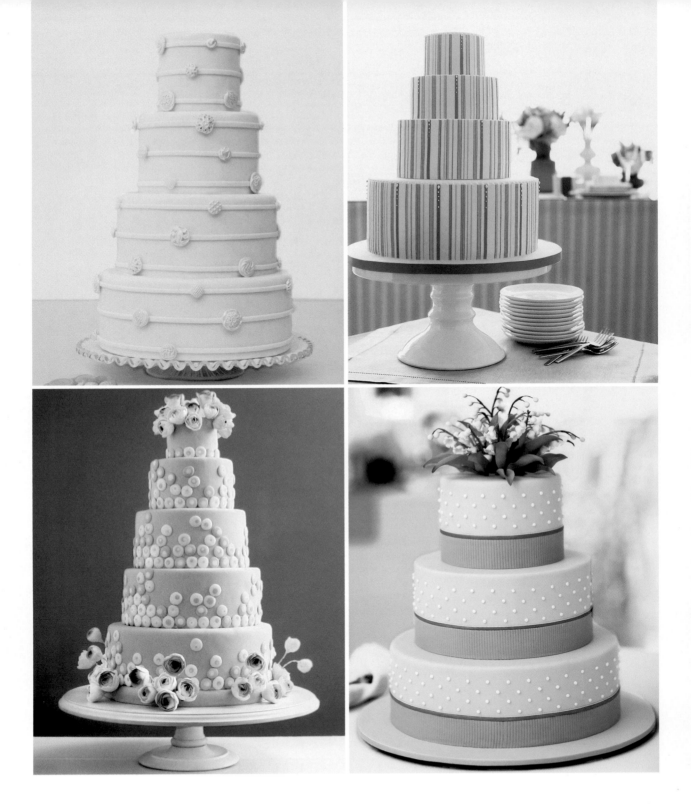

top Inspiration can literally come from anywhere. Old-fashioned buttons lend this cake a uniquely sweet touch. ▪ Stripes call to mind something decidedly peppy and preppy.

bottom Lots of randomly placed swirls add a hint of cheekiness to this five-tiered confection. ▪ What's stunning about this green and white combo is how all of the elements tie together: The white dots on each tier emulate the tiny bell-shaped blooms of the lily of the valley while the green ribbons play off the color of the leaves.

The combination of dots and flowers balances crisp modernity with old-world elegance for a fresh take on the white-on-white classic.

Shades of orange, apricot, ivory, and white fondant dots play up the modern shape of the cake on the left. An oversized paisley pattern, distilled to the essence of its graphic teardrop shape, is another way to give a modern vibe.

❧ creative cakes

Scallop-edged rounds, hexagons, octagons, or even mixes of different-shaped tiers or styles such as cupcakes—you're not restricted to plain circles or stacked squares.

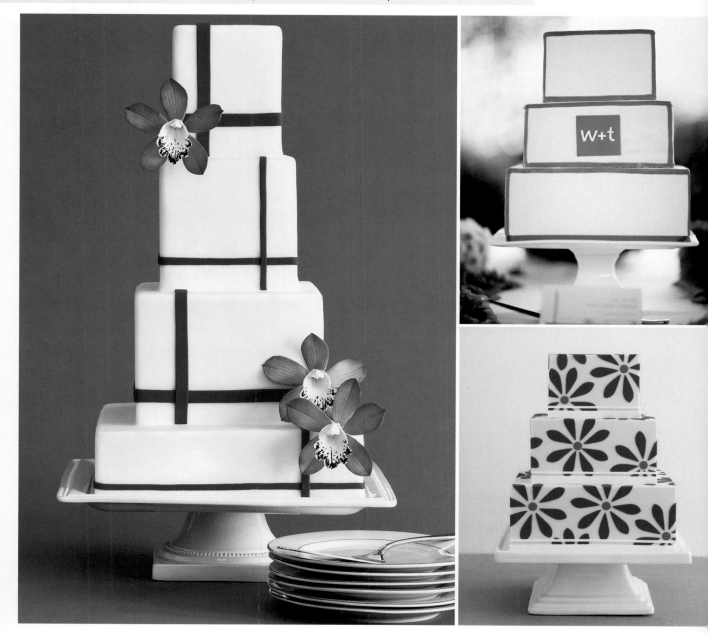

clockwise **This cake resembles a Mondrian painting translated into an edible treat.** ■ **A graphic, modern monogrammed design couldn't be simpler—or more arresting.** ■ **The sixties-style orange fondant flower cutouts strewn across this cake's square surface practically make it jump off the stand.**

At left, dark gray lines create a little chaos on an otherwise simple white cake while oversized sugar-made pink orchids give the confection a splash of color. Two-dimensional pop art–style orange sugar flowers add a little rowdiness to a very square, symmetrical cake that's trimmed with orange and white fondant bands.

The most breathtaking
motifs for a wedding cake
sometimes arise from the
most unlikely sources. This
stunner—with black
floral-patterned fondant
cutouts set against a white
background—was actually
inspired by Parisian
wallpaper. Très chic!

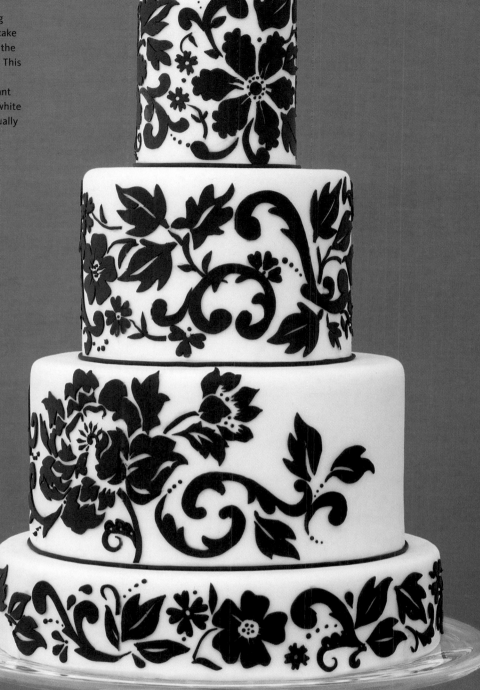

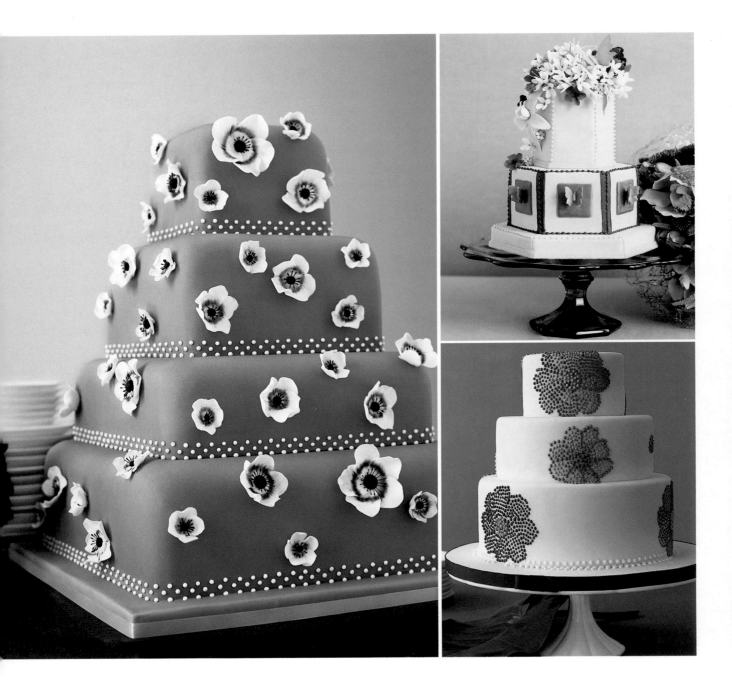

clockwise This lavender fondant, trimmed with purple polka-dot ribbon and blanketed with bold black-and-white anemones, strikes just the right chord. ▪ Even miniature cakes can use creative shapes, as proved here by this petite version made of hexagons in varying heights. Sugarpaste butterflies and delicate flowers add a final flourish, evoking a European-garden feel. ▪ The accents on this cake look almost pixilated, thanks to the tiny piped dots used to form the flowers.

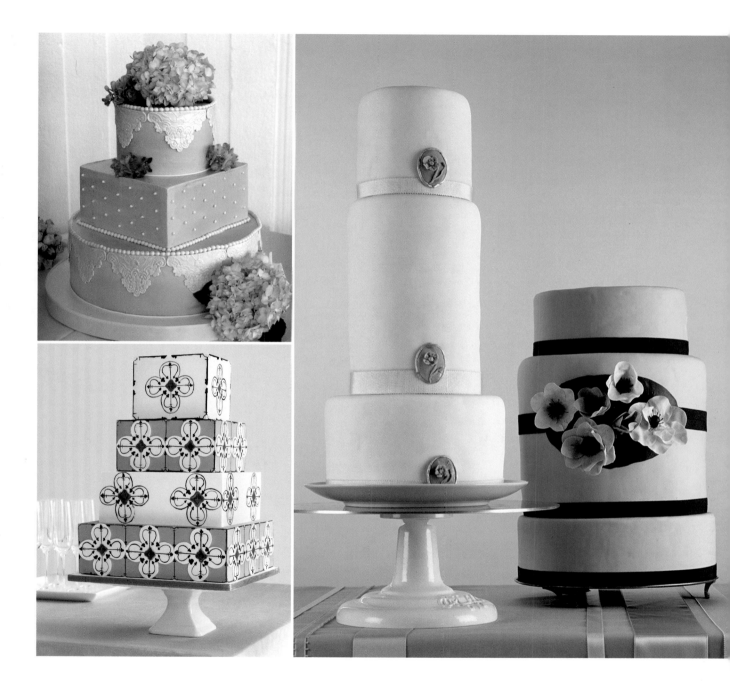

clockwise You can create a subtle effect with different-shaped tiers by making the rest of the cake more traditional. ■ Playing with scale and dimension is an easy way to put your stamp on things. ■ Your wedding cake is the perfect opportunity to honor your heritage. This Spanish-tiled design was hand-painted onto sugar plaques.

Soft green fondant leaves and light brown branches curve around a simple white cake for a seriously elegant design.

If you crave something hip but still sweet and charming, a big, graphic element on a smallish cake can make just the right statement.

Cupcakes can take on the
stature of a cake if they're
placed on graduated tiers and
topped with a mini-cake.

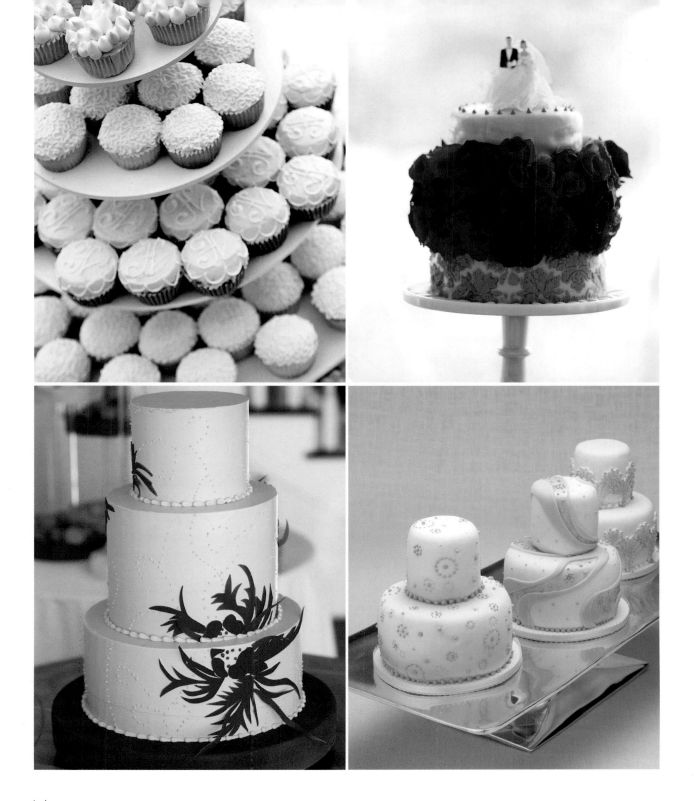

top A tiered stand is the best way to display cupcakes, but don't stop there. Have them frosted in a variety of patterns and colors and create a fetching arrangement. This one re-creates the tiers on a cake in the way the like-iced treats are grouped. ■ Mini-cakes can still take on a topper as long as it's proportional.

bottom This Asian chrysanthemum was modeled after the fabric of the bride's Vietnamese wedding costume. ■ Just as your bridesmaids may not be wearing the same dress style, your mini-cakes can also coordinate with one another rather than match exactly.

chocolate cakes

The secret to making a chocolate cake look elegant is being precise with the details—using straight lines, predictable patterns, and symmetry.

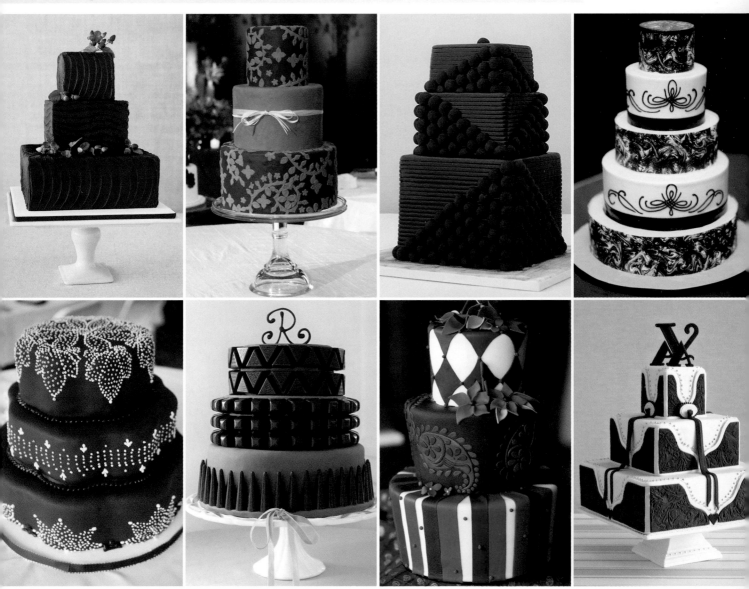

top Even a chocolate buttercream cake can be chic. The secret: a squared-off shape. ▪ Alternating intricate scrollwork with a smooth layer keeps the result from looking too busy. ▪ This looks almost like a box of chocolates thanks to the truffle add-ons. ▪ The scroll motif used here can be woven into other wedding details, too.

bottom A petal-shaped cake has a dainty, old-fashioned flavor, played up here by lacy white and gold beading. ▪ A simple, edible cake topper is the perfect finish for this covered-in-chocolate cake. ▪ Cutout fondant flowers make a whimsical pattern less predictable. ▪ The chocolate acorn design on this western-themed cake was made using real leather-making tools.

The density of these rich chocolate tiers hints at the mouthwatering treat to come—and is offset brilliantly by the single clutch of whorled white sugar roses and a single sugar dahlia.

FLAVORS + FILLINGS

Finding just the right combo of cake flavor and filling is one of the best parts of choosing your cake (since it means lots of sampling!). Unless you already have your heart set on a certain filling, it's best to start with the cake flavor and then decide on the filling. Your baker can help by suggesting flavors that work well together.

Bring at least two other people with you to the tasting. Since you are feeding this to seventy-five, one hundred, or two-hundred-plus people, it's smart to get a couple of opinions.

Remember: Once the cake is cut, the filling will make a dramatic statement on the plate.

Vanilla, yellow cake, or angel food
- **FRUIT OR FRUIT-BASED FILLINGS** raspberry, cherry, orange, Grand Marnier, blood orange, strawberry, coconut cream, lemon curd, passion fruit, apricot, Key lime, mango, pineapple
- **NUT-BASED FILLINGS** almond, marzipan, pistachio, hazelnut, praline
- **MOUSSES AND BUTTERCREAMS** mocha, amaretto, cappuccino, chocolate, white chocolate, vanilla
- **OTHER OPTIONS** cannoli cream, Bavarian cream

Chocolate cake
- **FRUIT OR FRUIT-BASED FILLINGS** raspberry, cherry, orange, Grand Marnier, blood orange, banana, strawberry, coconut cream
- **NUT-BASED FILLINGS** almond, marzipan, pistachio, hazelnut, peanut butter, praline
- **MOUSSES AND BUTTERCREAMS** mocha, coffee, Kahlúa, espresso, cappuccino, chocolate, white chocolate, vanilla mint, ganache

- **OTHER OPTIONS** cannoli cream, mascarpone, Bavarian cream

Carrot cake
- **NUT-BASED FILLINGS** almond, marzipan, hazelnut
- **OTHER OPTIONS** cannoli cream, Bavarian cream, cream cheese

Lemon cake
- **FRUIT OR FRUIT-BASED FILLINGS** lemon curd, raspberry
- **NUT-BASED FILLINGS** almond, marzipan
- **MOUSSES AND BUTTERCREAMS** white chocolate, vanilla
- **OTHER OPTIONS** cream cheese, mascarpone

above In the photo at left are some of our favorite cake-and-filling combos. From top: banana cake with apricot buttercream, yellow cake with a blend of chocolate ganache and mocha filling, chocolate cake with raspberry jam buttercream, and white chocolate cake with mango buttercream. ■ If you can't decide between flavors and fillings, using more than one kind of cake and a couple of fillings achieves a cool layered effect.

Different types of chocolate drape these tiny cakes; clockwise from top: modeling chocolate (a pliable paste), marzipan, ganache, buttercream, fondant.

DDIY (Don't Do-It-Yourself)

Even if you're a cake baker, think twice before assuming the task. A wedding cake can require a few days to make and assemble. You probably have other things to do in those couple of days before your wedding. It's not worth the stress.

Know what you want

It's helpful to have some idea of what you want before you meet with a cake baker. Even if you're still undecided on a direction before your first appointment, research local cake bakers' styles before you meet them. If you do have a specific style in mind, make sure you meet with the cake bakers who know how to incorporate that particular aesthetic and ask to see at least a few cakes in their portfolio that are reminiscent of what you want.

Think like a critic

The main thing that distinguishes a great cake from a merely good one is the attention to detail and the craftsmanship. When you're looking at a cake baker's portfolio, pay close attention to the frosting (it should be flat and not bubbled up or warped), the color (it should be consistent, without gradation), the tier shapes (they should be obvious), and the banding (it should be even).

Compare prices

When you're shopping around and gathering cost information, always ask the baker to break it down by cost per slice instead of just giving an overall price. This will make it easier to comparison-shop. Expect to pay at least $2.50 a slice, but know that it can be much higher ($25 or $30 if you're using a celebrity cake baker).

Order wisely

Not everyone will want a slice of cake, so there's no sense in ordering a cake that feeds the exact number of guests. Subtract about 10 to 15 percent from the total guest count. For example, if you're expecting 150 guests, order cake for 130.

Watch for hidden costs

The price the cake baker quotes you is usually just the cake cost. Ask about transporting fees and tax; and factor in a serving fee if your cake baker is not working at your reception site. You don't need to tip your cake baker, but the delivery person wouldn't refuse a small thank-you—a $10 tip suffices.

Get it in writing

Your contract should include the vendor's contact information, your wedding date, delivery location and time, delivery and set up fees, total amount due, cake design specifications (including frosting and fillings), plus the cancellation policy.

Don't be safe and sorry

Avoid completely plain-white tiers—your cake won't look just boring but also unfinished. Even if your tastes are very simple, at least add a single ribbon, quilting, dots, or scads of sugar flowers.

Show, don't tell

You say sugar flowers—your cake baker thinks jumbo roses, but what you really want are tiny petals. Pictures can convey much more information and leave little room for interpretation. Also, ask your cake baker for sketches of the cake. This is the one style detail you won't see before you walk into the reception so it's a good idea to have some rendering of what to expect.

Watch the colors

Yes, you want your cake to blend with the rest of your wedding colors, but here's a secret: Some food colorings taste better than others. Deeply saturated colors (red, green, blue) won't be as good as paler shades or white. Bring rich colors into the cake accents rather than covering the whole cake in them.

❀ Think double duty

You can get more mileage out of table cakes by having them serve as table numbers, too.

Avoid a meltdown

Buttercream cakes should be chilled ahead of time in order to look fresh—even if your wedding isn't being held outdoors in the summertime. So make sure there's a refrigerator on site. With fondant, avoid the fridge since the cold air can make it "sweat" beads of condensation.

continued . . .

Questions to ask your cake baker

1. How far in advance are wedding cakes prepared?
Cake bakers often have to prepare more than one order per weekend. So don't be surprised if your cake is made three to four days prior to your wedding day.

2. Who will bake my wedding cake?
Some places employ a baker and a designer; at others, one person creates the entire cake from batter to sugar flowers. Ask to see work by this person/these people.

3. What is the delivery process?
Usually the baker will deliver your wedding cake to the reception site for an added fee.

4. Are you licensed by the state?
It may seem like a silly question, but it's worth verifying that your baker has gotten the A-OK from the state health department.

5. What happens if the cake gets damaged?
If your cake does get damaged, some bakers will serve whatever's salvageable of the broken cake, but bring you a fully decorated Styrofoam cake from their shop window to display.

cake toppers

Why not have some fun with your topper? You can spend less than $100 on a cool, quirky topper that guests will remember. Or you can borrow your parents' or grandparents' topper for a meaningful, vintage touch. Here are some of our favorite ideas.

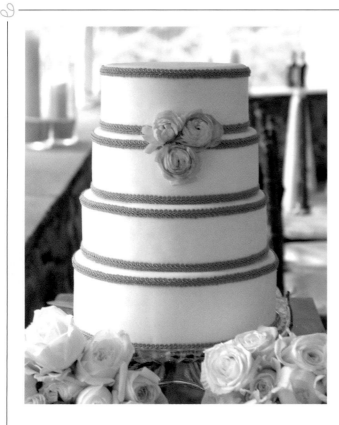

expects a groom's cake to make a style statement, so just have fun: hobbies, sports teams, and pop culture are all in bounds.

Make a good presentation
The simple rule about wedding-cake tables is that round cakes look best on round tables and square cakes are prettier on linear tables. Because you want everyone to have a chance to admire the confection before it's been cut, have it set on something grand near the entrance or underneath its own canopy. Strategically placed lighting, too, can draw attention (see chapter 6).

Don't forget the accessories
Give some thought to what kind of stand you'll use so that your cake shines. Make sure your venue or rental company can provide a cake knife, or better yet, borrow one from your mother or grandmother to lend a senti-mental touch.

Cut the cake
You can cut your cake either

right after you two make an entrance into the reception or after your first dance (a good option if you have a lot of older guests who may need to leave early); or you can wait until the last hour and make it a finale.

Wrap it up
The staff at your venue will probably just box up the cake. So here's what you (or the person you designate as cake captain) need to do once you get home. Remove the sugar flowers and chill the cake overnight in the refrigerator (this will harden the icing so it doesn't stick to the plastic wrap). Wrap the cake in several layers of plastic wrap (not aluminum foil, which can cause freezer burn) and put it in an airtight plastic bag.

Want even more cake ideas? Go to
TheKnot.com/cakes

Make a compromise
Some bakers can roll fondant into a thin layer and frost the inside with smooth butter-cream. That way, the neat-looking fondant will be what guests see, but it will quickly melt in your mouth while the

yummy buttercream taste takes over.

Let the groom eat cake
Even if you don't live below the Mason-Dixon line, consider trying the tradition of a groom's cake. No one

how much you'll need

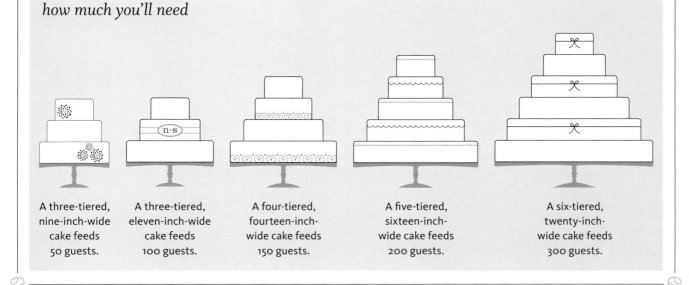

A three-tiered, nine-inch-wide cake feeds 50 guests.

A three-tiered, eleven-inch-wide cake feeds 100 guests.

A four-tiered, fourteen-inch-wide cake feeds 150 guests.

A five-tiered, sixteen-inch-wide cake feeds 200 guests.

A six-tiered, twenty-inch-wide cake feeds 300 guests.

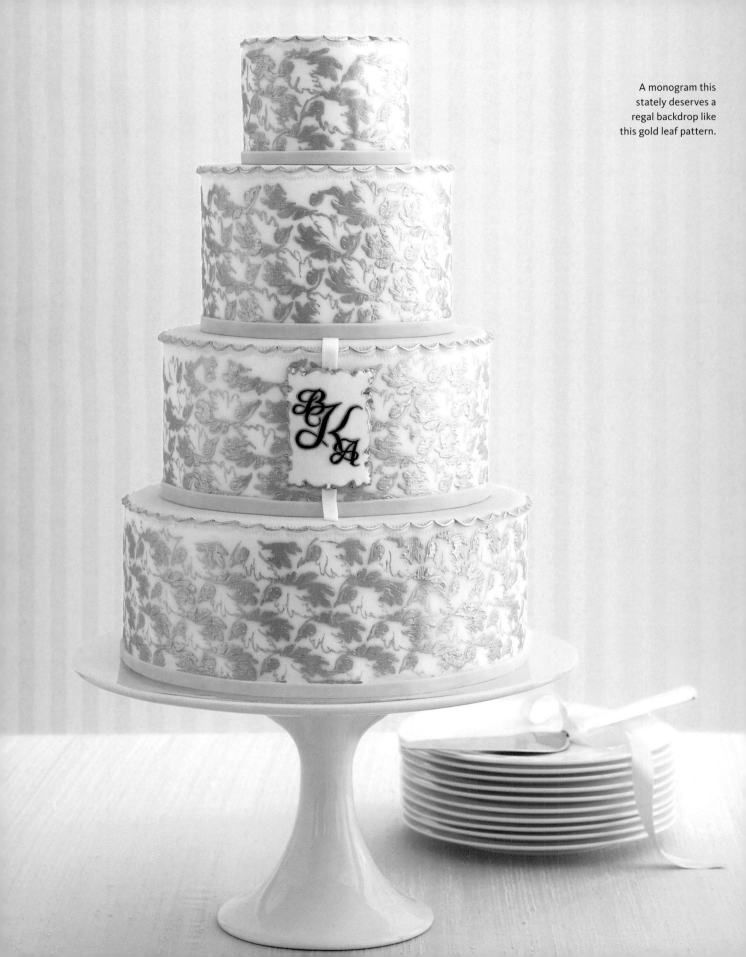

A monogram this stately deserves a regal backdrop like this gold leaf pattern.

blue

This cool shade evokes a range of moods. Of course, it also has particular resonance for a bride.

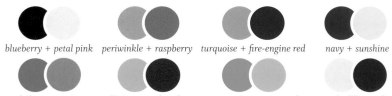

blueberry + petal pink periwinkle + raspberry turquoise + fire-engine red navy + sunshine

cobalt + tangerine robin's egg + chocolate aquamarine + sour apple powder blue + plum

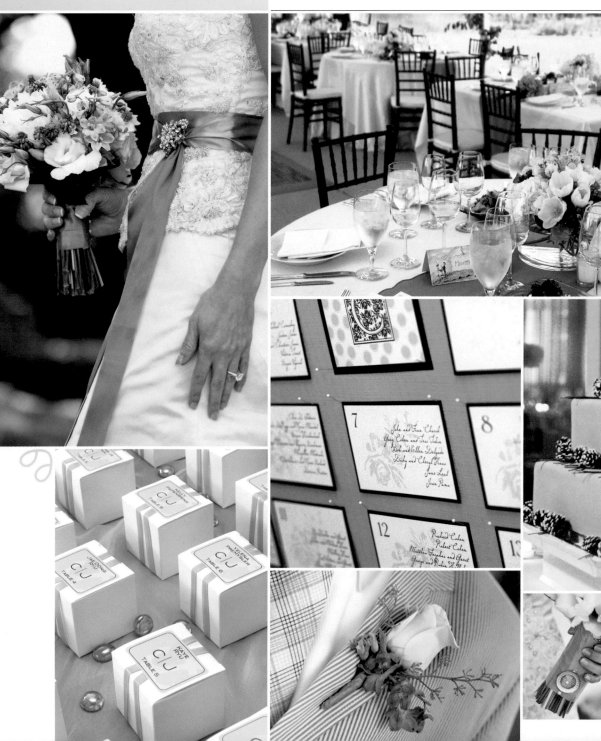

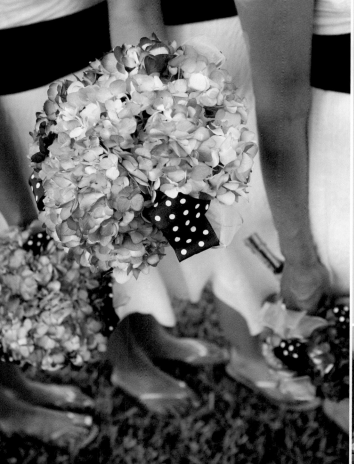

Flowers that come in blue

Baby blue eyes (nemophila)
Blue-green eucalyptus
Blue sea holly
Chrysanthemums
Cornflowers
Delphiniums
Geraniums
Grape hyacinths
Hydrangeas
Irises
Phlox

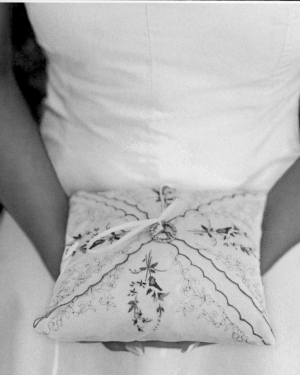

Menu

MIXED GREEN SALAD
FRESH BAKED ROLLS

GEMELLI PASTA WITH SAUTÉED VEGETABLES

CHICKEN ROMANO WITH LEMON CAPER SAUCE
BEEF TENDERLOIN WITH BORDELAISE
ROASTED POTATOES AND VEGETABLES

TRADITIONAL WEDDING CAKE
ICE CREAM STATION
ASSORTED COOKIES AND CANDIES
CHOCOLATE FOUNTAIN
CAPPUCCINO AND COFFEE STATION

turquoise
+
fire-engine red

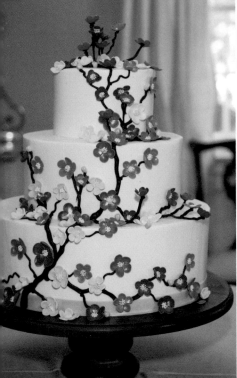

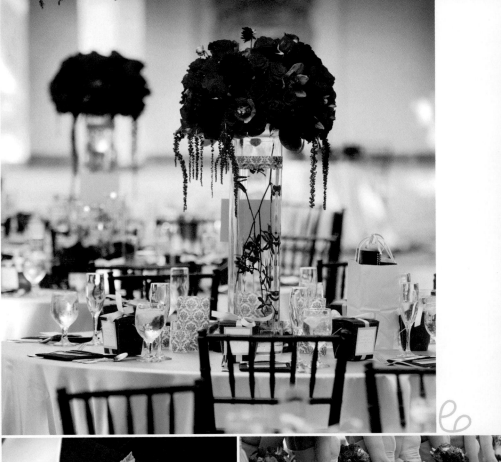

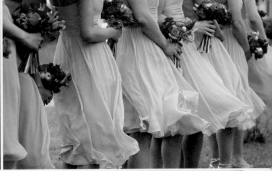

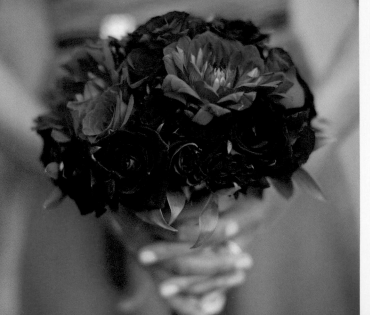

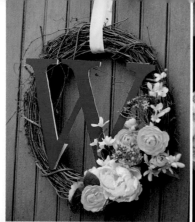

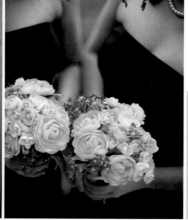

navy
+
sunshine

Nick Sevastakis
Bonnie + Hodgetts
table # 6

nandez
Vivona

Nick + Emily Bilotti
table # 8

Robert +
ta

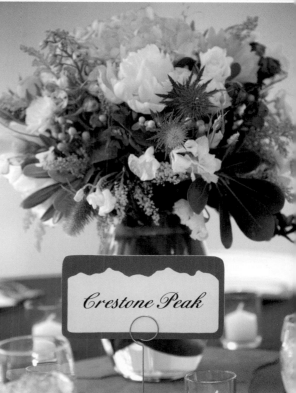

Crestone Peak

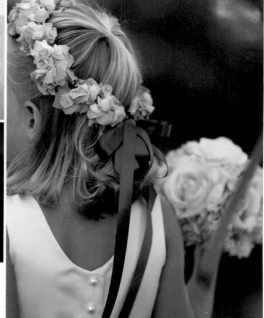

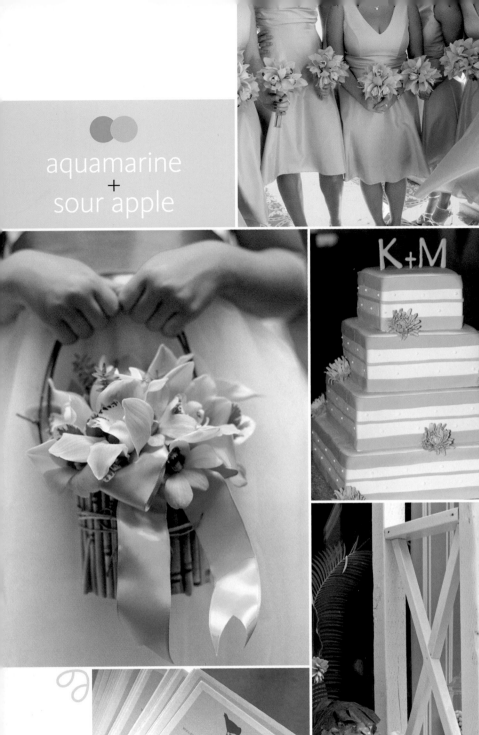

aquamarine
+
sour apple

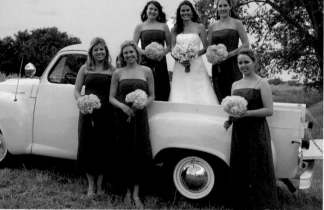

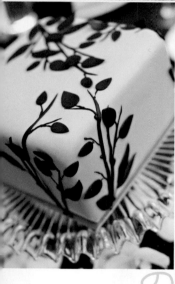

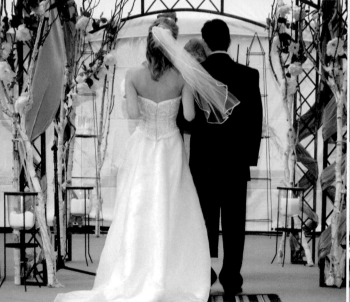

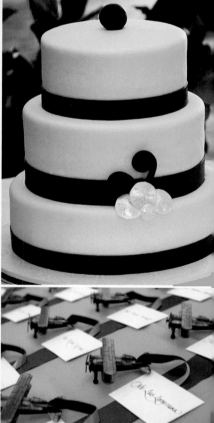

a summer wedding

Jen and Gabe's July wedding took its cue from the quintessential New England style, incorporating a red and white palette with touches of blue. Together, simple, understated details, like chalkboard table markers, red paper lanterns, mason jars filled with simple white flowers, and a playful lobster motif, gave this celebration a studied carefree quality that was at once casual and elegant.

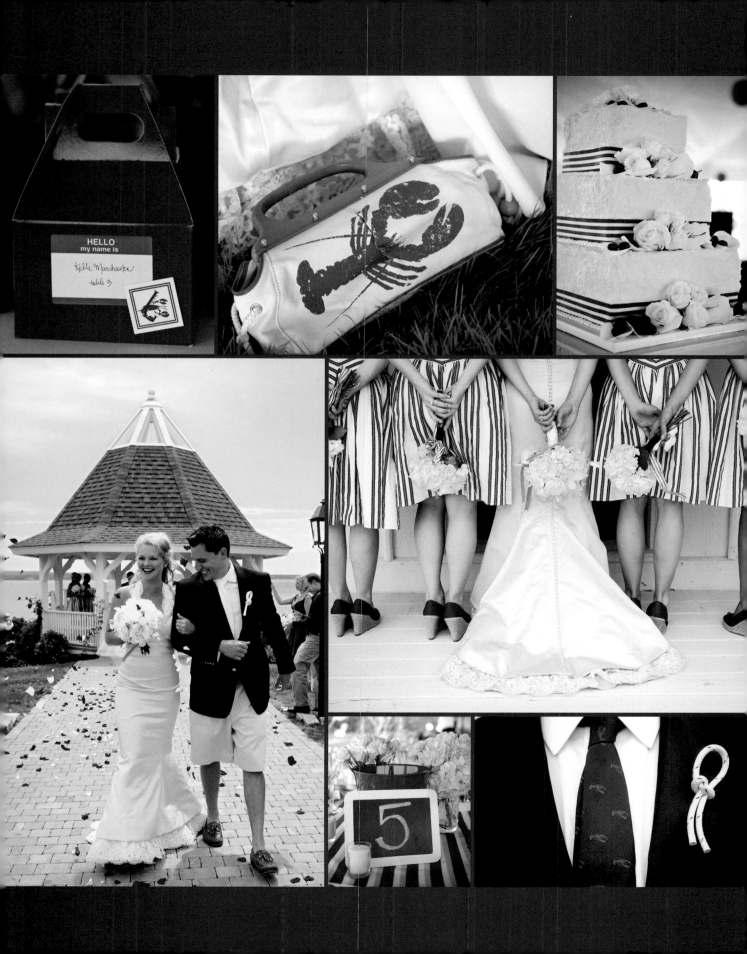

These aqua-and-gold-patterned paper bags with gold organza ribbons include matching tags that say "thanks" to guests for sharing in the day.

opposite Good things come in tiny packages, like these brown paper boxes tied with personalized tags.

the wedding favors

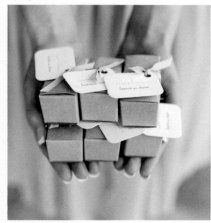

your countdown

1–2 months before:
Order the favors and any packaging.

1–2 weeks before:
Assemble them, if necessary.

2–7 days before:
Deliver them to the reception site, if they're not perishable.

1 day before:
Pick up perishable items, if you've ordered them, and deliver them to the reception site.

get inspired by

- A treasured family cookie recipe
- Your and your fiancé's favorite pasttime
- The ribbon wrap on your bridal bouquet
- Life's guilty pleasures, like truffles and wine
- Your culture's favor traditions
- Locally made or grown items

With most of the elements of your wedding, your goal is to make an impression in the moment. With your favors, you also want to leave a lasting impact. Whether raucous or refined, your parting gifts should embody the feeling you want guests to walk away with, while also expressing your gratitude in a personal way. The packaging is important, as it's the final element of your wedding style suite, but the practicality of the item matters, too. Maybe it's a bundle of cookies for a late-night snack (instant gratification!)? Or a cute tote guests can take to the beach (handy for years to come!)? Whatever it is, it's always best to come up with a favor that guests can truly use—whether in twenty-four hours or over the next ten years!

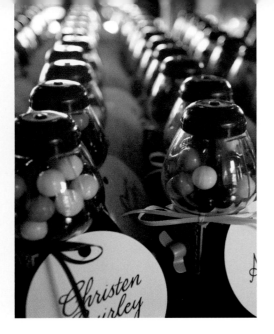

choosing wisely

Personalization is key to making your favors memorable: Including a favor tag with your monogram, wedding date, recurring motif, or favorite quote automatically makes your takeaway one of a kind. Even ribbon, tissue paper, or boxes in your signature colors can be enough customization. But the favor itself should be uniquely you, too. Whatever you decide to send home with guests needs to be one of two things: edible or practical. Before you make your decision, ask yourself—and maybe a few friends—if you really would use that item.

go with a theme
Look to your own region or wedding locale for favor inspiration. If the town is known for its locally harvested maple syrup or honey, a small jar of either is bound to stick with guests. For a mountain wedding, rock candy in your colors will nod to the locale. Black-and-white cookies befit New York events, and decks of cards are tops for a Vegas wedding.

For a garden party, you could give out topiaries or potted herbs. At a casual beach wedding, guests could go home with sunscreen in little bottles adorned with your monogram. After your country club affair, give out golf balls or tees.

Your favors can also be a perfect place to play up the season. If tiny pumpkins are too trite for fall, give out nostalgia-inducing candy corn in tins. Flower-seed packets (especially ones for your wedding flower) suit spring flings, while frozen drink mixes (so guests can replicate your signature cocktail at home!) complement summer soirees.

For a Mexican-style fiesta, guests can take home jars of salsa. No theme? No problem. Your favors can simply pay tribute to something you love. Brew your own beer and share bottles with personalized labels with your guests. Wine aficionado? Miniature bottles go over big, as do wine accessories, like stoppers and bottle openers.

Just be sure to avoid the common pitfall of turning a practical item into something that guests won't want to use. For instance, guests who enjoy entertaining would find coasters handy, but plastering your engagement photos on them renders the item tacky. Printing your names and

wedding date directly on favors has a similar effect. So if you want to personalize, do it on the favor packaging or on an edible gift.

If you're looking for an out-of-the-box favor idea, consider donating to charity in your guests' honor by choosing an organization that's meaningful to you and your fiancé. Let guests know about the donation by leaving a note at their place settings; add a small token that references the charity, like a jump rope if you donate to a kids' organization or a dog bone–shaped cookie if you give to an animal rescue foundation.

Gift cards are also off the beaten path and can feel personal if you choose ones from your favorite stores. The key is to pick online retailers or national chains that every wedding guest can take advantage of. Giving out cards for free music downloads or books lets guests select their exact gift. Alternatively, gift cards for free coffee are a treat.

types of packaging

Classic
Tulle circles folded up
 and tied with ribbon
Organza pouches
Paper boxes

Rustic
Burlap sacks
Galvanized pails
Wicker baskets

Modern
Acrylic boxes
Cocktail glasses
Silver tins

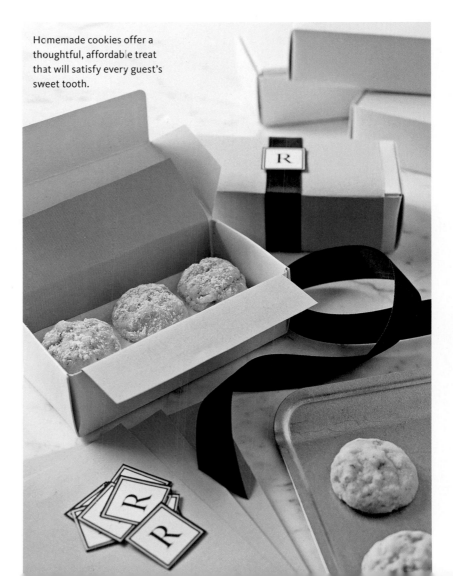

Homemade cookies offer a thoughtful, affordable treat that will satisfy every guest's sweet tooth.

Favor bars are a fun way to
go. Some favorite themes:
popcorn, candy, or cookies.

peanut butter &
white chocolate

sweet & spicy
barbecue

milk & white
chocolate

kettle corn

elise
&
jason
august 8, 2007

elise
&
jason

favor displays

Grouping favors on a separate table and having everyone help themselves on the way out is a sweet send-off.

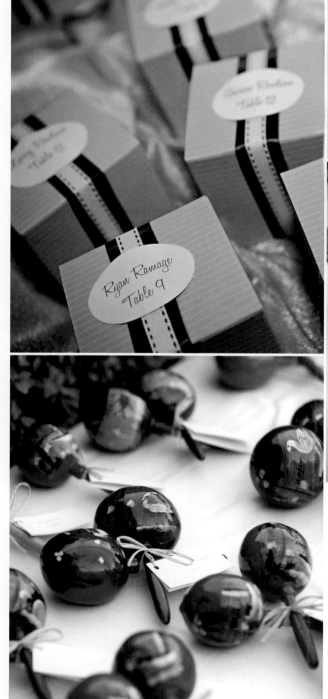

clockwise These favor seals include guests' table numbers so that they can double as escort cards. ▪ For a garden wedding with vintage Southern-style touches, honey-dippers are apropos. ▪ Guests who come to a destination wedding from far and wide will love to take home metal airplane-shaped luggage tags to use in their travels. ▪ Colorful maracas can get things shaking at a Mexican fiesta.

favors at the table

Trinkets that fit with the wedding decor can be left at each place setting to greet guests when they sit down for the meal.

top A nostalgic-style box of saltwater taffy suits a wedding by the shore. Baker's string holds a tag with a personalized stamp. ▪ A silver snowflake ornament not only embellishes the table decor but also can hang on the guest's holiday tree for years to come. ▪ Proof that packaging matters: Something as simple as tea bags can look amazing if they're in elaborate tins.

bottom For a fall fête, candied apples fit in deliciously, tempting guests before dinner has even begun. ▪ On this simple favor box, the pen-and-ink style gives the scallop-shell motif a sophisticated edge. ▪ A unique monogram makes a classic favor box feel even more special. The ornate Shakespearean lettering has an antique touch, more memorable than a standard block style.

A wrapped favor in the wedding colors is a pretty presentation for these mini-presents.

ℰpersonalized favors

Lots of different ways of putting a unique stamp on a favor exist—whether inspired by culture, hobbies, or a DIY project.

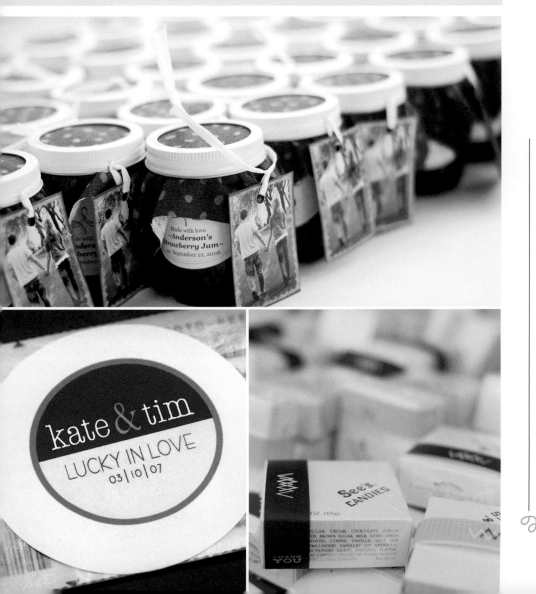

top A tin of popular Asian cookies proudly puts the couple's heritage on display. ■ Simply assembling the favors yourself can make them feel more personal. Stickers with the couple's names and a "Thanks for coming!" note in a handwriting font show off the newlyweds' casual style.

middle Pictures from the couple's engagement photo session are tied to these jars of jam.

bottom A lottery ticket in a glassine envelope with a colorful seal could make one guest a lucky winner at a Vegas reception. ■ The use of favors from a famous chocolatier—See's—clues guests in on the bride and groom's passions and lets them indulge a little, too.

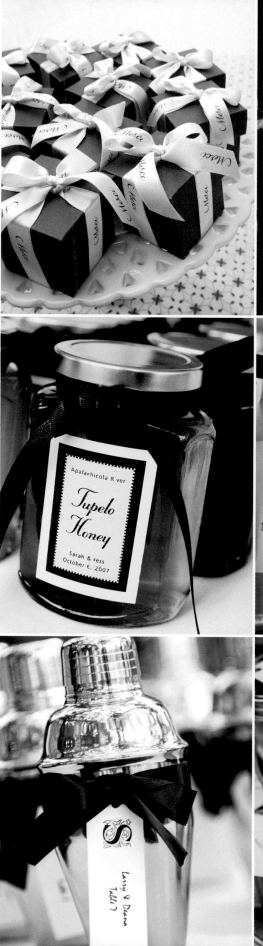

top A charming presentation: Favor boxes tied with ribbon that says *"Merci"* set on a vintage-style cake plate hint at the honeymoon destination. ▪ One creative bride made cocoa mix from her grandmother's recipe and wrapped a few servings in paper for each guest. A personalized rubber stamp and natural twine tie together the old-fashioned look.

middle Locally harvested honey wins points for reminding guests of your locale and being eco-friendly. ▪ For the environmentally conscious couple, packets of flower seeds are an eco-friendly choice, and leaf-shaped tags complete the nature theme.

bottom Cocktail shakers are a practical idea. They can be filled with a favorite drink mix or the recipe for the signature cocktail of the day. ▪ For a wedding with a green color scheme, mason jars were filled with limeade mix from an old family recipe and tagged with a refreshing slogan: "When life gives you limes. . . make limeade!"

Take your cue from other weddings

Before you decide what to give out, see what favors guests are leaving behind (or are trying to get extras of!) at other weddings you attend.

Comparison-shop on the web

Many times, the same favors are sold by many vendors, and prices can vary. Scour the Internet to find a reputable site or store that might offer your pick for less.

Do a taste test

That online description of truffles may make your mouth water, but they could actually turn out to be a disappointment. You may need to pay for samples, but it's worth the expense to know in advance that your favors really are tasty.

Do a run-through

Make some samples before you commit. If you only buy supplies for a small trial batch, you won't feel bad if you decide to scrap the idea and start fresh.

See a mock-up

If you're personalizing any part of your favors, you should see how they look before the whole batch is created. Ask for a proof or sample of all printed materials. Check that the information is accurate and spelled correctly; have a second pair of eyes give them a look, too.

Think green

If skipping packaging altogether isn't an option, look for boxes that are made from recycled paper or metal or plastic containers that can be recycled or reused when guests are done with them. Remind guests to reuse or recycle the packaging with a sign or personalized tags—printed on recycled paper, of course.

Order extras

Since favors are usually on the smaller side, it's easy for them to break or get misplaced. Having an additional ten on hand for every one hundred will give you some peace of mind.

Check that they're shipped safely

For perishable or fragile items, find out if they'll be packaged appropriately: with ice packs for food and with plenty of cushion for breakables.

Host a favor-assembling party

Because no bride should have to package everything herself, recruit your brides-maids and even the grooms-men to help. Entice them with pizza and drinks for some extra motivation.

See them in context

If you're leaving your favors at guests' place settings, round up samples of your linens and plates to see how everything will look together. If they don't look quite right, you may want to have guests pick up favors from a separate table on their way out instead.

Make sure there's room

Your guests' tables should look full, but not cluttered. Favors in small boxes probably won't cause too much crowding, but your tables may not have enough room for larger packages.

Give clear setup instructions

Whether you're giving out one favor per guest or one per couple, tell whoever is setting out your favors exactly what to expect. Specify where the favors should be placed, too. "On the tables" can mean near the centerpieces, on the plates, or on the napkins. Pick a precise place and make your decision known.

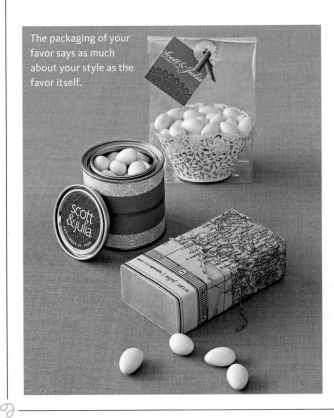

The packaging of your favor says as much about your style as the favor itself.

Want to see more favor inspiration? Go to TheKnot.com/favors

the whole package

Wrapping up a gorgeous favor is as easy as 1-2-3. First, find the right size bag, box, or container. Next, add a detail that reflects your wedding style, whether it's a custom tag or a colorful design element. Lastly, tie it all together with a pretty ribbon or string. Here are a few of our favorite winning combinations. *clockwise* A Chinese take-out container becomes flawlessly formal. ▪ Double-sided paper covers Rice Krispie treats. ▪ Pillow boxes get dressed up. ▪ The double happiness symbol adorns mini–bamboo steamers. ▪ See-through bags reveal the crunchy treats they hold. ▪ Larger boxes are perfect for out-of-towner gift packs.

brown

Today's brown is no neutral.
It comes in plenty of
standout shades.

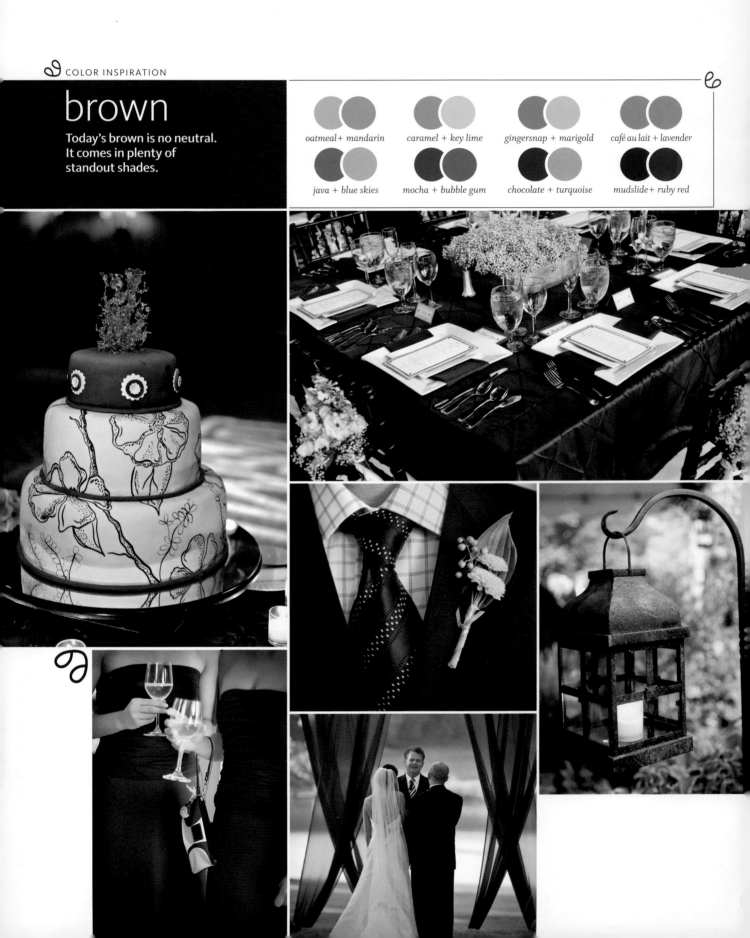

oatmeal + mandarin

caramel + key lime

gingersnap + marigold

café au lait + lavender

java + blue skies

mocha + bubble gum

chocolate + turquoise

mudslide + ruby red

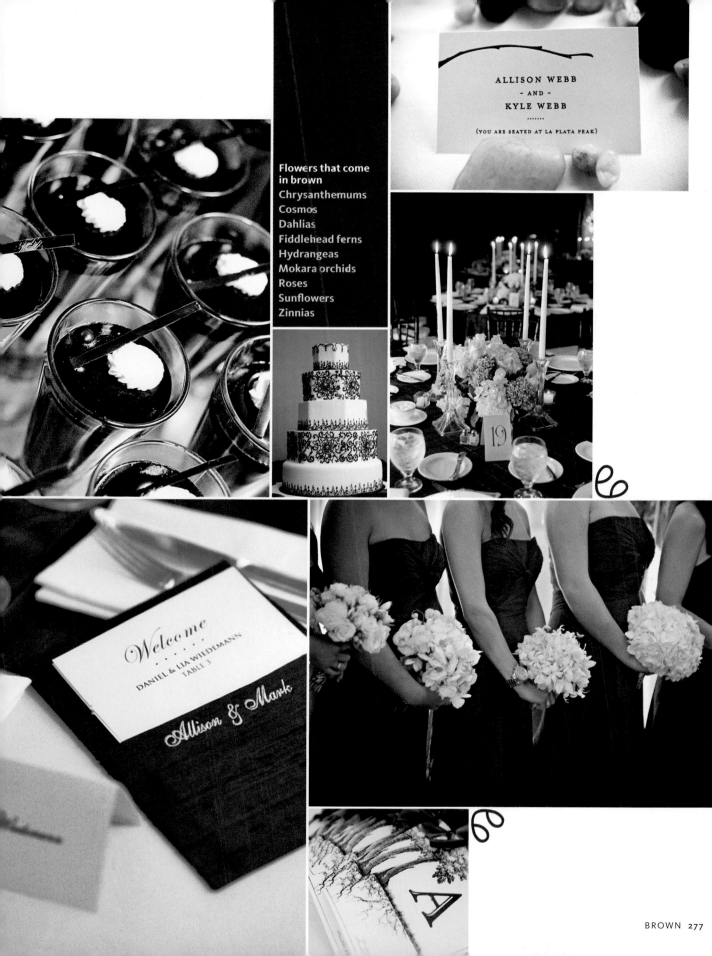

ALLISON WEBB
— AND —
KYLE WEBB
·······
(YOU ARE SEATED AT LA PLATA PEAK)

Flowers that come in brown
Chrysanthemums
Cosmos
Dahlias
Fiddlehead ferns
Hydrangeas
Mokara orchids
Roses
Sunflowers
Zinnias

19

Welcome
·····
DANIEL & LIA WIEDEMANN
TABLE 3

Allison & Mark

A

caramel
+
key lime

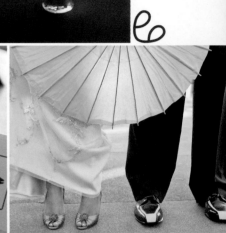

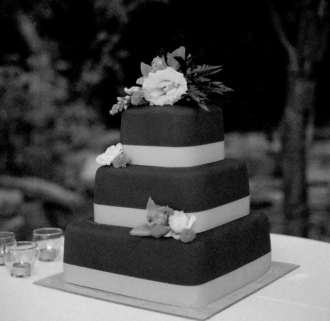

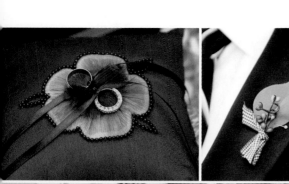

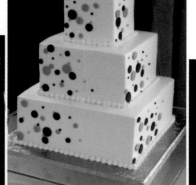

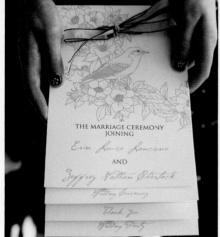

THE MARRIAGE CEREMONY
JOINING

Erin Louise Lancione

AND

Jeffrey Nathan Shertock

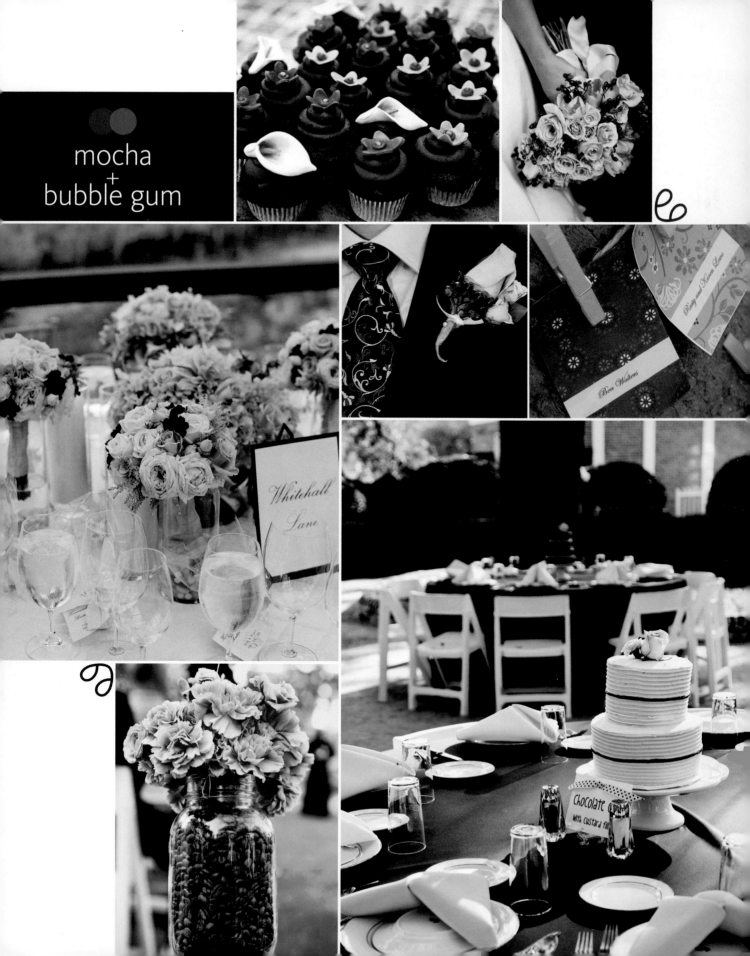

mocha
+
bubble gum

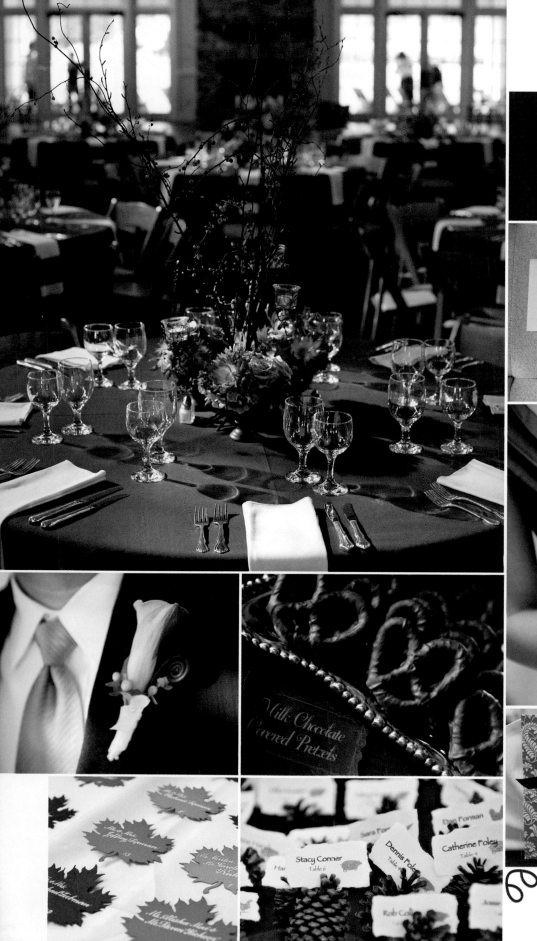

gingersnap
+ marigold

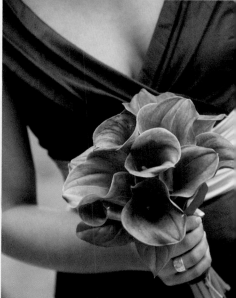

a textbook wedding

Self-proclaimed science geeks Amber and Jeff met as engineering students and wanted to pay homage to their time together in the classroom. One unexpected item—a piece of loose-leaf paper—inspired their vivid red and light blue color scheme. The couple found inventive ways to infuse the school theme, with details like tables named after their favorite subjects, escort cards made of test tubes, and stacks of red books scattered throughout the site.

CHEM ISTRY

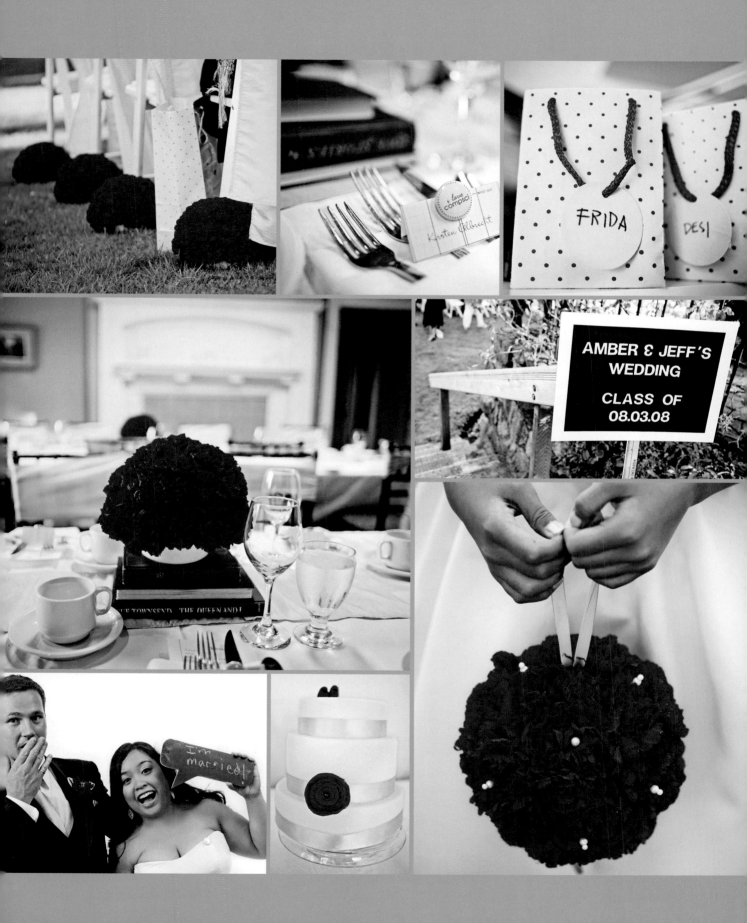

acknowledgments + credits

A large team of insanely talented people helped to create this book. I want to thank The Knot staff: Rebecca Dolgin, Liza Aelion, Rebecca Crumley, Rebecca Kimmons, Melissa Mariola, Anja Winikka, Lisa Freedman, and Jaimie Dalessio for finding the most beautiful wedding photographs, bringing them together in a gorgeous design, and discovering the story behind every picture.

In addition to the in-house team, I also want to thank Hilary Sterne for coming in and joining us on this adventure. Thanks too to all the genius wedding planners who shared their creations and suggestions: Nancy Liu Chin, Tara Guerard, Beth Helmstetter, Jill LaFleur, In Any Event, Lindsay Landman, Ivy Robinson, and Shannon Wilson; the incredible bakers who made us cakes, gave us budget tips and taught us how to make a vision come to edible life: Creative Edge Parties, Mark Joseph, Jan Kish, and Gail Watson.

We'd also like to show our appreciation to all the photographers who shared their work with us—without them, this book would not look nearly as pretty.

A special thanks to our team at Clarkson Potter; our agent Chris Tomasino; and our patient families. And finally, thanks to all of the wedding-obsessed Knotties who spend their days clicking around TheKnot.com and inspired us to create this book.

PHOTOGRAPHY

4Eyes Photography: 95; 5ive15ifteen Photo Company: 146, 147, 170, 173, 217, 260; 6 of Four: 221, 285; A Bryan Photo: 94, 272; A Dream Picture: 64; A House of Photography by Michael Ray: 257; A La Vie Photography: 196; Aaron Lockwood Photography: 121; Acorn Photography: 260; Adeline & Grace Photography: 205; Advantage Photo: 259; Aesthetic Images Photography: 299; Agnes Lopez Photography: 247; Alison Gootee: 96, 97, 106, 107, 113; Allegra's Studio: 256; Allison Garrett Photographer: 218; Allure Imagery: 248; Allyson Magda Photography Photography: 281; Alternate Angles: 94; Alyssa Almeida Duncan: 178; Amanda Kraft Photography: 145, 243, 276; Amanda Phillips Photography: 55; Amanda Sharp Photography: 195; Amber Procaccini Photography: 142; Amelia Tarbet Photography: 86, 257; Amy Martin Photography: 258; Amy Squires Photography: 30, 49, 63; Anastassios Mentis: 22, 26, 236, 241; 248, 253, 268, 287; Andrea Polito Photography: 81, 117, 141; Andrew Duany Photography: 141; Andrew McCaul: 206, 229; Anita Calero: 102, 110; Ann Wade Parrish Photography: 116; Anna Kilbridge Photography: 6, 67, 170; Anna Kuperberg Photography: 63, 93, 97, 151, 154, 155, 164, 165, 166, 167, 179; Anne Marie Photography: 31; Anne Ruthmann Photography: 132; Annie X Photographie: 24, 70, 71; Antonis Achilleos: 6, 8, 10, 13, 14, 15, 16, 18, 19, 21, 23, 27, 32, 75, 95, 121, 131, 180, 181, 208, 220, 228, 230, 231, 232, 233, 234, 235, 237, 238, 239, 240, 243, 244, 247, 248, 249, 250, 255, 264, 271, 274, 275, 285, 286; Apertura: 55; Arden Photography: 273; Arising Images: 286; Armitage Photography: 259; Arrowood Photography: 82; Art Pinney Photography: 9; Artful Weddings by Sachs Photography: 221; Arthur Remanjon Photographers: 177; Artisan Events, Amanda Sudimack & Associates: 35, 45, 86, 131; Ashley Garmon Photographers: 69; Barbara Banks Photography: 58; Bates Photographic Studio: 140; Bella Pictures: 253; Beloved Photography: 63; Ben Vigil: 193; Bisson Photography: 218; BKB Photography: 144; BLR Photography: 111; Blue Daisy Weddings: 135, 195; Blue Nalu Photography: 195; Boutwell Studio: 12, 49, 78, 83, 112, 113, 197, 201, 221, 258; Brett Buchanan Photography: 222; Brian Dorsey Studios: 34, 65, 91, 212; Brian Morrison Photography: 273; Brian Phillips Photography: 36, 37; Brooke Mayo Photography: 31, 66; Bruce Forrester Photography: 207, 288; Bruce Hilliard Photography: 196; Bruce Plotkin Photography: 30, 94; CA/VA Weddings: 219; Cakegirls, Ltd.: 120, 236; Cameron Ingalls, Inc.: 115, 197; Camilla Pucholt Photography: 116, 118, 287; Carrie Patterson Photography: 200, 201; Carrier Photography: 280; Casual Candids: 178; Catherine Leonard Photography: 261; CB Photography: 195; CCS Events: 131; CE Photography: 84; Cean One Photography: 266; Cheri Pearl Photography: 275; Chris Bickford Photography: 121; Chris Humphrey Photographer: 235, 276; Chris Joriann Photography: 30; Chris Moseley Photography: 63, 188; Chris Schmitt Photography: 223; Christian Oth Studio: 81, 86, 223, 248; Christie Pham Photography: 30; Christine Edwards Photography: 117; Chyna Darner Photography: 97, 135; Clark+Walker Studio: 23, 248; Clary Photo: 108, 259; Click Imagery: 35, 141; Couture Weddings: 142; Creative Photography, Inc.: 261; D. Bryant Photography: 61; Dan & Anne Almasy: 58; Danny Weiss Photo: 54, 130, 139; Daphne Borowski Photography: 85, 207, 285; Dara Blakeley Photography: 85; Darice Michelle Photography: 277; Dave Richards Photography: 32; David Lau Photography: 141, 215, 281; David Murray Weddings: 287; David Nicholas Photography: 49; David Prince: 49, 96, 243, 288; Davies+Starr: 116; Dayna Schroeder Photography: 69; Denise Cregier Photographer: 279; Dianne Adrian Photography: 97; DiBezi Photography: 115; DMDC Photography: 116; Dollface Studio: 278; Donna Newman Photography: 77; Donnalynn & Company: 287; Drew Newman Photography: 118; Duke Photography: 223, 270; Dustin Todd Photography: 272, 278; E Photography: 119; East Hill Photo: 194; Eclectic Images Photography: 69, 172, 133, 222, 257; Edyta Szyszlo Photography: 34; Elizabeth Messina Photography: 6, 73, 106, 185; Embrace Life Photography: 189; Emilie Inc. Photography: 223; Engaged Studios, LLC: 257; Eric Heger Photography: 95; Erik Ekroth Photography: 11, 46, 65, 68, 81, 96, 160, 161, 185, 209; Erin Beach Photography: 136, 286; Erin Hearts Court: 197, 278; Erin Johnson Photography: 32; Erin Kate Photography: 119; Evoke Photography: 131, 177, 220; Eyespy Photography: 219; Faith West Photography: 218, 219; Flashes Photography: 197; Frances Photography: 277; Fred Marcus Photography: 141; Freeland Photography: 281; Freestyle Weddings: 140; Gabriel Boone Photography: 189; Garbo Productions: 288; Gayle Brookes Photography: 84; Genevieve Nisly Photography: 117; Geoff White Photographers: 94, 223, 288; George Street Photo and Video: 278; Gerber+Scarpelli Photography: 68, 96, 129, 177; Gertrude & Mabel Photography: 127, 280; GH Kim Photography: 117; Gia Canali Photography: 193; Glenn Livermore Photography: 246; Goes Photography: 182; Grand Lubell Photography: 42, 43; Greenhouse Studios/Liz Stewart Floral Design: 63; Gregory Manis: 108; Halberg Photographers: 66; Hammerpress: 24; Hannah Photography: 143, 256, 284; Harold Hechler Photographers: 67; Harrison Studio: 222; Heather Donlan Photography: 49; Heather Saunders Photography: 116; Hemminger Photography: 119; Hillary Mayberry Photography: 191; Holland Photo Arts: 128; Holly Bond Farrell Photography: 281; Hooked on Photography: 68; Images by Berit: 69; In Photography: 49; Inner Spirit Photography: 143; Innovative Photography: 186; Ira Lippke Studios: 45, 65, 172, 182, 212; J Wilkinson Co. Photography: 61;0 Jacki V. Photography: 57, 192, 281; Jamee Photography: 143, 162, 195; Janae Shields Photography: 35, 97, 106, 170, 277; Jane Bernard Photography: 275; Jasmine Star Photography: 65, 112; Jason Wallis Wedding Photography: 129; Jeff Greenough: 35, 59, 183; Jeffrey Leong: 281; Jen Fariello Photography: 35, 53, 56, 129, 131, 170, 279; Jen Good Photography: 152, 153; Jen Kroll Photography: 32; Jenna Walker Photographers: 168; 169, 253; Jennifer Angeloro Photography: 269; Jennifer Baciocco Photography: 91, 112, 119; Jennifer Bowen Photography: 286; Jennifer Carroll Photography: 196; Jennifer Colina Photography: 279; Jennifer Davis Photography: 111, 136, 194, 219, 236; Jennifer Kloss Photography: 261; Jennifer Lindberg Weddings: 69, 192, 196, 197, 278; Jennifer S. Rau Photography: 103, 185, 275; Jennifer Skog Photography: 178; Jensen Studios NYC: 247; Jeremy Hess Photographers: 220, 221; Jesse Leake Photography: 2, 17, 121, 222, 286; Jessica Johnston Photography: 82, 118; Jessica Quist Photography: 195; Jill Higgins Photography: 33; Jocelyn Filley Photography: 121; John & Joseph Photography: 221, 286; John Hanson Photography: 278; Jonathan Allain Photography: 193; Jonathan Canlas Photography: 31, 34, 68, 115, 118, 120, 121, 131, 132, 140, 143, 265, 285; Jonathan Scott Photography: 49; Jorg Windau Photography/Swank Productions: 210; Jose Villa Photography: 6, 96, 100, 122, 123, 126; Joyelle West Photography: 58; Jules Bianchi Photography: 55, 115, 127, 278; Julia Newman Photography: 145; Julie Mikos Photographer: 58, 69, 89, 220; Junshien Weddings & Portraits: 195; Justin & Mary Photography: 200, 286; Justine Ungaro Studios: 118; Kai Heeringa Photography: 276; Kara Pennington Photography: 269, 273; Karen Wise Photography: 177; Karl Ko Photography: 32; Karlisch Photography: 81, 115, 131, 211; Kate Benson Photography: 192; Kate Connolly Photography: 259, 270; Kate Powers: 105; Kathi Littwin Photography: 288; Kathy Blanchard Photography: 34, 140, 215; Katie Lyman Photography: 64; Katie Moos Photography: 143, 194; KCK Photography: 213; Keith Lathrop: 108; Kella MacPhee Photojournalist: 196; Kelly Brown Weddings: 31, 95; Kenny Pang Photography: 33; Kenzie Shores Photography: 121; Kevin Chin Photography: 156, 157; Kim Box Photography: 35; KingenSmith Productions: 31, 67, 68, 85, 87; Klein-Davis Photography: 222; Kriech-Higon Photo: 143; Kris Rupp Photography: 256; Kristen Alexander Photographer: 63; Kristen Jensen Photography: 288; Kristin Spencer Photography: 31, 66, 80, 88, 103, 136, 145, 194, 215, 247, 253, 257, 260, 261, 270, 288; Kristin Vining Photography: 221, 258; Ksenija Savi Photography: 196, 258; Kylie Nixon Photography:

index